Bare Naked in Public

Bare Naked in Public

An earnest and humorous account of one
modern American woman trying to have it all

Christine Amoroso

Torchflame Books
Vista, CA

ISBN: 978-1-61153-340-8 (paperback)
ISBN: 978-1-61153-341-5 (ebook)

Library of Congress Control Number: 2024901514

Bare Naked in Public is published by: Torchflame Books, an imprint of Top Reads Publishing, LLC, USA

For information about special discounts for bulk purchases, please direct emails to: publisher@torchflamebooks.com

Cover design: Teri Rider
Book interior layout: Teri Rider

Printed in the United States of America

Dedication

For Mom
You once said to me,
"You can do anything. You get that from your dad."
Dad would say the best parts of me come from you.
I love you always.

For Dad
In your company was the best place to be.
I miss you every day.

For Ken and Tara
My kiddos, my sprouts
I will forever wish I was a better mom,
while always knowing I did my best.
I love you.

For my sibs
Patty, Susy, Mary, and Nick
The ones who love me, no matter what.

I knew the strength of my story would be its honesty, a true telling of the path I chose, and the twists and turns that shaped me. Inevitably my behavior, my motives and my choices will be judged. Unfortunately, some who played supporting roles in my story will be judged as well. They couldn't opt out of my memoir, and I couldn't write it without them. I changed their names and details and took care to ensure a fair representation.

With gratitude and sincerity, I honor their important contribution to my life.

CHAPTER 1

1986

We've been arguing and fighting for hours. For days, really. Cal waited and watched, checking credit card statements, and measuring the slow and steady disappearance of my diaphragm gel. I was careless. I counted on his disinterest in me—and our family—to maintain my cover. I never imagined he would find the truth through his own investigative work. The most damning evidence he found in Joe's bedroom. Cards, written and signed by me, shoved in my face as he screamed, "Are you fucking kidding me? My brother?"

I stood frozen, staring, dumbfounded. My mind raced; no time to lie, no excuses. I whimpered, "I, no, I'm not, that's not what's happening."

My voice trailed as his shouting escalated.

That was days ago. The initial shock over, he berates me every day: I lied. I cheated. I am a terrible wife, mother, daughter, sister, and friend. His pain and anger are relentless, and I am defenseless in their wake.

The telephone rings, a brief reprieve. He races to answer it. I chase him down the hall and catch his angry hello. He

yells into the receiver, voice shaking, "Shitty! It's SHITTY!"

Slamming the phone on the kitchen counter, he turns and pushes past me. I pick up the phone and quietly say hello. My mom's voice is soft and sad, "Are things really shitty?"

Tears stream down my cheeks; I swallow hard and force the words, "Um, yeah. I can't talk right now. I'll call you in a day or two."

In the silence, I feel the strength of her maternal pull through the phone. She is desperate to save me. I want to go home. I want to be twelve years old again, lying in my bed talking in the dark with my sisters, when boys were simple and safe and I liked myself. I want to start over. It's too late now. I've fucked up so badly. I don't deserve her love. I'm not worth saving.

For weeks Cal and I conceal the details of our personal drama. We stay close to home, no dining out with friends or family visits. I want to believe we can push past this and get through it unscathed. No one needs to know. I cut off all contact with Joe and promise to be the perfect wife. But deep inside, I want my marriage to end. I can't imagine Cal ever truly forgiving me. The reminders and snide jabs about my indiscretion will always be present. He is the sad, unsuspecting husband deceived by his wife and his own brother. It doesn't matter that he contributed to the collapse of our marriage. None of his behavior, faults, or mistakes matter because I was the cheater. And it's always the cheater's fault.

My fall from grace will be hard and fast. The favored daughter-in-law, the tolerant and forgiving wife, responsible for the death of her marriage, Jerry Springer style. I wake each day sick and achy. Before I open my eyes, I try to identify my pain, and then I remember . . . it's another day in hell, and I am paying for my sins. I want to be far, far away from all of this.

I want the instant gratification of my affair. I want someone to be on my side saying, "Yes, yes! You were driven to behave this way by your thoughtless, uncaring husband. Poor you, you carried the load!"

I hate him for not living up to my expectations, my fantasy marriage. I hate him because I loved him so much, and he didn't love me enough to change and be what I wanted, what I needed. I hate him for being exactly who I married.

✺✺✺✺✺✺

I sit cross-legged on the sofa, staring at the television, intentionally avoiding Cal's bitter stare as he makes several trips past me from our bedroom to the living room. He sighs loudly and slams drawers and doors. I ignore him. The kids are asleep, I hope. He gathers clothes and keepsakes and makes a pile near the front door. He is moving in with a friend, a guy from work. Someone who once whispered in my ear during a slow dance at a company party, "If your husband doesn't appreciate you, plenty of men do, me included."

But now he has taken Cal's side, creating distance between his previous impropriety and me. He wasn't the only one; close male friends had done the same.

I had kept my promise to stay away from his brother, to break off the affair, but I couldn't turn off my feelings of unhappiness in my marriage. As the mound grows at the front door, I remember a moment of clarity a couple of weeks ago: Cal and I laying on our bed in the middle of the day, exhausted from the daily digging through the rubble of our crumbling marriage. He said he was so angry with me that he had hoped my plane would crash on a flight home from San Jose last month. He said he couldn't compete with

the excitement of a new relationship, especially one with the dangerous and exciting elements associated with an affair. He seemed to understand clearly that he represented what was boring and broken, and he couldn't change that without my help. For the first time, I saw him as a thoughtful human, on a deeper level than I had ever seen. I understood his heart and his pain so clearly, and yet, I didn't want to make the effort. Reconciliation seemed insurmountable. He was a daily reminder of my indiscretion. Though I was sure the affair would not last, I needed it to help me end a marriage that hadn't worked for quite some time. I needed it to help me through the days ahead. Until I could tolerate loneliness.

The pile diminishes as Cal moves his belongings from the entryway to his car. Finally, he stands in the doorway. A load of dress shirts on hangers flung over his shoulder, he stares until I take my eyes off the television and return a stony gaze. With sarcasm that stings, he asks, "So, any advice for my next relationship? What should I do differently?"

I reply in kind, "Nope. Nothing."

He shakes his head and shuts the door behind him. I look back at the television. I am heartless, callous, and cold, and so incredibly sad.

✾✾✾✾✾✾

I stand on the stairway landing in my parents' home, holding my ground. Dad shouts at me from the second floor. Furiously spitting commands, he informs me I will not get a divorce; I will stay married. Desperate to change my decision, he shouts warnings about my actions and irreversible damage to my children and our family. Between ordering my children to

collect their things, I scream at him, "You cannot tell me what to do. I am not afraid of you!"

I am hoarse, crying, and shaking. The kids scurry past me on the stairs, doing their best to avoid the line of fire and still follow my directions to get their backpacks and get in the car.

From downstairs, Mom quietly asks for calm. I push past her, grabbing my purse and jacket. Through choking sobs, I defend my dramatic response to Dad's interfering, "He cannot tell me what to do!"

Exhausted by our screaming match, I make my exit, slam the door, and leave her to pick up the pieces. Poor Mom, always playing peacekeeper as Dad is constantly at war with one of us kids. We've each had our turn.

I had always been the dutiful daughter. I had been raised to fear physical punishment, Mom with her wooden spoons and Dad with his angry and unpredictable swats. Once I outgrew spankings, I feared their quiet disappointment. I wanted and needed their approval and love more than anything. And now, twenty-six years old and a mother of two, I defied them. I didn't want a marriage like theirs: years of arguments and Mom always giving in to Dad. I wanted to take charge of my own life. I wanted to be happy.

The car is quiet on the drive home. I look in the rearview mirror; little Tara sucks her middle and ring fingers while rubbing her nose with her index finger, a calming habit since she was a baby. Her brother Kenny catches my eye, "Are you mad at Grandpa?"

I take a breath, "No. I'm not, sweetie."

I'm telling the truth. I imagine after all these years, it must be hard for Dad to accept that he can no longer rule his children with fear, even if his intentions are good. He believes

he knows best and wants the best for each one of us. I feel sorry for him. But I'm not changing my mind.

1987

Mom and I sit on her living room sofa. Kenny P., a new nickname as a result of having two Kennys in his class, lies on a rug near our feet. First on his side and then rolling onto his back, the sun shines on his face. He looks up at the ceiling, teary eyed, and his little voice cracks, "When will my dad live in our house again?"

Mom sighs. I am sure she is already days into a *novena*, praying God will intervene and I will change my mind. Without hesitation, I respond, "He won't. He won't ever live in our house again."

My words are harsh, and I wonder when I lost my kindness, my compassion. I've said it, a moment I can never undo. I have to be tough; we all do. I don't want to give false hope. Though I could have been gentler in my response—a definite low point in my parenting. My boy is silent. I feel sick from the hardening of my heart.

Months earlier, Tara walked into the master bathroom to find me sitting on the toilet with my face buried in my hands. Her dad leaning against the bathroom counter, both of us crying as we discuss the details of him moving out. She looks at us through the smudgy lenses of her pink bifocals, thoughtfully cocks her head, and cries, knowing her life is also changing. I look at Cal and feel the aching of his heart. Deeply moved, aware of the awful power I wield, still I cannot let go of the resentment I let build for so long. Bitterness rules me.

Our kids are seven and eight years old. Too young to understand any of this, so we are vague in our explanation.

Their dad and I tell them again and again that our separating has nothing to do with them. We love them and will always be their mom and dad. We certainly cannot tell them the truth. Though I have been exposed publicly as the bad guy, I'll make sure our children never know the ugly details.

We haven't filed for divorce yet, but it is inevitable. Sometimes it hardly feels that Cal is gone. He comes to the house nearly every evening to kiss our kids goodnight, lay in their beds with them, and talk about the day. He sometimes falls asleep in his clothes and stays till morning. For now, I don't hold him to a schedule. It doesn't seem fair. We celebrated Thanksgiving together, and he arrived early Christmas morning to watch the kids open their presents. I am sure I'll see him for Easter Sunday and the birthday parties that follow.

The kids love to be with their dad and see the two of us together, getting along. After peaceful family gatherings, Mom often quips, "If you can be friends, why can't you be married?"

I don't know the answer. I shrug my shoulders and convince myself this is some modern arrangement she cannot understand.

Though this arrangement isn't always convenient. It requires planning, compromise, and kindness when, quite honestly, I don't feel like being kind at all. My in-laws cut me off completely. But that wasn't enough. My sister-in-law went so far as to call my mom and give her details about my affair. When Mom told me about this, I cried out, pissed. She innocently asked, "What did you expect?"

I screamed, "I expect them to leave me alone. To shut the fuck up and leave me alone!"

It didn't seem like much to ask, but it was. Everyone, and I mean everyone, weighed in on my life, judging me

harshly. Then there was silence and indifference, the worst punishment of all. Somehow Joe emerged unscathed from this mess. Strangely, even Cal found his way to forgiving him.

I am not sure of much these days. If divorce is what I wanted, I should feel better, some relief. But it isn't like that at all. Twelve years is a long time to invest in something and then to let it go. I am not good at failure, and I've always hated endings, even if I choose them.

✻✻✻✻✻✻

Home alone, I sit in the dark. My kids are with their dad, celebrating Christmas Eve with his entire family at Grandma and Grandpa Cleary's house. No longer invited, I imagine right now Grandpa is passing out the quirky gifts he stockpiled all year, something for everyone. Jars filled with pennies he finds on the streets and sidewalks while riding his adult-sized tricycle around town. A collection of potholders, calendars, and notepads left on his doorstep by the local realtor. It's strange to no longer belong.

I lie on the sofa, Christmas tree lights twinkle, and presents are neatly arranged beneath the tree. The only thing lacking is holiday joy. Over a year since Cal moved out, and I still punish myself.

I hadn't planned to continue a relationship with Joe. He was meant to stay a secret that would eventually disappear. But I created an impossible and isolating existence, so I hang on, denying myself any hope for redemption or happiness.

I hardly hear the quiet knock at the door. Peeking between the curtains, Joe peers back at me. I wasn't expecting him but welcome the company. The holidays have highlighted the recent disconnect with my family. I

feel like an outsider as my parents and siblings tend to Cal's broken heart. They won't acknowledge Joe's existence. I can't blame them. I barely acknowledge it. My family loves me, but they greatly disapprove of this choice. The only way back into the fold is to end my relationship with Joe, but I don't know how.

He steps in from the cold, and we hardly say two words before we are undressed. I hadn't planned on sex either, but then, it's the only thing we do. As he rushes through the motions, I whisper that I don't have my diaphragm in, and he'll need to pull out. He doesn't slow his rhythm. I put my hands on his hips, trying to push him off, scooting myself up and away. I tell him to stop, this time louder. It's too late. He releases, and I catch my breath beneath his full weight. I smack him on the back—hard. "Didn't you hear me!"

A year of cheating, and I know my ovulation schedule like clockwork, no mistakes. Until now.

※※※※※※

I sit in my doctor's office—the same doctor who delivered Tara eight years ago. The nurse is holding my pregnancy test. I cannot speak. She takes in a deep breath and says, "I know. It's always that one time. I'm sorry this is not the news you wanted."

I cannot stop crying. She puts her arm around me and hands me the information for the clinic I requested. She tells me to take my time as she leaves the room.

I sit alone, my paper gown wet with tears. On my list of regrets, I can now add a terminated pregnancy. I will tell no one, except for Joe. I blow my snotty nose into the gown before pushing it in the bin. I dress slowly. My body shows no signs

of pregnancy; it's too soon. Still crying, I hurry through the waiting area. A very pregnant woman gives me a sympathetic look. I cry the entire drive back to work. Fortunately, I am alone in the office today.

I immediately call the clinic. I clear my throat of any signs of emotion and take my voice up an octave sounding oddly cheery. I make an appointment for the following week. The faster I get this over with, the faster I can put the nightmare behind me, pretend it never happened. When I am told that I will need someone to drive me, I lie and say I've made arrangements for a ride.

Later that night, I call Joe to confirm what I knew to be fact the night it happened. I hang up without asking for a thing, no money, no ride, nothing. I take full responsibility. It's what I do.

I drive myself to the clinic and park a distance away. As I approach the entrance, I am forced to pass the Right to Lifers lining the sidewalk, holding posters of bloody, chopped-up fetuses. I look away and keep walking. They have no idea why I am here. Anyway, they are too late with their judgment. No one is a more unforgiving judge than me. I enter the building, sign in, and wait.

I wake up in a room with other women. I take a second to remember where I am, and when I do, I want to leave. The nurse slows me a bit, offers some water, and asks how I am feeling. I don't reply. She remarks to another nurse, "I guess she is not talking."

I ignore her. Speaking would give voice to this decision and acknowledgment that I had been here today, and I refuse to believe this ever happened. I get dressed and leave the recovery area. As I check out, I am asked again if I have a ride. "Yes, waiting for me outside."

I drive back to my office and bury myself in work until 5:30 p.m. Physically and emotionally spent, I race to pick up my kids before 6:00 p.m. They'll be thrilled to have a fast-food dinner.

CHAPTER 2

1978

The old Ford van hums along Interstate 15 headed to Vegas. It's very early morning, and I am sleepy. Dad is driving, Mom next to him, and my future in-laws sit behind them. My boyfriend Cal and I sit in the way back; my head rests on his shoulder, we hold hands. High school sweethearts, I am seventeen, and he is twenty.

We met the summer I turned fifteen, hanging out on the beach at Magnolia and Pacific Coast Highway in Huntington Beach, known simply as Magnolia by the locals. He was tanned, tall, and lean, with broad shoulders and defined muscular arms, the quintessential surfer. Shoulder-length hair, blue-green eyes, and a shy smile, he had all the qualities a fifteen-year-old girl wished for in a boyfriend. I didn't know him well. We grew up in different neighborhoods. He would be a senior in the fall. I never made the first move with boys and only responded to those who showed interest in me. I was no different with Cal.

On those long summer days, I sunbathed with my sisters and girlfriends for hours. We cooled off in the ocean, body

surfing. Swimming beyond the waves, we floated in the swells. The boys surfed early and then headed to Naugle's for breakfast burritos or home for a shower. We watched for their return, glancing back toward the lifeguard station. The three-story stucco structure provided the perfect lookout for checking the afternoon surf. Eventually, the boys made their way to the sand and to us. Not a beach towel among them. They were way too cool for that, so we shared ours.

Cal sat with me when someone hadn't beat him to it. We talked about school, our classes. He loved art and woodshop and admired his teachers Mr. Nichols and Mr. Monji. My studies were more academic. I was required to graduate as a junior, Dad's plan. Cal listened. I wasn't sure if he was impressed or uncomfortable. Boys were sometimes surprised that I was smart. Changing the subject, he looked toward the ocean and shouted, "Check out that left!" I knew he was talking about the waves, but where the surf was concerned, I didn't know my left from my right. So, I smiled and gave the universal response, "Cool."

One afternoon, he asked me to walk to the snack shack with him to grab some Strips. Tortilla chips smothered in cold grated cheddar cheese and hot sauce; I could never pass them up. Away from the crowd, he seemed nervous. He stopped suddenly and said, "Okay, I have to kiss you."

So, we kissed. I swear I heard hooting from our friends in the distance. We've been inseparable since. Though I'm not sure either of us imagined a Vegas wedding a few years later.

I lift my head and stretch my arms. My belly flutters. I am a solid five months pregnant. I wanted to be married young like my parents, maybe not this young, and perhaps with an engagement and a wedding. But it's all going to be okay. We were going to be married eventually. The pregnancy just put us on the fast track.

There is an uncomfortable quiet in the van—an uneasiness I cannot name. Maybe everyone is tired. Maybe we are all a little nervous. Cal leaves me in the back and maneuvers toward the front of the van to retrieve something from his dad. Sitting next to me again, he opens his hand. A gold ring with a tiny diamond embedded in its slim band rests in his palm. I push it down my pregnancy-swollen finger and call to my parents, holding my left hand high. Mom turns her head to see me. Dad glances in the rearview mirror. They share a knowing look and do their best to be happy for me, for us. My future in-laws do the same, both unconvincingly.

We are getting married in Nevada because it is fast and easy—no complicated paperwork or blood tests needed. Because I am underage, the only requirement is that my parents be present and willing to give me away.

The van is quiet again. I look at my hand and admire my ring. I will be married today. I love him. We love each other. Loggins and Messina's "Danny's Song" plays in my head, and I feel sure it is the soundtrack to our beginning. I want to feel happy in the way I think a bride should feel. But the mood feels heavy as we drive through the desert. I try to lighten the air with happy chatter, but I can't be heard from the way back unless I shout, and I sound like a loud, restless child, annoying, as I repeat myself. My voice trails, and no one notices I've stopped talking. Each of them in their own heads, telling their own story of this day. I wish I knew their thoughts. It's probably best I don't.

We arrive downtown at the Office of Civil Marriages. With our parents as our witnesses, we receive our marriage license and then wait in line for a judge to pronounce us man and wife. I glance down at my belly and wonder if anyone can tell I am pregnant. Fidgeting, I twist and turn my wedding

band. I listen to the conversations around me, as everyone with me is silent.

The line moves slowly. We inch forward as couples leave the courthouse chapel, some in full wedding attire, white dress, black tux, with wedding party in tow, others less formal. I wear a loose gauze blouse and yellow, loose-fitting pants. By far the most unflattering thing I have ever worn, a hand-me-down, and currently the only thing that fits. A lump grows in my throat. This day does not match my dreams. I force a smile and talk about nothing to distract myself from a nagging truth. I am a statistic, another sexually active teen, pregnant too soon, and now a shotgun wedding. It occurs to me that this morning's quiet was the absence of celebration and pride.

We say the traditional vows, no personal touches or original words. Just, "I do." The deed is done. We eat an early lunch at the Golden Nugget, polite small talk with bits of awkward silence between us as we chew and push bad food around our plates. I imagine Dad preoccupied with worry, sure his smart girl will never finish college now. Mom, already starting a *novena*—praying for a good life for me, my husband, and our baby. Cal talks a little about his new job and the future. I listen, not sure if he is trying to convince himself or our parents that he feels great about all of this. I have no doubt he loves me, but that is much different from wanting marriage at twenty and taking on the responsibilities of having a wife and child. I suddenly feel sorry for him.

His dad jokes and laughs nervously; his mother has not said more than a few words all day. With their unwed daughter living at home with her toddler daughter, perhaps they were hoping for something different for their oldest son. Married nearly twenty-five years, they have not slept in

the same bed for years. Maybe after ten children, they've had enough. Maybe they cannot imagine a happy future for us.

The ride home is more of the same. I'm looking forward to getting out of this van, away from our parents. There is a room at the Balboa Bay Club in Newport Beach waiting for us; our first night as a married couple. I want to be alone with my husband, to love him, to talk about the day and our future.

Late in the day, we check in, Mr. and Mrs. We unpack the little we have between us as we are only staying one night. The phone rings and startles me. It's Dad. Turns out he and my husband have a game of racquetball planned. Within minutes, Cal is suited up in gym clothes and runs out the door, shouting a quick good-bye. I sit alone on the bed and take notice of the room for the first time. It's hardly romantic, dark with heavy drapes—more of a dated time-share apartment than a honeymoon suite. I lie down, exhausted from the early morning start, the emotions of the day, and the enormity of the life changes ahead. This scenario is not at all what I expected. I am mad at Dad for his insensitivity and angry with Cal for agreeing to play. But I say nothing. I fume and curse myself for wanting a little wedded bliss. I cry for a long time before crawling under the sheets and falling asleep.

❊❊❊❊❊❊

The minute hand ticks past midnight; my labor hits the twenty-hour mark. I am miserable. The drugs have increased the intensity of my contractions, but I remain dilated only a few centimeters. Cal appears from the waiting area and says, "Everyone wants to know what's taking so long."

By everyone, he means his parents, specifically his mother. It's hard for a woman who has given birth to ten children—no

labor lasting more than a couple hours—to understand how anyone could take so long to have a baby.

It had been decided that after we got married in April, Cal and I would live in my family home. Perfect timing as my parents and younger siblings were moving to Oregon in the summer. With her two oldest daughters married teens, Mom was desperate to avoid the same fate for her remaining three children. Leaving Orange County for a slower-paced country life seemed like a good idea.

My family left before dawn on a mid-July day. We had said our good-byes the night before and talked about their visit once the baby arrived in September. Lying in my bed, with Cal sleeping soundly by my side, I listened as my family shuffled luggage through the hallways, my younger siblings grumbling about the early hour, and my parents whispering, "Be quiet."

Mom and Dad came into my room for one last good-bye, each of them kissing my forehead. I felt the brush of Dad's beard, and I knew Mom was crying. Pretending to sleep, I fought to keep my tears inside, barely breathing until the door quietly closed behind them. They were moving a thousand miles away. Too embarrassed to wake my husband, too strong and proud to tell him of my aching heart, I quietly cried.

Now, in my confused, drug-induced state, the hours seem like days, and I want my mom. Exhausted and utterly unprepared for this marathon birth, I turn my body over to the nursing staff. I rely on them to interpret my pain and guide me through the order of events.

The intensity and frequency of the contractions increase. Where the hell is the doctor? When he finally arrives, he examines me and is quite surprised. My cervix has finally decided to participate in this labor. Nearly 2 a.m., and I am ready to deliver. He mentions something called a saddle

block, and the nurses get busy. I receive an injection in my back and am suddenly numb from the waist down.

My useless legs are lifted into stirrups, the doctor positioned between them, and I am told to push though I cannot feel a thing. I bear down with imaginary might, and somehow my brain gets the message as the nurse acknowledges my pushes and assures me the baby is on the way. As slow as my labor was progressing up to this point, these last moments of childbirth seem to be happening at breakneck speed. The doctor's commands, the nurses' responses, and my husband's play-by-play commentary are all a blur as I concentrate on my baby's journey through the birth canal. A final push, and like magic, a baby boy is held high for me to see. Covered in slimy goo, he squawks a bit and blinks as if trying to get me in focus. Nine pounds and two ounces, we name him Kenneth, after Cal's dad. He is my boy.

I let the hot water hit my face and chest. My neck and shoulders relax, and the pain of childbirth is a distant memory. I look down at my deflated belly, sagging skin, and deep purple stretch marks from my pubic bone to an inch above my belly button. I can only hope they fade as Mom has promised. I gently pat myself dry. Slipping on my bathrobe and slippers, I walk to the nursery to visit my baby. He is significantly bigger than the other newborns, and I am filled with pride. I am happy and not at all frightened or worried about motherhood. Ignorance is bliss.

Back in my room, the door pushes open, and my doctor appears and offers a friendly greeting. He sits on the end of my bed and asks me how I am feeling. I'm bubbling with happiness. Then the conversation takes a serious turn, "You know, Christine, raising a baby is a lot of responsibility. Many couples are waiting for babies to adopt. You could put

this baby up for adoption. I can help you. Have you thought about that?"

I am shocked. Flustered and angry, I reply, "I am married. I have a husband. He has a job. We are a family. We will be good parents and raise our own baby."

With a conciliatory shrug, he leaves my room. My heart races. I am a mother now. Being a mother cannot be undone.

❊❊❊❊❊❊

I've gotten used to the insensitive comments that strangers, and sometimes friends, make. "Oh, look! Babies having babies!" is one we hear often, followed by pointing and lighthearted laughter. "How old are you?" "Did you plan this?" "I could never do what you're doing." "Yeah, I was your age when I got pregnant, and I had an abortion." "How will you ever finish college?" "What do your parents think about all of this?"

I behave like an obedient schoolgirl, force a smile, and sheepishly respond to the comments and questions. I don't have the courage to tell people to mind their own business. I push away feelings of inadequacy and doubt. I'm a good mom, and I'm doing a good job. I didn't anticipate the loneliness that comes with hard decisions. My whole life, I had been applauded and admired for taking on responsibility. Somehow, motherhood at my young age didn't garner the same respect.

Away from the naysayers and judgers, my little family thrives. I am happiest left alone to love and care for my baby. At midnight, when Cal comes home after working the swing shift at a large bottling plant in Los Angeles, we welcome him back into our tiny world. Late-night feedings become our regular dates. I love how much Cal loves our boy. We are all that matters.

1979

The sun has not quite risen, and a subtle glow fills my bedroom. Wide awake, I haven't had a comfortable night's sleep in days. Lying on my side, a pillow between my knees, my huge pregnant belly tightens again; the contractions come regularly now. A recent ultrasound predicted the first week in December, a tiny girl, but I think today, Thanksgiving, will be the day. Slowly I sit up. Cal stirs, and I tell him I'm having contractions, but I'm not going to the hospital until the last possible moment.

Kenny, just fifteen months old, runs down the hallway to my room. So little, but already in a twin bed because we need the crib for his baby sister. I take his dimpled hand, and we walk downstairs together, counting one slow step at a time. I make him breakfast and tell him the baby is coming. We've talked about the baby, about him being a big brother. He says, "Okay."

A baby himself, I'm glad he does not understand that he'll be sharing me now. He happily eats his cereal, getting more on the highchair tray and the floor than in his mouth. I call my mother-in-law, Jo. I know she's up early, preparing for today's feast. Hearing my voice at this early hour, she knows it's time. I'll be dropping Kenny off on the way to the hospital. I tell her I'm sorry to miss her delicious spread, and she promises leftovers.

I dress Kenny; he squirms and wriggles. Am I really ready for two? His dad takes over as I finish packing his diaper bag. I quickly clean the bathrooms, make the beds, and straighten up around the house, stopping now and then to let a contraction pass. I call the doctor, my new doctor, to tell her we are on the way. Her service reports she is out of town. Of course—it's

Thanksgiving Day. A doctor on call will deliver our baby girl. As we pull away from the house, I say out loud, "We'll return as a family of four."

We are happy.

The hospital is quiet, with few staff and patients—the labor and delivery floor equally so. My room is chilly, and my teeth chatter as the nurse checks my cervix. She announces I am dilated five centimeters. I smile. She laughs and says, "I've never seen anyone so happy to be in labor."

Without knowing my history, she cannot understand. I know this time will be different. I refuse all meds, and my labor moves along quickly—very quickly.

At 12:03 in the afternoon, my tiny girl is born, nine pounds and five ounces. Tara; a strong name. She'll be a tough cookie, I can tell.

CHAPTER 3

1980

Tara's head rests on my shoulder. She falls asleep. I gently pat her back, hoping for a quiet burp, a small release of gas, rather than the projectile vomiting that has become a part of our daily routine. I don't want to accept that my milk is the problem, as the pediatrician has hinted. Holding her close, I slowly stand and carefully walk toward her crib. I feel the familiar tightening; her knees pull upward against me, the only warning. Then a splat as regurgitated breast milk hits the floor behind me with a force that spreads it spattering far and wide. A sour odor fills the air. I resist my own gag reflex.

No crying, not even a whimper, she finds her way to sleep again, and I lay her in the crib. On my hands and knees, I clean up the mess while Kenny stacks blocks and talks to himself, unfazed, while I worry. My little girl is far, far away from becoming the chubby butterball that would bring me tremendous comfort.

Rather than try to feed her again, I watch her sleep. Peaceful with her eyes closed. I imagine they feel relief from the strain of their terrible crossing when she is awake. Her tiny

irises stuck in the corners of her eyes. Sometimes I frantically wave my hands in her face and make silly noises, an attempt to uncross them and direct her gaze toward me.

I am overwhelmed by the weight of my responsibilities. A cross-eyed, vomiting infant, an eighteen-month-old, and my college courses. I want to take a break from my studies and just be a mom for a while. But I can't disappoint Dad or Cal. A degree and a well-paying job have always been the goals. I'm not sure I can manage it.

❉❉❉❉❉❉

Tara points and jabbers on about the brightly colored items on the shelves as I fill the shopping cart with this week's groceries. She looks at me through her tiny cat-eye bifocals, her brown eyes magnified, and smiles her deep dimpled smile. I smile back. With the eye surgery and the new glasses, she can see, and her development has surged.

From the back of the cart, her big brother informs me that they both need a snack. I unwrap a fruit roll for him and open the box of teething biscuits for her. She gnaws on it, and sticky, brown juice runs down her double chin. She has outgrown her tummy trouble and gets chubbier by the day. I lean in and kiss her nose, avoiding her messy face. I grab juice boxes and string cheese, perfect snacks for our afternoon at the beach.

The slow and simple pace of summer days are my favorite: no school, no work, no schedule, and no stress. I survived spring semester and even managed some decent grades, proving again to myself and everyone else that my super-achiever capabilities have not been compromised by teenage motherhood. I can do it all, and I am only twenty years old. All is right in my world again.

1981

The kids run between our two houses. Cal and Al surf together, and Sharon is like a big sister to me. They moved in across the street five years ago. I was their baby girl's first sitter. Now I spend most Friday evenings with them and the other moms and dads of Shell Harbor Circle. Everyone is more than a decade older than Cal and me. I feel grown-up in their company, talking politics, solving world problems, drinking, and smoking pot.

Sharon and Al's home is the party house. So, this afternoon when she shouted an invitation from across the street, I eagerly accepted. Remembering that our best friends Randi and Bill might stop by later, I ask if they can join. She has a "more the merrier" attitude, it would not be a problem.

Homemade gazpacho and ceviche fill large ceramic bowls on the kitchen counter. Al blends margaritas and hands me an oversized glass. I lick the salt from the rim and take a sip: strong and delicious. Chatting with the ladies, I drink it faster than I should. I hear Cal's voice. He is late, arriving hours after his workday ends—a bad habit he makes zero effort to break. When we had only one car, I was at his mercy, waiting forever for him to pick me up from school or the grocery store. With my own car now, I am not as stuck, but as a full-time mom, and full-time student, I am hardly free.

Al shouts, "About time, man! Margarita or beer?"

Cal grabs a beer and gives me a nod. I offer a reluctant smile; it is Friday, and I do not want to be pissed at him. Al pushes a second margarita my way—or is it a third? Not yet twenty-one, I am a lightweight and should pay closer attention. Gary, an old friend of Sharon's, raises his glass to mine, and I respond with a quick tap. He recently relocated

from Colorado to California with his teenage daughter. They are temporarily living with Sharon and Al. Creative and quirky, he talks about a way of life I have never experienced— definitely a product of hippie culture. He is around the house a lot, doing miscellaneous things for Sharon until he finds a job. Occasionally he will shuffle over to my side of the street to talk while the kids play. I like him, an adult who is interested in me, my point of view.

Chilly, I leave the kitchen and sit in front of the fireplace. Gary follows and squeezes in next to me. The flames crackle behind us, and my back warms. The combination of alcohol and pot has me all buzzy. I tune in and out to Gary's voice. He runs his hand from the nape of my neck to the small of my back and casually rests it on my exposed bare skin. His touch is easy, smooth. With his free hand, he laces his fingers between mine, behaving as though this is normal behavior between friends. The inappropriateness of this moment does not register immediately. Lost in hazy thought, I lift my head to see Cal stand to attention. Fuming, he glares at us and says loudly to Al, "He's holding her hand!"

I sit up and pretend not to hear him, hoping he will let it go. Gary keeps talking but is no longer touching me. Searching the faces in the room, it is clear that everyone has witnessed this indiscretion. To prevent the shit from hitting the fan, I jump to my feet and announce it is time for us to go. Randi and Bill are way ahead of me. Cal is on my heels. Gary never moves, no reaction to the chaos he has caused. The foyer is filled with quick, awkward goodnights, compliments on great food, and promises to meet up later in the weekend. Randi and Bill rush off to their car and shout goodnight. I am left to face the music.

Lying in bed, the silence is deafening. My heart and mind race. Cal hasn't spoken a word since we came home. I know I

should offer some explanation, an apology. I clear my throat, "The whole thing was nothing, no big deal. Gary was having some kind of hippie, free love moment. How was I supposed to know he was going to do that?"

"Why would Gary even think he could do that if you had not given him some reason. What were you talking about?"

I do not remember. I guess I could have prevented the scene or at least reacted with some level of indignation. The truth is it felt good. I sigh. "What do you want me to say? Geez. Sorry."

I try to understand my behavior. The rebellious teenager I never was chases me, begging me to have some fun. The pull is strong; I must resist. *Suck it up, Christine, be a good wife, and appreciate what you have.*

1983

I race against the rising sun to complete a major project for my auditing class due this morning, no late work, no exceptions. Up all night, my eyes burn, and I long for sleep. Two days of vomiting preschoolers put me way behind an already tight schedule. Knowing I must stay home with them today, I make a quick call to a classmate, Rob. He'll meet me outside the business building and turn in my project for me. I shout to Cal, "I've gotta run to school, but I'm not staying. I'll be back in a flash."

In baggy sweats and flip-flops, I run out the door, into the pouring rain. The morning commute is a blanket of red brake lights. I'll be late. I stew. I hate everything: the traffic, my major, my stupid accounting classes. With the finish line near, I only want to put an end to suffering hours of homework and studying a subject I hate. I want to be fucking done.

Class starts in minutes. I've missed the window to meet Rob. Desperate, I leave my car, engine running, in the red zone. With folded spreadsheets tucked under my sweatshirt, I run. Wet and breathless, I peer into the classroom and spot him, possibly looking worse than me. I slip in and drop my project on his desk. He glances up and gives me a nod. Mission accomplished. I return to my car, no ticket, the parking angels on my side.

I take Pacific Coast Highway home—a slower, scenic route. Even under stormy skies, it's beautiful. Passing Bolsa Chica Wildlife Reserve to my left and the cliffs to my right, my mind wanders to a young girl's dream of becoming a teacher. I spent my childhood playing school. I liked being teacher's pet, and I loved helping in the classroom. When I enthusiastically shared my college plans with Dad, he shook his head. "Christina, teachers are being laid off. There are no jobs. An accounting degree is secure and stable. Business will be your major."

And just like that, Dad decided, and my dream was over. A grown woman, a wife, and a mother, I still needed Dad's approval. I wanted him to be proud. Now, my degree within reach, I have no sense of pride or accomplishment, only relief that this torture will soon end.

College has been more of an endurance test than a growth experience. Unless I count growing apart from my husband. He is still gainfully employed in Los Angeles. A decent career path that doesn't require a college degree. In sales now, he is in and out of grocery stores all day. Making friends and breaking hearts. When we attended a company picnic last summer, I learned that most of his colleagues had no idea he was married or had kids. He had kept his relationship status private, leading coworkers and customers to assume he was single. That hurt. Did I embarrass him?

For my part, I spent endless hours on campus, bonding with classmates in study groups, day drinking in both celebration and commiseration, and weakening our bond as a couple. I had more in common with my college friends. I enjoyed their company.

My overachiever status has suffered as well. My grades are uncharacteristically average. I cannot boast of any outstanding academic achievements or accolades. Instead, I remind myself that I am only twenty-three, I have a five-year-old son and a four-year-old daughter, and I will graduate from college in days. This is my revised story: making it despite the odds. I'll save pride for some other accomplishment, some other dream.

I open the front door, Cal bolts past me, shouting a quick good-bye. The kids greet me with tattling, requests for breakfast, and cartoons. Clearly, they are feeling better. I wish I were.

CHAPTER 4

1984

Sitting in the window seat, I squint into the bright blue sky as the plane taxis toward the runway. We're headed to Mazatlán. My mom's best friend Brenda reaches for my hand and squeezes. Since I was eight years old, I have wandered across the street to visit her, try on her shoes, water her plants, or watch Dinah Shore. She invited me on this spring break trip to help chaperone her teenage daughter Sandra and a few of her friends, including Cal's brother Joe. But I suspect she wanted to help me forget real life for a while.

I pull down the window shade and close my eyes. My thoughts drift to home, and I fight mom guilt. I deserve this trip. After all, Cal spent a few weeks surfing in Costa Rica in January. But our relationship needs work, more time together and sharing the load rather than escaping the daily grind we have created. We compete for free time, and I am always on the losing end of that game. He has a knack for disappearing for hours, checking the waves while having coffee with fellow surfers, then surfing if the conditions are good. Other days he stops by his dad's print shop to shoot the shit with his

brothers. He rarely spends his free time with me and the kids.

I try to give Cal his due. He works hard, but so do I. We agreed I'd work part-time for his dad until I graduated. I'm stalling; a full-time job means more work for me without help from him, and I'm already resentful. I shouldn't complain. We have a decent life, and we've defied the odds that predicted our failure. Yet, I constantly question my happiness. A friend suggested couples counseling. When I approached Cal on the subject, my voice quivered as I alluded to cracks in our marriage and the possibility of therapy. Without a second thought, he replied, "If I don't talk to you, I'm definitely not talking with a stranger."

That was it. A dead end, and more time apart. Laughter brings me back to the party on board the plane. The girls engage our fellow passengers with teenage enthusiasm. I am not much older than they are, but the lightness of their lives and the brightness of their future feels a million miles away from me. Childhood to motherhood, with college sandwiched in between, was a straight shot. No time for fun.

✼✼✼✼✼✼

Gathered in the lobby of the hotel, we wait for our taxis. We need two. The girls don tiny white shorts. I wear a new outfit that had me smiling at my reflection in the dressing room a few days ago. Now it seems a tad conservative, like I am ready for the cruise set.

I blame my insecurity on the constant barrage of female attention bestowed on Cal and the endless compliments regarding his youthful good looks. In case I miss the shock and awe of strangers exclaiming disbelief at his being the father of two young children, he is sure to recount every detail.

His reaction to the young women who flirt with him in my presence is most hurtful. In restaurants or while we're shopping with kids in tow, they engage with him as though I don't exist. And he responds in kind. When I glare at him in disbelief, he scoffs, "What am I supposed to do?"

"How about ignore them?" I snap.

I have never been the jealous type. I was confident and popular when we met, the smart girl with the cute figure. He was the lucky one. I know my character, good heart, and strong mind are most important. But right now, I care about the way I look—a lot.

Before I have a chance to run to my room for a quick change into short shorts, our taxis arrive. Cruise wear it is.

Señor Frogs is one giant party. Our table is quickly spotted by the tequila team. Good-looking young men with noisemakers and Bota Bags filled with tequila rush over. One by one, they blindfold the girls, tilt back their heads, and squirt bottom shelf alcohol down their throats. I don't want to do this, but cheers from the roomful of tourists tell me I will be participating, like it or not.

Sloshy margaritas follow, and the dining room transforms into a dance club. Madonna's "Holiday" plays so loudly my ears are ringing. Having gone beyond my two-drink limit, I am queasy. I pray that if I keep dancing, I can sweat out the alcohol. Even in my drunken state, I am quite aware of the girls getting the lion's share of male attention. I stare and smile stupidly at sloppy, drunk, groping strangers. What is wrong with me?

My gut lurches. Pushing through the crowd, hand over my mouth, I run as quickly as a stumbling drunk woman can. I barely make it to the toilet, lean over, and barf, again and again. Eyes watering, I cough and gag. Sure I am finished,

I flush and sit against the partition to the next stall. Legs splayed, my face and chest clammy, my stomach settles, the room stops spinning, and I have a moment to assess my situation. I'm a grown woman partying with teenagers in Mexico while my husband plays bachelor at home. We should be fighting for our marriage. Instead, we fight for time away from each other. I wonder if deep down I don't want to save our marriage. Maybe it's too late.

<div align="center">❋❋❋❋❋</div>

Beach towels lie edge to edge, corner to corner. Tubes of Bain de Soleil, straw hats, and magazines litter the large patchwork quilt of terry cloth. Resting on my elbows, the occasional light breeze cools me as I baste, oiled up, in the Baja sun. I spot Sandra and her friends, tanned and toned, near the water playing smash ball. Joe's gaze is fixed in their direction, and he leaps off his towel to join them. I don't blame him; he is seriously crushing on one or two of the girls.

Left alone with my thoughts, I evaluate my appearance. Again. Opting for the one-piece swimsuit to cover my stretch marks wasn't such a good idea after all. It looks matronly. A bikini has always been my thing, but I didn't want to draw attention to my mom status. I wanted to blend in with the girls. I'm uncomfortable with the envy I feel.

My cheap tequila hangover lingers, and I wince behind my sunglasses. Patting my flat stomach, an unintended perk of last night's purge, I wish it was getting tanned like the rest of me. I miss my smooth-skinned, pre-baby body. I think my husband misses it too. I try to recall the last time either of us paid the other a compliment. Nothing comes to mind.

❋❋❋❋❋❋

Absence did not make my heart grow fonder. I come home to every problem I left behind. Alone in my marriage, I find solace in extreme exercise, time with single friends, and my role as the perfect daughter-in-law.

At least one night a week, I'm out drinking with Ev, Nili, or Michele. I complain about Cal, and they join in my criticism and affirm my truth. I go to the gym every day, sometimes twice. Cal has no interest in joining. I'm glad of that. It's my sanctuary. I have amassed a vast collection of G-string leotards and shimmering tights. They hide my stretch marks and show off my hard work. I like being noticed.

I continue to work for my father-in-law. I am dependable, efficient, and appreciated. Fairly often a customer will ask if I am his daughter. He replies, "I wish. She is my daughter-in-law." A compliment I love.

My mother-in-law does not drive, so I take her grocery shopping every Friday. A local celebrity at her neighborhood market, she fills two, sometimes three, shopping carts to feed seven boys living at home. She has done so much for me, caring for my kids while I went to school and now while I work. I'm happy to help her.

My girlfriends, my in-laws, strangers in bars, all give me what I crave: attention, validation, and praise. Would it kill Cal to say, "Hey babe, you look great," or "Thanks for all you do for our kids and our family"? Resentment builds. We find more reasons to be apart, me at the gym and him with his new cycling obsession. I decide to see a therapist, alone.

❋❋❋❋❋❋

In the therapist's office, I sift through details of my childhood and marriage. I recount significant events, quite aware that I am showcasing myself in a positive light and making my husband look less than favorable. The therapist knows there is more. She probes to get closer to the truth. Pretty soon, I'll have no stories left to hide behind, nothing left except the work required to save a marriage. If that's what I choose.

Not ready to confess, I cry instead. Disapproval and failure are hard for me. I am loved because I work hard. I am good, helpful, loyal, and caring. And now I'm doing something bad. Hiding the truth is a painful, brutal internal fight. But I am not ready to surrender my secret.

1985

New Wave music blasts and cocktails flow. A milestone birthday, I am twenty-five, or "twenty-five and still alive," as my girlfriends and I keep joking. It's a full house; all my closest friends and family are gathered in the house I grew up in. My siblings have recently returned to California, having finished college in Oregon. Seven years since their move, my parents will follow next month. Cal and I will move to our own place. I am not the least bit excited. I've enjoyed hanging with my sibs. Since their return, they've been living with us—a giant slumber party, with a heavy emphasis on party. Cal has had enough of the Amorosos. I'm not sympathetic. I've spent the last seven years playing perfect daughter-in-law in his family.

The party shows no sign of slowing down. As far as I can tell, no one has left, and friends keep coming. Boys from the neighborhood, all grown-up now, put their arms around me and reminisce about my sweetness as a girl. Like older brothers, they express pride. If they only knew.

I join friends that have spilled onto the patio. A high school friend, Mike, hands me a nearly empty bottle of mezcal, challenging me to finish it and eat the worm. With tequila-induced courage, I take a deep breath, then one giant gulp and swallow it whole. Friends cheer as I hold the empty bottle high above my head, my brother-in-law Joe among them. I have managed to keep my distance all night. He gets my attention and signals to meet on the small side patio, out of view from everyone.

While nothing happened between us in Mexico, we pushed the boundaries of what we called a friendship. Working together at the print shop and going to the same gym, we were always together. It was a matter of time and opportunity. We carelessly took advantage of both.

We sneak off to the patio and kiss. I hear footsteps and bolt into the garage through the side door. Leaving Joe behind, I don't look back. I slip back into the house and join a conversation in progress. Cal comes right up behind me. It was he who nearly caught us. He is pissed, and suspicious, but he won't make a scene. He would never make a scene. I am smug. I deserve this, some fun, some happiness.

❈❈❈❈❈❈

I swallow two aspirin and brush my teeth. Cal comes into the bathroom. I go about my business, hoping he won't bring up last night. But he does. "I saw you. I saw Joe. What were you doing on the patio?"

Rinsing my mouth, I decide on a gaslighting defense. "What? We were just talking. You're paranoid."

He shakes his head and presses, "Really? You two are always together. What the fuck?"

I whine, "Leave me alone. I haven't done anything."

He leaves and slams the door.

I call Nili to complain. "I mean, he won't even allow me a simple friendship."

She calls me on my bullshit, "Christine, c'mon, seriously? What do you expect?"

I want her to be on my side, no questions asked. I end the call abruptly and try to justify my behavior. She's right. I'm lying. I ask God to help me—not to stop me, but to give me permission. To see things my way. I shake my head at the ridiculousness of my prayer. What kind of person asks God to collude with them? I convince myself that all of this will simply fizzle and never be discovered.

1986

Before we go inside, Nili and I discuss a game plan for an early exit in case the party is a bust. Since eighth grade, Nili and I have shared everything, from Dittos to halter-tops, even crushes on the same boys. And we've shared secrets. She's been my alibi more than a few times. Tonight, I didn't need one.

We let ourselves in, and there are only a handful of familiar faces. That was expected. Kurt invited us. He's a new friend. Last summer, Nili introduced him to our circle at Studio Cafe Concerts in the Park on Balboa Peninsula. A quiet artist with a sweet smile and shoes always covered in paint, I liked him immediately. His latest girlfriend, Talia, an artist as well, is hosting the party. It's her place.

We spot Kurt and weave our way between the guests to greet him. Talia at his side offers a shy hello and directs us toward the food artfully displayed on unique ceramic platters she crafted. One dish adorned with whimsical ceramic figures

around its edges is piled high with pesto-covered pasta. She made that too. It's hard not to be annoyed with her quiet grace and her talent. But we behave ourselves, smile, and compliment her work.

Nili and I hang with Kurt until Talia pulls him away. We whisper about the cute guys in the room, though neither of us is in the market. Nili is dating a model who lives in New York City. And I am deep in the throes of an affair with Joe. The guilt eats at me but not enough to make me stop.

The party thins, our interest wanes. We talk about where we might go next. Nili absentmindedly rattles off a few local bars as she digs through her oversized purse. She pulls out a small camera. Looking up, she asks the first person she sees to take our picture.

He fumbles with the camera, pretending to not know how to use it. Nili begins to explain, and he chuckles at her gullibility and jokes about the camera's lack of complexity. Is he a photographer? Another artist? Fast-talking, charming, and funny, he makes me laugh. With one eye squinted and the other pressed against the viewfinder, his entire face smiles. Where had he been all night? Then I spot her, his date. She stands nearby, pixie pretty and petite, arms crossed, scowling. How could she not be smiling? He's darling, hilarious. I guess if your date is flirting with two women, the party is over.

I carry dishes and empty Solo cups into the kitchen. The funny photographer finds me there alone. He is barely taller than me, with dark brown hair and eyes and, like me, a nose too big for his face. It suits him. He strikes up a conversation and flirts with ease. For a few minutes, I forget my messy life and enjoy the lightness of our attraction. I never mention a husband, a lover, or that my life is a complete disaster. Instead, I sigh, "You have a girlfriend."

He gives me a long look, smiles, and says somewhat dis-appointedly, "Yeah."

I return the smile, say goodnight, and look for Nili.

My mind wanders on the drive home. Deceit has taken its toll. I don't sleep well. The hollow pit in my gut grows, making me more empty, devoid of love, hope, and happiness. I think about the flirty guy. I don't even know his name. I wonder if he is a friend of Kurt or Talia.

✺✺✺✺✺✺

The movie is painful and real. A man cheats on his pregnant wife. He is a complete asshole, a liar. I am him. The credits roll in the dark movie theater; I nervously shake my leg. Randi sits beside me. Since her move to San Jose, we don't talk as often as we'd like. I haven't told her about my affair. I can't. I'm crying. There is reason to cry, this movie is so fucking depressing, but I'm overdoing it. She quietly whispers, "What's wrong?"

Between sniffles I manage, "I'm a horrible person."

She doesn't say another word. I'm relieved. I cannot tell her. She could not possibly understand the pain that led to my affair. She is happy in her marriage. High school sweethearts, she and Bill are best friends, great parents to their two boys, and very much in love. Wedded bliss would be an understatement. I am both jealous and in admiration of their partnership, their unbreakable bond.

On the drive back to her house, we are quiet. I wonder if I would be in my current mess if she and Bill still lived in Southern California. They were supportive friends, Godparents to our son, and a huge part of our social life, our family. We were a happy foursome in constant company. Since their move their marriage grew stronger, and ours grew weaker.

I can't tell Randi. I cannot face her disappointment. In reality, it is my shame I cannot face.

CHAPTER 5

1988

Little black dresses and a single fuchsia one lie across the bed. Stilettos, still in their boxes, are stacked high on a chair. Every available surface in the hotel room is littered with makeup, lotions, nail polish, and hairspray. Five of us—Ev, Nili, Michele, my sister Susy, and I—share a hotel room. We talk over one another, laughing as we reminisce and get ready for our ten-year high school reunion. I scoot out of the crowded bathroom to finish my makeup elsewhere. Leaning into the mirror above the desk, I avoid a hot curling iron and apply black eyeliner and gobs of mascara. I take a long look at myself; not bad.

I swore I would not come to this reunion. Edison High School was a place I shined, and I did not want to return a loser. In the end, it was Ev who changed my mind. She said if she could face her high school demons, I could undoubtedly handle probing questions about the collapse of my marriage. She was right. I had already been fielding questions for over a year. I had seen shock and sadness on the faces of old friends as they learned that everyone's favorite couple had ended

their twelve-year relationship. Even when people knew the gossip, they pretended otherwise. Hoping for salacious new details, they would fake a cheery hello and ask, "How is Cal? How are you guys?"

I wanted to snap back, "Oh, didn't you hear? I fucked his brother."

Instead, I was politely vague, "Okay, I guess. We split up last year, grew apart, you know."

I'll use the same script this evening if anybody asks. I squeeze into my tight-in-all-the-right-places black dress—its fit improved thanks to a newly acquired padded, push-up bra. I check myself in the full-length mirror. I am exactly as I am remembered: the girl with the hot body. It's terribly shallow, but tonight it's all I have. I push away shame and promise to end this ugly chapter of my life, to finally cut ties with Joe. Tomorrow. I'll do it tomorrow.

We spill out of the elevator and into the packed reception hall. Our graduating class was huge, and tonight's turn out is impressive. I'm feeling better about my decision to come. I was lucky; high school was fun for me. Well-liked with great friends, I was a part of the popular crowd. I graduated with my heart and spirit intact and a full year early with an excellent academic record. I was good. I followed the rules. I had a plan, and I knew my way. Shit, I've strayed so far. Before I have time for more self-analysis, there he is, standing right in front of me, smiling. Drew.

We met our sophomore year in history class. My foot on the back of his chair with my leg restlessly shaking, I unknowingly shook the hell out of his desk. I watched him search the floor around him, thinking maybe he had lost something. When he locked eyes on my foot, I realized he was looking for the source of the tremors. Glancing at me over his

shoulder, a little embarrassed, he said, "Oh, I thought we were having an earthquake."

I laughed, "Sorry. It's a bad habit."

That was the beginning. We sat together in common classes, walked together when our paths crossed on campus, and never ran out of things to talk about. Drew knew I had a boyfriend, and while I suspected he had a crush on me, he never took advantage of our friendship. He was a straight arrow, a solid guy.

After high school, I ran into him at El Paso Cantina. I had ditched my husband for late-night dancing with Ev. We were sipping discounted Ladies' Night drinks when we spotted Drew in the smoky crowd and dragged him onto the dance floor as "Tainted Love" played. Later he and I found a quiet corner and caught up. He was boyishly handsome, with the same great smile. Single and dating, he said. He knew I had married Cal and had kids. Everyone did. We exchanged numbers. In our last call, he told me he had fallen in love, said she reminded him of me. After that, we lost touch—until now.

We hug. He is fit and strong and smells freshly showered. We hold on just shy of a bit too long. We compliment one another on not having changed a bit. He tells me of his recent divorce, and I tell him about mine. With so many people to see, we promise to find each other later.

I find the girls, and we compare notes to ensure that we do not miss out on seeing old friends or cute guys—easy to do in a class so large. There are the usual awards for those who have come the farthest, been married the longest, or have the oldest kid. I might have won that one had I completed the survey.

I am happy to go unrecognized in that department. Being the single mom of a nine and ten-year-old at the ripe old age of twenty-eight is hard. The kids struggle in school,

particularly Kenny P. He is inattentive and underachieving. I blame myself. If our family was intact, school would be easier, and he would not be so distracted. I turn off the broken record of remorse that plays in my head. Right now, I want to be lost in the good old days, the good girl with the bright future.

Late in the night, the ballroom empties, and smaller parties move into hotel rooms. Susy goes home to her husband, Ev meets up with a new boyfriend, and Michele leaves with Kurt—he and Talia are ancient history. Nili and I stay. She finds a party, and I find Drew. It's not hard. We've been within ten feet of each other all evening. We take a walk, just the two of us. He fills in the details of his divorce, and I carefully limit the information I share. I don't lie, but I don't share the whole truth, certainly nothing about Joe.

Two a.m., it is time to say goodnight. And for the first time, we kiss. A good kiss. A kiss that says let's do this again.

I quietly enter the hotel room. Nili is in bed. She springs up, and before I can say a word, she exclaims, "Okay, spill!"

I laugh and tell her about Drew. She wants juicy details, but all I can offer is the kiss. She says he is a good stepping-stone for me, a way to step away from my current toxic mess. My heart sinks. She has already deemed Drew temporary. I want her spinning with me in the crazy whirlwind of possibilities. I shrug off her comment and go to sleep, dreaming of something new and long-lasting.

❋❋❋❋❋❋

I fall back onto my bed and stare at the ceiling. My wanting to finally call it quits should not be a surprise to Joe. Random late-night visits are fewer and farther between. We have totally separate lives. I am busy with my kids, proving to

myself and the world that they come first. I overcompensate. The consummate PTA volunteer and team mom, I try to chip away at the damage I have done to their psyches. Keeping Joe a secret has become another exhausting task.

The phone rings a few times. He picks up, and after the usual small talk, he asks about the reunion. I tell him I had fun. And before I lose my nerve, I blurt out, "I want a normal life."

And then a string of rambling phrases: "I'm tired of hiding and having secrets. We will never be a regular couple. People whisper and talk about us. We will never be together. When I saw all my old friends, I didn't even mention you. I can't."

I stop short of saying that I am embarrassed and never intended for things to go this far. I don't tell him about Drew. I take a breath. In the brief silence, he sighs. He makes no attempt to change my mind. I imagine he is sick of this whole charade too. Maybe he was waiting for me to end it. I don't ask.

I hang up the phone, struck by how quickly and easily it all ended. The fire that once raged between us, damaging everyone and everything in its path, extinguished. Hardly a fizzle from a bond once fueled by passion. I ended my marriage for this.

When Cal and I were together, friends and family joked that I was married and he was single. Most of his friends were. When they gathered in our garage, I sometimes eavesdropped on their locker room talk, details about their dating escapades, and uncensored descriptions of the latest hottie. Cal contributed his own tales. I wished he would say he was lucky to have the kids and me, to have found "the one." He never did, not once. I was used to people thinking I was great and could not understand why Cal didn't think so too. Ashamed of my insecurity, I never told him how desperately I wanted and needed to feel his love.

Instead, I stuffed away my feelings, stewed in resentment, and eventually reacted with an explosion of want and need that led to Joe—a huge mistake. I had mucked around in the dirtiness of my affair for far too long. My self-imposed penance was over.

✳✳✳✳✳✳

On his living room floor, both of us lying naked from the waist down, we catch our breath. We didn't even make it to the bedroom. Drew and I have been on a few dates. Still, I feel sure neither one of us planned for things to move this quickly. With zero dating experience, I wonder if there is a respectable waiting period for sex these days. Did we break the rules?

Careful not to rest his full weight on me, he asks if I need anything. I say I have to pee and wriggle out from under him. Quickly scooping up my underwear and jeans, I excuse myself to the bathroom, and he tells me where I can find a washcloth. Flicking on the light, I check for smudgy mascara, splash water on my face, and comb my fingers through my hair. I have to get home.

Pillows already back on the sofa, no evidence of our romp on the floor, I find Drew in the kitchen cleaning up a bit. "It's late, and I've got to go."

He walks me to the door, hugs me, and says, "In high school, I would have given anything for this."

I smile and say, "And, here I am."

✳✳✳✳✳✳

Driving to Drew's house, I recount his phone call: He invited me for a home-cooked meal. He wants to talk. I have not seen

him since rolling around on his living room floor a couple of weeks ago, but we've both been super busy—me with kids and him with work. I'm not sure what he wants to talk about, but I'm not worried. I look forward to seeing him.

When I arrive, he quickly lets me in and rushes back to something in the oven. The house smells great. He is sweet and polite as he serves up grilled chicken and vegetables. We eat, share some wine, and I talk too much. It's hard for me to sit in quiet company.

After dinner, we move to the sofa. He nervously clears his throat, "Things are happening fast between us. It reminds me of when I met my wife. We had sex quickly, and the relationship was physical. We didn't take the time we should have to get to know one another. I don't want to make that mistake again. I had such a crush on you in high school, but now it's different. You're divorced. You have two kids. I want kids. Your ex-husband was at a bachelor party for a friend of mine. It was weird. I've thought about this a lot, and I talked to my pastor. There are so many things I like about you. You are smart and funny, and it's obvious that you take care of yourself."

He stops short of saying the words, but the message is clear. He does not want to be my boyfriend.

I ignore his little speech, climb over him, and straddle his lap. I settle against him, as if to say, you don't mean any of that. I lean in to kiss him. He looks away, arms limp at his sides, and says, "You're going to make this hard for me, aren't you?"

In a moment of clarity and, thank God, integrity, I get off of him, sit with my hands firmly on the sofa's edge, and say, "No. No, I'm not."

I am embarrassed, but I'm not mad. At least not at him. While there has been a physical attraction, we don't have

much in common. I'm annoyed with myself. I'm being passed over by someone I don't even really want to date. A waste of my time and his. I thank him for dinner and gather my things. He gives me a gentle hug and offers the consolation prize of friendship. I accept and leave with my dignity.

CHAPTER 6

Winter 1989

Spanish-style bungalows sit back on manicured lawns, the quiet streets lined with ancient trees. We are near Hancock Park, I think. Her home is elegant. Every painting, every piece of furniture carefully chosen and perfectly placed. Pastel sweet peas spill gracefully over the edge of a crystal vase. Their reflection caught in the glossy black lacquer of the baby grand piano. A long dining table is exquisitely set for ten.

Our hostess is a retired first-grade teacher. A glamorous platinum blonde, bejeweled, and impeccably dressed, she is called Mother Goose by those who know her well. She is an aunt of sorts to Kurt, his mother's long-time friend. A group of friends from Orange County has gathered here to celebrate an art opening for a friend, Greg, an LA artist. I don't know him; Michele and Kurt invited me to tag along.

Mother Goose calls us to the table. I am careful to choose a seat that will not split up any couples. I sit next to Brian and Aubrey. They work together at a gallery in Newport Beach. Brian and I work out at the same gym. We'll have plenty to talk about. Platters piled high with sliced roast beef and side

dishes of mashed potatoes, green beans, and sliced tomatoes are passed around the table. Wine glasses are clinked in unison. We talk and laugh. I am comfortable as a single woman, the first time in my adult life without a man by my side. After we stuff ourselves, we shuffle into the living room. Mother Goose plays piano. Michele and I stretch out on a large ottoman, relieving our full stomachs. Couples slow dance, and we giggle for no reason. We have had too much to drink.

Across the room, Kurt greets someone. With all the party noise, I had not noticed the new arrival. I peer between the dancing couples, and I am pleasantly surprised to see the funny photographer who flirted with me at Talia's party a few years ago. He is no longer unknown to me. His name is Andy.

Kurt and Michele introduced me to him after they started dating. He and Kurt are close friends. They share a love of art and good coffee. They met at Orange Coast College, in a ceramics class, I think. Andy rented a room from Kurt's mom back when he waited tables at an upscale restaurant in Corona del Mar, Trees. I've seen him a handful of times since our first meeting. Once at El Paso Cantina, I was out with Michele and Kurt, and he showed up as the bar was closing. He and Kurt talked in the parking lot. Rather than join us for a 2:00 a.m. breakfast at Harbor House, Andy opted to go home. Deep in the throes of my marital mess, the timing was all wrong.

The next time I saw him was the annual Fourth of July parade. He appeared with a bag of bagels in one hand while he ate one with the other. He offered me a bite, then bumped his hip in time against mine as the marching band played through. With a smile and quick wave, he was gone, until now.

He gives Kurt a warm and lasting hug. Generous with affection, he embraces one friend after another. Michele walks toward him and greets him with a kiss. He looks my

way, and I wave. He smiles. I'm happy that he is sans crabby pixie or any other pixie for that matter. Three years since I first met him; please God, let him be single.

Andy continues to make the rounds, eventually joining Michele and me sprawled out on the giant ottoman. Not quite enough room for a third body, he squeezes in anyway, drink in hand. He tells Michele what he has been up to since moving back to San Jose—business school and work mostly. They reminisce about his Orange County days. I don't listen to his words exactly. I'm more tuned in to the sound of his voice: warm, sincere, and a bit raspy. I'm aware of his leg pressed against mine, his free hand casually grazing my arm. I wonder if it's intentional, or if he is like me, the touchy-feely type.

Close to midnight, we say goodnight to Mother Goose. Her tipsy hugs and kisses take forever, but no one complains.

Rather than make the long drive back to Orange County, Kurt, Michele, and I had planned to stay at Greg's loft in LA. Andy, Aubrey, and Brian are staying too. Kurt drives, and for once, Michele and I are quiet. Neon signs flicker and illuminate the windshield. A memory flashes: I'm five or six years old, lying in the back of our old, white Studebaker with my siblings. We are in pajamas, covered with blankets. Dad is driving Mom to her graveyard shift at the post office. We have one car, and Mom does not drive. The littlest ones are sleeping, but not me. I am looking at the lights of a giant neon Felix the Cat, high above the Chevy dealership. He smiles and points at the lot below. It's been twenty years since my family left LA.

Michele snaps me back into the present. "So cool Andy showed up tonight. He's so great. Isn't he great?"

Not wanting to reveal my feelings, I offer a lame, "Yeah, he's nice."

Greg is already home and greets us at the door. We enter the large, sparsely furnished room. His paintings are carefully curated in what appears to be a gigantic industrial warehouse space in a not-so-great neighborhood somewhere, maybe Vernon. We talk about his art, his show, the reactions he overheard from guests. I know nothing of the LA art scene, but I'm interested. An accountant, I'm the only non-artist in the group besides Michele, but she's attached to Kurt, and that counts for something.

The conversation slows, shoes are kicked off, and I can see everyone eyeballing where they might sleep. Kurt and Michele call dibs on the futon. The rest of us will be on the floor with sleeping bags and various pillows and blankets. Digging through my duffle bag, I realize I forgot pajamas. I shout out a plea, "Anyone have anything I can sleep in?"

Andy calls to me and hurls a balled-up pair of white boxer shorts my way. I slip them on with a T-shirt, and voila, pajamas.

After brushing my teeth, I walk back into the living space. Michele and Kurt are already curled up on the futon, and I am having severe futon envy. Brian and Aubrey have made a cozy nest on the rug. Andy and I stand over what is left of the bedding: one big blanket to share and a couple pillows. He looks at me, gives a double eyebrow raise, and grins. Without speaking, we make a bed. I'm nervous as hell but pretend otherwise. I mean, what's going to happen, there are six of us in this room. Greg does one last check ensuring everyone is comfortable before retiring to his bed. Then, lights out.

I'm sure Andy can hear the pounding of my heart. I catch my breath, louder than intended, and he whispers, "Are you alright?"

I say yes even though I'm anxious. I'm not afraid of him. I'm afraid of the end, and it hasn't even begun. I breathe him in, and though our bodies are not touching, I can feel the warmth of his so close to mine. He puts his arms around me, pulls me close, and I relax. On my side, I slip my hand under his T-shirt and slowly up the length of his back. I make my way back down and then under the waistband of his boxers. His skin is soft and smooth. Face to face, toe to toe, he might have an inch and maybe twenty pounds on me. We fit.

We are quiet, careful, and slow in our exploration. We breathe each other's breath, our legs entangled, our hands free to touch, we kiss. He tries for more, but I don't let him. For a long time, we kiss, and then we sleep.

�֍֍֍֍֍֍

The loft fills with morning sun and the noises of people rising from deep sleep. There are grumblings of needing coffee. My back and hips ache after a night on the hardwood floor with little padding. I open my eyes to find Andy's still closed. I notice his lashes grow inward toward the bridge of his nose. Somehow that amuses me. His eyes open slowly, and I'm startled, embarrassed to be caught gazing at him. He is unfazed, yawns a "good morning," and stretches himself awake. From the comfort of the futon, Michele catches my eye and gives a wide-eyed glance toward Andy as if to ask, "So . . .?" I try not to laugh. I shake my head and return an "I'll tell you later" look.

We agree on Gorky's downtown for breakfast. Hustling out the door, Andy holds it open for me and then catches my hand as I walk by. A gesture so familiar, I'm sure he's held my hand in another life. I spend breakfast paying attention to

details. Andy is considerate and polite. He rests his hand on mine as he carries on a conversation that does not include me. As if to say, "I haven't forgotten you are here."

We feel easy and uncomplicated, funny since we hardly know one another. I want to stay right here, in this crappy booth, forever. But I can't. After breakfast, I'll head back to Orange County with Kurt and Michele, pick up my kids from their dad's house, and Andy will go home to San Jose. I'm okay with all of this, and that surprises me.

I walk him to his car. He asks for my phone number. We make no plans or promises. We kiss good-bye and then he hugs me long and hard with a tight squeeze at the end. I walk away, still holding his hand until the distance between us is greater than our outstretched arms, then one last wave. I think of him and his eyelashes the whole drive home.

�✿✿✿✿✿

Michele and I sit on the couch talking while the kids go nuts around us—my two doing everything in their bag of tricks to make her daughter Amanda giggle uncontrollably. Barely able to hear one another, we shush them. The phone rings: I finish my sentence and yell above the noise, telling the kids to quiet down. I say hello, the ruckus in the background audible to the caller, I'm sure.

I know his voice, and I shout to Michele, "It's Andy!"

I make no attempt to hide my happiness. I want to take it back, or at least take it down a notch. *Be cool, Christine.* Then he laughs, says he is happy to hear my voice, and I can tell he appreciates my enthusiasm. A bit awkward at first, we try to find our conversational rhythm—not easy with all the racket. I excuse myself to deal with my kids and hand

the phone to Michele. I check the time. It's a school night, and I've got to get dinner started. She passes the phone back to me. Andy mentions a trip down south soon and says he'd like to see me.

I don't think twice, "I'd love that."

* * * * * *

Lying awake in the quiet darkness of my bedroom, I think about his phone call and feel a lightness I cannot name. I'm struck by the fact that someone who has spent so little time with me feels an attraction. Enough so that he's willing to drive nearly four hundred miles to see me again. This first step toward the possibility of more makes me smile. And I remember, special is what I feel. It's been so long; I had forgotten its magic.

* * * * * *

Dull workdays are highlighted by calls and faxes from Andy. A young woman he works with draws two stick figures walking on clouds and labels them with our names. He faxes it to me, and my assistant slips it into my inbox, face down. He's told his coworkers about me, that means something. He works full-time for a San Jose publication and is in the home stretch to finish his business degree. Finding time to make the drive to Orange County wasn't easy.

With his first visit days away, we count the "sleeps" until his arrival. Sleeps—a word my sister Mary used as a little girl to measure the days until birthdays, holidays, or the final destination of long family road trips. She was always asking, "How many more sleeps?"

The phrase is a part of our family colloquialisms, and now Andy uses it too. Another fax, the number three fills the page. Three sleeps until I see him.

He calls to give me his ETA: close to midnight. The kids are with their dad. I have no intention of introducing them to Andy until the time is right. Only recently have Cal and I determined a regular visitation schedule. The open-door policy was okay in the beginning, but my privacy was suffering. We needed boundaries, and our kids needed consistency. He has a girlfriend and seems happy. We're finding our way to friendship after divorce.

I take a long, hot shower. Shaving my legs, I examine every square inch, ensuring I do not miss a single hair. I towel dry and look at my naked body in the full-length wardrobe mirror. I frown at the sight of my stretch marks, still prominent, ugly. I never realized how many people had never seen stretch marks until mine got so much attention. It's always a little unnerving when someone points, grimacing, "What's that?"

I am fit with a springtime tan. Maybe Andy won't notice them. I dream of a miracle cream or surgery that would make them disappear forever. Until then, I convince myself that they aren't so bad in the right light.

Nervous and excited, I wait. To pass the time, I mindlessly flip through a magazine and replay every conversation we've ever had. He likes me. My newfound bliss is real.

Earlier than expected, he knocks. Duffle bag flung over his shoulder, he grins. "Can you believe I am actually here?"

I give a nervous laugh, and he steps inside my home. Dropping his bag to the floor, he hugs me long and hard.

We break apart, and I fill the air space with anxious chatter, explaining where things are located in my small duplex. Already filling a glass with water, he says, "It was a long drive. It's late. Let's get into bed if that's okay."

He is making no assumption; he is sincerely asking if it's okay, if I'm okay. He doesn't appear to be the least bit nervous. Comfortable in my home, helping himself to what he needs, as though he's made this drive a hundred times to find me waiting here. I pick up his bag and show him the way.

Sharing the sink, we brush our teeth. Spitting and rinsing, we remove any pretense of formality. I give him a few minutes alone to finish up, and I climb into bed. The sheets are chilly, and I sweep my arms and legs in snow angel fashion, doing my best to warm up. In his boxers and T-shirt, he turns off the light and finds his way to me in the moonlight. I warn him about my freezing hands and feet. He blankets me with his body, and things heat up. We help each other with the slow removal of the little bit we are wearing and explore the landscape of our naked bodies. My mind does not wander. I am keenly aware of every sound, taste, and touch. I am memorizing him.

❊❊❊❊❊❊

We arrive late to meet friends already seated at the large table—the same group from Gorky's. I'm sure they thought we'd be a no-show. Apologizing, we make a quick round of hellos. We overslept. Not wanting to miss our breakfast date, we threw on wrinkled clothes and rushed out the door looking as though we rolled right out of bed because we had. Andy signals the waitress, asks what I want, and orders for me too. I'm pretty sure that has never happened to me.

Settled in now, he tells his friends what he's been doing up north. He looks my way and chuckles. He's laughing at me, and I don't know why. I give him a quizzical look, but he only grins. He does this a few more times. I playfully roll my eyes and ignore him.

Walking to the car, we are alone again, and I ask, "What was so funny?"

He tells me I have a love bite on my neck and touches it. In my rush to get ready, I hadn't noticed. If I had, I wouldn't have piled all my hair on top of my head in a messy bun. He reacts to my wide-eyed embarrassment with laughter.

I angle the rearview mirror toward my neck to get a closer look. Thankfully, it is more of a rosy smudge, but it cannot be missed. He kisses the spot, gently puts his hands on my cheeks, and turns my face toward him. "No one noticed, only me. You are beautiful."

I believe him.

�֎ �֎ ✖ ✖ ✖ ✖

The hot water stings our ice-cold feet. We yelp on tippy toes until the prickling passes. Steam escapes the low, tiled shower wall, and in no time, the small bathroom is a sauna. Our teeth stop chattering, our bodies warm, and we quit wrangling for space under the showerhead. Sandy, wet jeans lie where we peeled them off at the door. Catching the sunset was worth the chilly walk home and the mess. I wash his hair, massaging his scalp. He lathers my back with soap, a luxury for someone living alone. I stand to rinse, facing him as he sits on the tile bench. He reaches up, fingers splayed, and presses his hand against my belly, across my stretch marks. He studies them. I don't move. "From your babies?"

I reply softly, "Yes."

He has seen me naked before and never commented on them. I do my best to hide them when I can. Feeling secure with Andy, I let my guard down. His hand still on my stomach, he asks, "Do you want any more babies?"

Without hesitation, I say no. I don't have the courage to say I don't deserve any more, and I can't tell him why. I hope he can be happy with being a bonus dad to my kids, but we don't talk about it. He puts his hands on my butt and playfully pulls me close. He helps me onto his lap, face to face, and I wrap my legs around him; we find our rhythm easily and lose ourselves in love.

�֍֍֍֍֍֍

Browsing Rizzoli, my favorite bookstore, I find the large coffee table books filled with beautiful images. Turning each page carefully, I admire the photography, the capture of light and emotion, moments in time. Pictures of Hollywood glamour, high fashion, and sweeping landscapes draw me in. I get lost in the pages, appreciating the artistry found in human beings and nature. Glancing up, I don't see Andy anywhere. We started our shopping holding hands. Pulled by different interests, we went our separate ways. He'll find me eventually; he always does.

After carefully returning the heavy book to its display stand, I check the recent bestsellers. A collection of short essays catches my eye. I open to a random story and read. Before long, I am quietly laughing and struggling to keep myself from breaking into a full snort. Too funny not to share, I close the book on my finger to hold my place and look for Andy.

I survey the faces buried in books. When I spot him, I am startled by his nearness, so close that I was looking right past him. Leaning against a bookcase, arms crossed at his chest, he smiles. His expression of love captured the instant I discovered him happily watching me. I walk straight to him and kiss his lips. I want to kiss them for the rest of my life.

CHAPTER 7

Spring 1989

I sing my favorite childhood songs as we drive from San Jose to Carmel, taking repeat requests for "Pennies from Heaven," Andy's favorite. At ease in his company, I am my true self. He loves me exactly as I am.

He gives my hand two quick squeezes, and I squeeze back. Quiet now, I relax. A few hours ago, I was nervous as hell anticipating my first trip north to see him, and to meet his mom. Calm washed over me as soon as I saw his smiling face outside the gate. We hugged, and he asked if I wanted to meet his family now or after our road trip. I voted for after, and he agreed.

Traffic is light, and the weather is perfect. We've made good time. Before we reach our destination, Andy asks, "Have you ever taken the Seventeen Mile Drive?"

"As a kid with my family, but let's do it."

The rugged coastal landscape never disappoints: the vibrant blues and greens of the ocean, the white sea foam splashing against the rocks. Andy pulls over, and I climb out of the car for fresh air. I remember the leftover snack

crackers and toss them to the seagulls. They fly all around me, squawking for their fair share. Andy takes in the spectacle I've created and smiles. Life feels perfect. After having screwed up so badly, to be gifted with this sweet human is nothing short of a miracle.

✽✽✽✽✽✽

We lie across the white chenille coverlet on his bed. He grew up in this house. I rest my head on his shoulder and whisper, "Your mom doesn't like me."

He laughs, "That's just how she is. Don't worry about it."

I change the subject and recount our fun-filled days, the good food, the great walks and talks.

Andy casually adds, "Sex in the kitchen."

I shush him, afraid his mom will hear. He persists with dirty details, and I try to cover his mouth. A wrestling match ensues, and we can't stop laughing. We call a truce to catch our breath. I become pensive. My flight is in hours. I want our time together to last forever.

✽✽✽✽✽✽

A piano plays in the adjacent bar where we'll meet Kurt and Michele after dinner. I have never been to Trees. I tell Andy my parents love dining here. We wonder aloud about the possibility of him ever having waited on them when he worked here. He recounts a story about receiving a very large tip and the lesson he learned when he tried to return it; the importance of graciously accepting generous appreciation for good service and humbly acknowledging the value of our work. The message of self-worth and its significance is not

lost on me—a personal struggle I know all too well.

His words fade as the music from the bar catches my ear, "Can't Take My Eyes off You" plays.

"Listen," I say and then sing along.

The song has made a recent comeback, and we've claimed it as our own. I place my hands in his. I love him, his strength of character, his natural inclination to see the good in people. He found it in me at a time when I could not find it in myself. He reaches into his jacket's inside pocket and produces a slim velvet case. My eyes grow wide as he places the box on the table and pushes it toward me. I understand now why he needed time alone this afternoon—time I disliked giving up because we never have enough of it. I open the case revealing a strand of lustrous pearls, my birthstone. Already out of his chair, he helps me with the clasp. I touch my hand to the pearls, cool against my skin. He kisses my cheek. I turn and kiss his lips. Is this normal? Or am I the incredibly lucky recipient of a love that only few experience? I decide not to question my fate, no guessing what is next or predicting the future.

<p style="text-align:center">✽✽✽✽✽✽</p>

My low back aches. I have been bent over the scattered plants and potting soil for far too long. Slowly and gingerly, I straighten my temperamental spine. One false move and I could be laid up for days. I stretch toward the sun, a beautiful spring day. Surveying my project, I estimate another fifteen minutes and the patio will be bright with fresh flowers—lobelia and marigolds—and newly potted succulents. The kids used to love to do this with me. Now they prefer the company of friends.

Despite having a proper shovel, I use my hands to dig and plant. The dirt packed tightly under my fingernails will take some effort to remove. I push the remaining flowers into the soil and sweep the patio before spraying it down and watering the new flowers. I admire my handiwork, a fresh new look. I make a last attempt to blast the dirt from beneath my nails and then wrap up the hose. Wiping my wet hands on my shorts, I grab the mail. Shuffling through the stack, I separate bills from the junk. I recognize Andy's writing on an envelope and smile, a pleasant surprise. I write to him more often than he writes to me; I suppose sending sappy notes and letters is more of a girl thing. Inside I sit on the couch and open the envelope—a letter instead of his usual card. My heart beats faster in happy anticipation. I smooth the page flat against my legs and read, "Dear Christine, I'm writing to let you know that I am dating someone up here . . ."

The words that follow are blurred by my tears. Wiping my eyes, I read the lines again, sure I have misread them. I search desperately for expressions of regret, the admission of a terrible mistake. I look for the apology, words that indicate a desire to come clean, and the promise of a fresh start. But he has not written what I wish to see. His message is clear. The first sentence in the present tense, and the remaining words reveal the truth. A choice has been made, and I was not chosen.

Perhaps since the letter was mailed, he has changed his mind, and it is me he wants. I hold on to that possibility and call him. The phone rings several times, and when he answers, I cannot speak, I cry. He takes a deep breath, "You got my letter."

I do not ask any details about her. To hear them from his mouth would be too painful. I've already created a young,

sexy, beautiful college girl with no children, no ex-husband, no baggage. Someone he can see whenever he pleases; they laugh and kiss and make love. She is better than me in every way. Of course he would choose her.

I try to digest all that is happening, a punch square in the gut that I hadn't anticipated. And then it occurs to me, I am getting exactly what I deserve: my heart busted into a million tiny pieces, an unbearable hollow ache. Karma isn't finished with me yet.

❋❋❋❋❋❋

The house is clean and quiet. My kids are with their dad for the Memorial Day weekend. Clothes neatly folded on my bed, I mentally put together outfits, counting underwear and socks to ensure I have packed all I need for a San Francisco road trip with Michele and Kurt. I grab the necessary toiletries from the bathroom and finish packing. They'll be here soon. We want to beat the traffic, and I don't want to keep them waiting.

I sigh. This is not the trip I had planned. I make one last pass through the house. Everything is in its place. Looking out the living room window, I see Michele's white VW Fox. My mood is lifted. This is exactly the distraction I need—endless inside jokes with a girlfriend who makes me laugh. Poor Kurt has some idea of our ridiculous middle school girl behavior, but I am not sure he is prepared for six hours of our nonsense.

Michele and I talk over one another and try to explain to Kurt jokes that are only funny to us. He smiles not because he understands but because he wants us to stop explaining. Hours pass, eventually we run out of stories. Michele and Kurt talk, and I stare out the window. Heartache creeps up on me. It's weird to drive right through San Jose with no plan

to see Andy. Weirder still that Kurt will leave Michele and me in the city and join Andy for his graduation celebration. We'll stay in North Beach with her brother Donnie, see his play, and hang with his friends for the remainder of our trip.

The plan is understood; no need to talk about it or mention Andy's name. I'm glad of that. In the days that followed the now infamous letter, I talked to Kurt and Michele, separately and together. Had Andy said anything to them to indicate that I was just a fling, temporary? Both were as surprised as I was by his sudden change of heart. I lean back to rest my head, turning toward the window. I allow myself to dwell in our beginning, I wish for a different ending, and mouth the words, "I still love you, Andy."

❀❀❀❀❀❀

My kids will be home soon. As I unpack and sort laundry, my mind wanders to weekend antics. Michele and I managed to lock ourselves inside Donnie's apartment. Who knows how long we would have been stuck there if he hadn't happened to make an unexpected pit stop home? After his play, we went to the after party, met the actors, and were entertained by their quirkiness. Once they started shaving each other's heads, we decided it was time to go. We accidentally wandered into a sketchy neighborhood and ended up being chased off by some badass women. Some sort of turf violation, we supposed. I chuckle as I picture the two of us running in boots through the hilly streets and alleys, ditching our pursuers. Back in North Beach by 4 a.m., the smell of freshly baked bread filled the air. By 5 a.m., we found coffee. Who needs sleep? I'm glad I went. I had fun, and I could begin to picture life without Andy.

The phone rings, and I run to answer it before the machine picks up. It's Andy. Without even a hello, he demands, "How could you be in town and not see me? How could you drive right through without saying hello, without coming to my graduation?"

Is he kidding? "Was she there?"

Realizing the ridiculousness of his questions, he offers a guilty, "Yes."

For the first time, I unload. "Did you actually think I would show up to see you and your girlfriend, to be humiliated? You didn't even invite me. I should just show up? What are you thinking? I have been so hurt by you. I *loved* you."

There is a long silence between us. He tells me he doesn't love her. I don't know what to say. And then the perfect excuse, "My kids are home, I've gotta go."

I am covered in hugs and kisses, a welcome distraction. Why do I still love him?

CHAPTER 8

Summer 1989

Fingers crossed, I give my mom a last-minute call and ask if she can pick up the kids from childcare so I can go straight to the gym. She answers with her usual, "No sweat-D-dah. I'll make them dinner too."

She's a lifesaver, and sometimes I take advantage. Rushing around my office, I hastily organize loose papers and scribble a to-do list for tomorrow. Before turning off the lights, I check the time. Shit! My aerobics class starts in fifteen minutes. I'll have to change in the car between stops and starts—a dangerous habit I swear off daily. I shout good-bye to anyone still working and run out the door.

In minutes I transform from working girl to aerobics queen, amazed that I managed another quick change without incident or accident. I pull into the post office parking lot adjacent to the gym, ignore the no parking signs, and take a space. I lace up my Reeboks, run up two flights of stairs, and dash past the front desk. The ponytailed receptionist acknowledges me with a nod. I burst into a full class and find my place, front and center.

As our instructor adjusts her mic and selects the music, I take long, deep breaths and stretch a bit. My reflection in the gigantic, mirrored wall reveals I am a few pounds lighter, which always happens after a breakup. The music begins, and before long I am lost in the bass, jumping, twisting, and sweating right through my leotard. I focus on my form: arms straight, knees bent and lifted high toward the ceiling. Beyond my reflection, I glance up to the second floor behind me. Bulked-up guys in their tank tops designed for maximum muscle exposure lean over the ledge and participate in a popular extracurricular gym activity. They stare down into the aerobics room to watch. I follow the direction of their gawking to see who or what has caught their attention, usually a woman with fake boobs, braless and bouncing. Someone is waving, and he's waving at me.

His name is Alec. We work in the same business park and see each other occasionally at a sandwich shop in the complex owned by an Iranian couple, Sarah and Abraham. They carry the usual deli fare and a selection of homemade items, hummus, tabbouleh, and rose water treats. I eat there often with my colleague Adrian. We always finish lunch with a delicious sweet bread. Baked in a round pan, cut into pieces like a pie, and wrapped in cellophane, Adrian refers to them as "wedges." We love them so much we will share when there is only one left on the counter. Over the three years that Adrian and I have worked together, we have become close friends. Those who don't know us think we are a couple. A comment that always makes Adrian cringe. I laugh and say, "Do you think I want anyone to think I'm with *you*!"

It was Adrian who first noticed Alec's friendliness toward me, commenting in disbelief or maybe disgust, "Oh my God, I think that guy might like you."

I smacked his arm hard and laughed, "Guess what, Adrian, some men actually find me attractive."

I had not noticed Alec. It was later, when I spotted him at the gym, that I made the connection to the deli. Even in business attire, it was easy to tell he was incredibly fit—his tailored clothes accentuated his muscles. And after seeing him in his gym clothes, there was no question. Dark and handsome, several years older than me, he is a grown-up. We exchange casual hellos when we pass in the hall. But I cannot conjure up any interest.

The pace of the class slows, and we cool down and stretch. Wiping sweat from my face and neck, I head down the musty hallway to the drinking fountain. I wince when the freezing water hits my teeth, and I resort to loud slurping sips. Wiping my mouth with my arm, I straighten and turn face to face with Alec. Startled, I say, "Oh hey, how's it going? I'm headed out. Enjoy your workout."

Before I walk away, he tells me he is taking a trip to Asia, part of his MBA program. "I'm leaving next week, but I'll be back by the month's end."

I give a reply that is unlike me, contrived even. "Shoot, you'll miss my birthday."

He smiles. "Well then, I'll have to send you a postcard to wish you a happy birthday. What's your address?"

<p style="text-align:center">❖❖❖❖❖❖</p>

Singing along to the car radio, I catch glimpses of the Pacific Ocean sparkling and shimmering under the summer sun. Light traffic for the Fourth of July weekend. I am headed to San Diego, excited to see Randi and celebrate Bill's milestone birthday, the big 3-0. They moved back to Southern California

two years ago, an opportunity to grow professionally and a better life for their family. They make a powerful team. Cal and I were never good partners. The idea of working on a marriage seemed silly. I was naive. I expected our marriage to work like magic. I tried harder to end my marriage than I ever did to save it.

I wonder if there will ever come a day when I don't cringe at the thought of my failure and the disastrous affair. I resist negative thoughts that threaten to darken my mood, roll down the window, and turn up the radio. Taking in the fresh air and surrounding beauty, I imagine a time when my past is old news, when nobody knows or cares about its significance any longer, including me.

The house buzzes with activity. Randi prepares Bill's favorite Mexican dishes while he fills coolers with drinks and ice. I set out paper goods and clean up plastic wrappers and cardboard boxes emptied of their contents. Working up a sweat, I'll need a rinse before the party. The phone rings, and Randi answers. She doesn't say more than a couple of words and hands the phone to me. Only my kids or their dad would be calling me here. Wiping my hands on a dishtowel, I whisper, "Who is it?"

She brushes past without answering. Maybe she didn't hear me. I say hello, a short pause, and then a familiar voice. It's Andy. I glance at Randi, who looks pleased. She loves to pull off surprises. I give her a gentle shove.

I'm glad he cannot see me because I am grinning from ear to ear. I should not be happy to hear his voice, but I am. He tells me he will be in San Diego in about an hour. He laughs and asks if I can pick him up at the airport.

"Of course, I will."

✳✳✳✳✳✳

I wake up to a sun-filled living room. Andy stirs beside me on the sofa bed. He rolls toward me and rests his arm across my belly. Kissing my shoulder, he asks, "What would you like to do today?"

The decision is easy: La Jolla. It feels odd to take off for the day, away from Randi and Bill. But they knew he was coming before I did, so I'm sure they're expecting me to spend the day with Andy. He leaves tonight, and I'm already counting the hours.

Randi emerges from the bedroom. Still in her jammies, she greets us from the second-floor landing. She beams, proud of her handiwork, bringing the wayward lovers together again. Like me, she is an incurable romantic, a lover of fairytales and dreams come true. She and Bill seem to have it all. They attend to the tiniest details of loving one another. My best friend since the eighth grade, she wants the same for me. If anyone possesses the power to influence our love story, it's her. Having lost faith in my ability to attract a happily ever after, I want the people who know how to intervene.

Through the large picture window in the La Valencia Hotel lobby, the Pacific Ocean is framed before us. A spectacular view that I could not wait to show Andy. We half-jokingly promise to meet here on New Year's Eve. I want him to say that is too far away. But he doesn't. Not a word about what happens next for us. Everything is the same, yet everything is different. We pick up right where we left off a few months ago; the ardent rhythm between us runs constant, uninterrupted, and seemingly unharmed by his unfaithfulness or my heartache. He holds my hand, kisses my lips, and tells me that I am beautiful. We don't talk about

her or what happened. I am the perfect companion: no anger, no tears, all-forgiving, cool with the past. He'll see he made a mistake. He will want me in his life again, this time for good. But he never speaks those words, never gives me the confirmation my battered ego needs. Could I ever trust him again? I glance at the clock on the wall without him noticing. His flight leaves in a couple hours.

❉❉❉❉❉❉

The Indian Guides run along the parade route, smearing paint from paper cups on the waiting faces of kids who sit curbside. My kids have outgrown painted faces. Kenny plays tag with friends and asks for money to buy cotton candy. I grab him and point out the things he used to love. He humors me for a minute watching the miniature dune buggies and race cars zoom back and forth and then spin in circles for the crowd. And then he takes off. Tara holds the new babies, giving the moms a break and playing big sister. They're growing up.

I am watching the parade go by when Michele nudges me and points to one of the ancient parade floats; we laugh at the outdated clothing and hairstyles on the mannequins, more suited for 1969 than 1989. I've been coming to this parade since I was eight years old. For the last few years, we've made a habit of meeting on the corner of Crest and Main. I think of Andy offering me a bite of his bagel a few years ago on this very spot and wonder what he is doing today.

There is a break in the parade, and anyone who has been trying to cross the street for the last thirty minutes makes a run for it, Alec among them. Last week at the gym, I casually mentioned I would be here. He was noncommittal, and I had forgotten about it. He spots my gang of friends and me and

flashes a confident smile. I nonchalantly point him out to Nili, and she quips, "Foxy. Not my type, but cute."

I laugh. He says hello, and before I get a chance, he introduces himself to everyone. He has lived in Huntington Beach for a few years but has never seen the parade. I tell him about my first time in 1968 with my family; we stumbled upon it while visiting our new home under construction nearby. I chatter on about actress Dorothy Lamour being the grand marshal, how my dad was starstruck. He half listens. I get quiet, self-conscious. I talk too much.

Locals riding their decorated beach cruisers followed by the city street sweepers signal the end of the parade. The crowd thins, and before Alec takes off, he invites us to meet him tonight outside the high school for the fireworks show. He and some friends have staked out a section.

Walking home, mixed emotions flood my heart. Seeing Andy in San Diego only made me want him more. I've replayed every discussion and searched for the words that would indicate the possibility of a future for us. There was no shortage of love professed, but not a single promise, not one word of a commitment. Burned once by assuming that we were the real deal, I will not ask for what he has already denied me. In September he will take a trip around the world, traveling for months. Maybe he'll meet someone new, fall in love. I cannot have my heart broken again. But I find it impossible to let him go.

✻✻✻✻✻✻

Wooden stakes and kite string carve the grassy median along Main Street into hundreds of small sections. Each packed with spectators. Up ahead, I see Alec and his friends seated

on lawn chairs, a picnic spread before them. With my kids in tow and my sister Mary with her year-old daughter Jamie close behind, we carefully step over the makeshift boundaries to reach Alec. I hope Michele and Kurt show up soon. I don't want to have to make small talk for too long.

Alec's friends are nice enough, all of them well into their thirties. The discussion of symphonies, popular restaurants, and exotic travel seems more like a contest than a conversation—or worse, an interview. As a twenty-nine-year-old single mom, I'm feeling insecure, and uncultured. I'm grateful for the arrival of my friends and a change in conversation. My little niece Jamie provides comic relief as she stares at Alec's friend Richard's impossibly curly mop of hair. It appears to grow up and out rather than down. We laugh at her bold curiosity as she points and babbles, seemingly trying to explain the mess on top of his head.

The first loud crack draws our attention to a spectacular burst, and the sky lit with color, the firework show begins. I did not bring a chair, and Alec invites me to lean back on his shins, recliner style. It's uncomfortable, and I find an excuse to sit closer to my little gang. After thirty minutes of oohs and aahs, the crowd breaks into wild cheers. The grand finale does not disappoint. Red, white, and blue starbursts fill the sky, their fingers spread wide and overlap, and their tails trail and trickle downward. Smoke dissipates, and we call it a night.

Before I make my getaway, Alec walks toward me. I reach toward him to create some kind of boundary or preempt what I fear might come next. He takes my outstretched hand, pulls me close, and kisses me. Not quite on the lips, but close enough to indicate something more than casual friendship. He steps back, his gaze intense. I am cool-headed, my heart

not ready to leap. I hold on to the dream that is Andy and consider the possibility of someone new.

✳✳✳✳✳✳

Sunbathing on my patio, my arms are heavy and stiff, locked at my sides. Somewhere between a dream state and consciousness, I try to push through concrete, my body paralyzed. This strange sensation is not new but still unsettling. I stop fighting, and sleep paralysis loosens its grip. My body goes limp. The return of these episodes means only one thing; I can no longer outrun the stress and sleep deprivation that has become my life.

Exhausted from playing games, dating both Alec and Andy, my health is suffering. Rather than get off the fence and decide, I've been straddling it, legs dangling on either side, for weeks.

The physical distance between Andy and me, and our history, creates intense longing. He is easy, and we fit. But there is no clear path to us being together. He leaves next month for his trip and won't return until after the holidays, a natural parting of the ways.

Alec lives blocks from me; I see him often, at the gym and at his beautiful home at the beach. Convenience has advantages. Never at a loss for words, he boldly shares his opinions on all topics, including the subject of my life. He demands I stop with this bullshit and choose him. His assertiveness is attractive. Older and wiser, letting him take charge appeals to me. I imagine being taken care of, and I like it.

Andy and Alec fume over sharing me. I pretend to be an evolved, modern woman keeping my options open. To anyone who questions my actions I say, "Hey, I've been honest

with both of them. If they don't like it, they don't have to participate."

I keep up the pretense, but it's total crap. I am stalling, and deep down I feel trashy.

Resting on my elbows, my brain fried and tired, I think about dinner a few nights ago with a friend, an older woman. After listening to my dilemma, she advised me to dump them both and start fresh. Start over? Is she crazy? I am twenty-nine. My best years are nearly behind me. I lie down and doze again.

❀❀❀❀❀❀

I listen to Alec's message on the answering machine twice. His frustration is loud and clear. He is no longer interested in my definition of dating. He does not ask me to make a choice or even return his call. He says he is headed to Catalina for the weekend and says good-bye. I am sure he won't be calling me again. I suppose I needed someone to draw a line in the sand. Being cut loose does not sit well with me. I will not be the loser in this deal.

I make the practical choice: Alec. He isn't going anywhere. He is shiny and new. He has never hurt me. I call and leave him a message. I don't beg, I make an appeal. I ask him to give me—to give us—a chance. I hang up the phone and sit. My shadow grows long against my bedroom's blue painted wall. No turning back, my heart sinks. There is no off switch for loving someone.

CHAPTER 9

Fall 1990

I pull the wooden wagon carrying our supplies along the uneven dirt road to our campsite in Cinnamon Bay. Alec carries the heavier luggage. The lush green landscape extends as far as the eye can see. We chose St. John in the Virgin Islands because it is mostly national park, pristine with few tourists. A motionless iguana watching from his rocky perch startles me. I point him out to Alec. Beyond the reptile is our campsite, a large white canvas tent set on an elevated foundation and a picnic table. We unload two large plastic water containers, a lantern, and a small camping stove onto the table. The remaining towels and linens we bring inside the tent. Pushing the cots together, we create a double bed and cover it with crisp white sheets. Exhausted from a day of travel, we collapse into a deep sleep.

Startled awake in complete darkness, a loud and consistent thrashing I cannot identify beats against the tent. Once I realize it is raining, heavily, the steady rhythm comforts me. Alec snores. His travel schedule is grueling— home on weekends only, a few months in one city, followed

by a few months in another. When he can't come home, I meet him for extended weekends where he is consulting or at a nearby tourist destination. Between projects, we take longer trips. He has kept his promise: a life of adventure. Snorkeling, hiking, camping, and sightseeing fill our time together. There is excitement and romance to this lifestyle. I think about my kids and hope their dad is keeping them to the schedule I left behind. My relaxed state is always disrupted by mom guilt.

Never married and without children, Alec does not understand the emotional baggage connected to motherhood, or parenthood for that matter. Frustrated with my sense of duty toward my kids, he reasons away my feelings, calling them bullshit. He declares me a good mom, end of discussion. He likes our time together to be free of upset or concern. Maybe he's right. Finally awake, he asks, "What is that noise?"

"It's the rain," I say.

We peek outside the tent. Pitch black, our eyes adjust with the help of a distant light. Above ground, we watch rivers of sand and rock flow past us. Now we understand the importance of the raised foundation. Alec checks the time, 2 a.m. We fall back into bed for a few more hours.

Spring 1991

I peer over bags of groceries in my arms and frown at the condition of the front lawn. Shaggy and full of weeds, it needs mowing. A project for the weekend, and for a change, I'll be home. Alec's car is parked on the street; he must be inside with the kids. He's been in town for weeks. Unhappy with his last project, he was bold with his criticism and ruffled a few feathers. He hoped to be assigned to a new project soon, but nothing has transpired.

Before I get to the door, Alec appears, grabs the bags from me, and sets them on the sidewalk between us. Something is up, and I search his face for an explanation. He swallows hard, "I've been laid off."

A wave of selfishness washes over me—no more trips, no more adventure. Questions swirl in my head: Will he be able to pay his mortgage? Does he have any money saved? Can he get a job as good as this one? As his girlfriend of nearly two years, am I obligated to help? I fake calm and reassure him, "Don't worry. Things will work out."

He's worried, and so am I.

Summer 1991

All the salespeople are traveling, my boss as well. Taking advantage of the empty office, I tackle a stack of expense reports. I hate accounting work. I miss the early days when my work was varied. I organized trade shows and sales meetings, even traveled some. Five years later and lots of growth for the company, I am left behind—the bean counter, as Alec likes to say. I hurry to complete payroll before he arrives to take me to lunch.

It's strange to have him home so much. We are working out the kinks of our new normal. Used to dedicated time with my kids during the week, Alec's appearance every night interferes with our routine. I don't mind eating dinner together so much, but I do mind his spending the night. I have kept my bedroom activity hidden from my kids. And while weeknight romance is nice, I want him to go home once the deed is done. When we've accidentally fallen asleep, I wake up in a panic and shove him out the back door. He thinks my rules are stupid, and I'm sick of explaining and justifying my boundaries again and

again. Our relationship was easier when he was gone all week. His take-charge attitude is less attractive in my home. This is my domain, and I prefer he butt out.

Immediately following his layoff, he was a flurry of activity, dedicated to networking and finding a job like his consulting gig—something with great pay, great benefits, and travel. With no significant leads, his outlook soured. He has adopted a new attitude toward traditional employment: being a working stiff for corporate America is bullshit.

I am a woman with a plan, always staying the course. For the last five years, I have worked at the same company with steady raises, health insurance, secure employment, and a 401K. Determined to be the master of his financial future, Alec decides to start his own business. The uncertainty of his plan and the fact that he isn't earning any money seems proof enough that he needs a real job. He disagrees.

Entering my office, he smiles. His physical presence boasts an air of confidence, but I know differently. In weak moments he'll let on that he is worried, always adding that this is only a temporary setback. I'm sure he'll mention it again at lunch. My standard response will annoy him, and I'll say it anyway. "I can't understand why you won't take any job right now. If you are earning money, what difference does it make? Then you won't be stressed about your finances."

He'll sigh in frustration and tell me for the one-hundredth time that he will never work for anyone ever again. The predictability of this exchange is growing proof that neither of us is budging. I decide to leave the discussion for another day. I return the smile and kiss him.

✿✿✿✿✿✿

The phone call won't cost a dime if I make it from work—something I took advantage of when we were dating. I close my office door. I dial Andy's number, still memorized, and clear my throat as the phone rings. He answers with a friendly and very professional hello. Warmed by the sound of his voice, I give a light and cheery, "Hi. It's me."

His tongue-tied surprise is predictable and endearing. We laugh and stumble over our words. We last spoke when he returned from Europe, over a year ago. He made one last attempt at my heart, and I told him I was happy with Alec, committed. I manage a casual tone and ask, "What's been going on? What's new?"

A short pause, and then he blurts out, "Uh, I'm getting married."

I pretend that his tone did not convey happiness, but I'm only kidding myself. Any wavering in his response was to protect my feelings. My inner voice cries, "No, wait! Marry me. We belong together. Marry me!"

Grateful for a moment of grace, I swallow hard and say, "Congratulations. I am so happy for you, really, I am."

He thanks me, and before the silence becomes awkward, he asks about the kids and my family. I give him the latest news, convincing him and me that everything is great. Many more words follow between us, but I can only hear the background track of my heart, *He's getting married. He's getting married. He's getting married.* What did I expect? That he would never fall in love again?

I called because I missed him, and I was curious. Never in a million years did it occur to me that he would announce his upcoming nuptials, never. To save face and appear super okay with this news, I initiate the good-bye. "So great to catch up, so happy for you. I better get back to work."

We say good-bye, then there is the sound of our breathing. He says he loves me, and I know it's not in the romantic way but in the way that says, "I can love you, knowing we will never be together."

We say good-bye again, no promises to talk soon. I hang up the phone and sit with my feelings, an achy mix of tenderness, warmth, and longing. I imagine Andy sitting at his desk, staring at his phone. Maybe wondering why the hell I called. I never mentioned Alec, and he never asked. The final letting go lingers. I dislike endings, and good-byes. I put them off for some future date, and that date has arrived. My heart surrenders to the facts; one love story ends, so another may begin.

❀❀❀❀❀❀

I lean over the bathroom sink washing my face and thinking about my call to Andy. Doing some quick math, I determine he and his girlfriend were not dating long before they were engaged. He knew she was the one. I hear Alec's voice coming from the kitchen. I wasn't expecting to see him tonight, and it's late.

Dressed in his gym clothes, he leans against the door jamb with a bowl of cereal in his hands and asks about my day. Before I can answer him, Tara comes in to tattle on her brother, who rushes in to give his side of the story. My patience thin, I shout, "Stop! Knock it off and get ready for bed."

They scatter, and Alec proceeds to tell me about possible leads for work, unaware that I didn't answer his question about my day. Without looking at him, I interrupt, "I talked to Andy today."

He chews, no response. I continue, "He's getting married."

He swallows forcefully, "Good for him."

I'm pissed—annoyed with my lame attempt to engage Alec in another discussion about marriage by bringing up Andy. I don't want to get married this minute. But I want Alec to at least have a plan for marriage when his finances turn around. After two years, he should know if he wants to marry me.

Andy only recently met his fiancée, yet he knew he wanted to spend the rest of his life with her. He never felt that strongly about me. I thought Alec did; he was supposed to be the sure thing. Seems I'm good enough to pass the time with but not suitable for a lifetime commitment. Maybe I had my one and only chance with Cal and blew it.

Spring 1992

Borrowed camping gear lies stacked in the living room, ready to load in the car. Canned pork and beans, packaged deli meat, cheese, and snacks cover the kitchen counter. I organize the mess into meal plans. The kids are busy in their room packing. Every now and then they rush into the kitchen holding up a piece of clothing, "Should I bring this?"

I remind them that the Grand Canyon is cold this time of year, so lots of layers. Excited, they ask again if Alec is coming. I keep it light, telling them he's been busy. We'll see. I haven't heard from him in days. It's not the first time he has disappeared without warning. It happened at Christmas; he emerged a few days later, telling me that he struggles with depression during the holidays.

I planned this spring break camping trip weeks ago— mapped out the route, reserved the campsite, and checked the weather. Alec was committed to joining us, one hundred percent. And then he fell off the grid, no calls, and no returned calls. Used to doing things on my own, I power through the

final preparations. We'll leave town as scheduled.

I check on the kids' progress, and when I return to the kitchen, I'm surprised by Alec standing in the living room. He mutters something about work struggles and stress. I fume, exasperated by the ups and downs of his unemployment. I don't start an argument because, deep down, I want him to come. I want his help. I want a partner. I plead, "Just go home, pack your shit, and be back here in an hour."

✳✳✳✳✳✳

Alec snores in the passenger seat. Kenny and Tara, lulled to sleep by the low rumble of the Land Cruiser, are silent. I am white knuckling the steering wheel, desperate for the torrential rain to stop. The constant and hurried swish of the windshield wipers wears on me. Exhausted from planning, navigating, and driving, my resentment grows. I am sick of being the captain of this whole stupid trip, this stupid relationship, and my stupid life. I seethe. I wouldn't be driving into this storm had we left on time. But I waited for Alec.

The pounding rain lets up, and my passengers awaken, never knowing of the storm or the stress I endured while they slept. They are concerned about one thing only—our arrival time. I describe the intensity of the pouring rain to Alec, trying to elicit some sympathy or concern. He is uninterested but offers to drive. In the passenger seat, I try to sleep. But Alec's erratic driving has me on edge. Rather than complain, I sigh and keep the peace.

We race the setting sun, hurrying to pitch our tents in the frozen earth before dark. My mood warms as I watch my kids work as a team. Funny how well they get along away from home. Alec finishes our tent, and I set up a camp kitchen on a

large picnic table. I survey the scene; maybe this is as close as we'll ever be to a family.

Dusk turns to dark, and the temperature drops. My hands exposed to the freezing cold go numb as I prepare a quick, easy meal of hotdogs and baked beans. The kids play tag, seemingly unaware of the frigid air. I light the lantern and then the small camping stove. Without warning, pea-sized balls of ice fall fast and hard, bouncing off the picnic table. Nowhere did I read reports about the possibility of hail! Kenny and Tara scream and run for cover in the Land Cruiser; Alec joins them. I rush to the back of the truck, lift the back window, and pull down the tailgate. Quickly I move the stove and food into the makeshift covered kitchen. My straw hat—more suited for the beach—has captured the icy balls in its brim. I lean forward, dumping the accumulated hail onto the ground. I swear that I will never, ever, camp again.

✳✳✳✳✳✳

We wake to clear blue skies and freezing temperatures. Having slept in layers of clothes, we spring from our tents ready for breakfast and then a walk to view the Grand Canyon. I haven't been here since I was a kid, and I cannot wait to show Kenny and Tara the breathtaking landscape. Steps from the look-out point, I stop the kids and tell them to cover their eyes. With arms linked, I lead them toward the canyon and say, "Okay, open your eyes."

Watching their faces, I am pleased and proud to share the majestic beauty. Kenny asks in genuine disbelief, "Is it real?"

Tara moves forward for a closer look. Blinking and squinting as if to remove any remaining doubt, she says, "It looks like a painting."

Mission accomplished; I have succeeded in creating a happy childhood memory. I am always hoping I can lessen the sting of the painful ones.

The guide leads our small group on a trail ride through picturesque Kings National Park. I've only ridden horseback a few times in my life. Each time I am alarmed by the distance from my butt in the saddle to the earth below. Unsteady and teetering on the back of this large mammal, I hide my fear from Tara and hopefully the horse. The last thing I want is for this skittish creature to sense my nervousness and take off on a crazed sprint into the woods. Tara looks comfortable on her horse, fearless, and I relax. She wears my favorite sweater. It has become her favorite too. A late bloomer, she is much more a girl than a preteen, not too cool to be in the company of her mom—not yet anyway. She turns to me and smiles.

The sun high in the sky, I wonder how Alec and Kenny are managing their hike to the bottom of the canyon where it is at least twenty degrees warmer. Kenny thrives in the outdoors and nature. Free of time demands and the insistence of specific outcomes to measure his success, he learns from his natural curiosity. Alec indulges my boy's interests and genuinely enjoys his company. I think if we were married, Alec's consistent presence would have a positive impact on both Kenny and Tara's lives. But marriage hasn't been a topic of discussion for ages.

Tara and I meet the guys at the trail's head. Dusty and sunburned, they enthusiastically share the details of the daylong hike. We wander into the souvenir shop, and Kenny buys an "I hiked the Canyon" T-shirt. He immediately slips

it on to boast his accomplishment. Out of nowhere, Alec announces that we should leave tomorrow, a full two days before our scheduled departure. Before I can respond, he adds that we've seen and done everything. He's ready to go home, has things to do. Like what? He's not working. I'm disappointed but not surprised. He is easily bored and rarely happy in one place for very long. A fun evening with friends or family can end abruptly when he has had enough. I acquiesce, often leaving good company or a lively party long before I am ready. Now that he has planted the seed, the kids want to go too—a chance to spend the remainder of their spring break with friends. Not wanting to force everyone to stay for the sake of sticking to the plan, I agree to pack up.

The ride home is subdued. Alec drives, focused on the road; he is quiet. I stare out the window. This trip would have been different if the kids and I had gone alone. I won't give Alec one ounce of credit for making the trip better for the kids or easier for me. I'm angry because he hijacked my plans without considering my feelings. I think about something Alec frequently says to me: "Babe, you're a giver, and I'm a taker. It's just how it is."

I hate that.

Summer 1992

Kenny and Tara walk with the dogs and explore the expansive property, a beautiful, newly built, California ranch house. I watch them from the large open porch, complete with a picturesque view of green, rolling hills and mountains in the distance. Here against my will, I quietly fume while Alec chats it up with folks who would have been his in-laws had he made a different choice. Driving home from Yosemite through the

Central Valley, we argued about making this stop. I had no interest in visiting the parents of his ex-girlfriend, Kimberly. I protested, "I don't know them. I don't want to know them. I'm uncomfortable. Please, I don't want to stop."

Behind the wheel and in complete control, he ignored my wishes and declared he was stopping, end of discussion.

The sweet couple greeted Alec warmly. They were thrilled to see him and welcomed all of us into their home. Photographs of their beloved daughter are displayed on walls and shelves throughout the house. She is blonde, pretty, and petite.

Drinking iced tea on the patio now, her parents proudly tell Alec the latest details of their daughter's life, her job, and her volunteer work with rescued animals. I'm polite, I don't let on that this is the last place on the planet I want to be. I smile and pretend to be interested. I knew of Kimberly before today; she and Alec were quite serious. Things ended between them because he didn't want to get married.

I feel vulnerable and exposed, compared and judged. I don't want these people to know me or share information about me with their daughter. I can almost see the eye rolling as they tell Kimberly my story—dating for three years, no ring. Finally, vindication for the ex-girlfriend. It wasn't her; it was him! He is afraid of marriage! She'll be relieved that she set him free. In reality I am sure they don't care about me or my relationship with Alec. It is me who cares.

The sun sets, and they offer dinner and a place to stay for the night. Before Alec can open his mouth, I thank them profusely and say we must make our way home. Back on the road, Alec wants me to admit that making this unplanned stop wasn't so bad. He misses the point. I try to explain that he discounted my feelings, ignored them. He uses his standard answer, "You are hypersensitive."

CHAPTER 10

Fall 1992

Introduced to the art of domestic duties before I could read, I consider myself an expert in the execution of every task related to achieving sparkling cleanliness in a home. Trained by the best—our mom—my sisters and I are basically the A-Team of housekeeping. She had high standards; one speck of powdered green cleanser left visible on a countertop was reason to be called home from a playdate. Mom would point to the spot, I would fix it, and then be free to play again. I learned that perfectionism was an honorable trait. I can do this work with my eyes closed, freeing my mind to ruminate on the aspects of my life that I cannot control.

Knee-deep in Saturday chores, I fold Alec's clean clothes and try to remember when exactly he started leaving his laundry here or spending consecutive nights, until he never left. When did my garage become his home office? One day he was complaining about his housemates, and before I knew it, he was carrying his desktop computer, cables dangling, through my house. He never asked. We never discussed an arrangement, his contribution to rent, or the future of our

relationship. How the hell did this happen? I feel cramped in my small duplex. Worse, I'm breaking my rule. I didn't want to live with Alec unless we were married. I want him to go home. I miss visiting his beautiful house, my getaway, all that space. I liked the tidy separation of our dating life from my family life. I was upset the morning we overslept, and the kids came into my room to find Alec in bed with me. They were casual in their discovery, as though they had known all along. When they wandered off to make themselves breakfast, Alec looked at me and said, "See, that wasn't so bad."

I could only see one more parenting blunder.

I put his clothes away in the drawers I have cleared for him. My message mixed—no wonder he doesn't believe me when I say no. I'm a pushover. When friends ask if Alec lives with me, I'm vague, offering a non-answer. When my parents ask if he contributes financially, I tell them he occasionally makes dinner, buys groceries, and helps around the house. I'm uncomfortable with this arrangement. I want a commitment. Would he leave for good if I drew a line in the sand? Maybe that wouldn't be the end of the world.

I walk into the kids' shared bedroom to drop off their folded clothes. They need their own space. Kenny and I had talked about making the single garage his bedroom, giving him and his sister the privacy they need. The plan fell apart when Alec made it his office. I sit on Tara's bed and evaluate my relationship with Alec for the zillionth time.

✿✿✿✿✿✿

I stare at the grass sprouting in the large crack in the concrete between our feet, not wanting to meet Alec's eyes or read his expression. I asked him to move his things back to his house.

We could continue dating, but he could not live in my home or keep an office here. I do not mention the future, only what I need and want right now.

Slowly I lift my head. He is thoughtful, and I wonder if he is considering another solution. When he speaks, it is only to agree with me. Over the next couple of days, he collects his stuff and moves back to his house.

Nearly as tall as me and certainly stronger, Kenny answers to Ken these days. I hardly lift a finger as he moves his bed into the garage and creates his new space. Tara makes their once shared room her own. They are happy, so I am happy. I have done the right thing. I want them to notice and remember that I put them first. I want this gesture to mean as much to them as it does to me. I need it to be something more because I'm keeping score. Another point for being a good mom, choosing my kids' well-being over Alec's needs and wants, or mine. My conscience is a powerful motivator.

Fall 1994

After years of housemate drama, Alec is the last man standing in the giant pink stucco house. He purchased the home with his best friend John and John's girlfriend, Anne. They got a bargain price on the foreclosed property two blocks from the beach. It was a great investment and the party home of their dreams. But before escrow closed, John took a job in Japan. Eventually, he and Anne split. In five years, I've met him once, and despite Anne living here, I rarely saw her. A few days ago, sick of California, she packed her shit and moved to Alaska. Other than the barstools and Alec's bedroom furniture, the house is empty. I had no idea most everything belonged to

Anne until it was gone. For the first time, Alec lives alone, left holding the financial bag.

Tonight, he is pensive, no boasting of upcoming projects or new ideas, thank God. I've lost track of the number of businesses he's started and then abandoned. He prepares pasta primavera, and I watch, enjoying a glass of cab. He is an excellent cook, "Made with love," he always says. The extravagant days of fancy dinners and travel are over. For now, we peruse bookstores and coffee shops and rent foreign movies. I'm not sure how he stays afloat or how he'll hold on to the house.

I pry a bit, "What's your plan with regard to the house?"

I sense a crack in his confidence as he tells me that this house is all he has, and he intends to keep it. I look around at the nearly empty living space. I want to live here. Ken and Tara would have their own rooms and plenty of space. They would be closer to the high school. My condition for moving in is marriage, a topic Alec has not even hinted at. I wonder about a compromise.

Summer 1995

The house and yard are filled with our family and friends celebrating the Fourth of July. Alec mans the barbecue on the patio, flipping burgers and turning sausages, sharing culinary tips as he enjoys a beer. He's so casual, nerves of steel. I rush around, restocking coolers with ice and drinks. Nervous as hell, I avoid too many conversations, afraid my face will give away the surprise. A few days ago, in our living room, kids present and my dear friend Moe as our witness, Alec and I were married. We will announce the news today. Surprise! After six years of dating, we are hitched. The stats say the longer you

date, the higher the risk of divorce. The stats say the divorce rate is higher in second marriages, even higher when there are children involved. I hate the stats. I'll challenge them again; we'll beat the odds.

In the end, we made a deal. It was the perfect storm of want and need. I wanted to get my foot in the door, a bigger home for me and my kids, and eventually marriage. He needed someone to help with the mortgage. I would move in, and when Alec's finances improved, we would be married.

The months rolled by. I honored my end of the bargain. As far as I could tell, Alec worked enough to cover his part of the expenses. My kids had the space they needed, and I enjoyed the house and its proximity to the beach. There was only one thing needed to complete the deal. Had Alec forgotten? Or had he hoped I had forgotten?

I recall silently practicing the words in my head as I sat on the bathroom counter while he shaved and then speaking them out loud. "Hey, I've been thinking. We said that after I moved in and things were better money-wise, we would get married."

I cough to clear the shake in my voice. "It's been eight months, and we haven't even talked about it. I kinda feel like I want to go home and live in my own house if we're not going to get married."

Still shaving, he said, "Okay. So, let's get married."

I blinked. Not the proposal of my dreams, or even a proposal at all, but I accepted his statement as the completion of the deal. In a matter of minutes, we decide on the quickest plan: city hall, no church wedding or fancy reception. We'll surprise everyone on the Fourth.

Now my heart pounds in my chest, and I'm sweating. We give Moe's husband Dan the signal to give his prepared speech.

He stands on a chair and shouts to get everyone's attention and then begins, "As Patrick Henry once said . . ."

What? I chuckle to myself as Dan's speech leads the unsuspecting crowd down some patriotic path. I can no longer hear his words above the sound of blood rushing to my head until he announces, "Alec and Christine were married a few days ago, July 1st!"

There are screams of joy and surprise as everyone rushes to hug us. I return the hugs while walking toward my parents. Dad stands slowly, beer in hand. Eyebrows raised, he exchanges a glance with Mom, no words. I've seen that look before. His smile seems forced as he accepts congratulations, his daughter finally an honorable woman. I detect worry in their faces. I want to say, "This is different. This will be better. This is good." Instead, we embrace. Alec joins in, bear-hugging all of us and kissing my mom. He honored the deal; he honored me. I've done the right thing. I stood up for myself and got what I wanted. And I am pretty sure I have found happiness.

1996

Making good use of my number-crunching skills, I scribble notes and calculations on a yellow legal pad. With a few lifestyle changes and some sacrifice, my dream to become a teacher will be realized. After I complete one last requirement—student teaching—I'll leave thirteen years of accounting behind. I won't miss the work, but I'll miss my coworkers, particularly Adrian. I've shared more lunches with him than anyone on the planet. We'll remain friends, but it will be different. Hardest of all is making this change without financial or emotional support from Alec. To say he is disappointed with my new career choice is an understatement.

He mocks me in front of anyone who will listen. "Can you believe my wife is leaving her cushy job to become a teacher?"

His mean-spirited comments are followed by my silent embarrassment. He reminds me that he married a businesswoman, not a teacher. I've stopped defending myself and my decision. I ignore him and head in the direction of my dream.

Adding to the strain on our relationship is teen drama. Tara pushes all my buttons and ignites fury in Alec. He criticizes me for being too soft and demands she follow his rules in his house. There are blow-ups between the two of us, the two of them, and sometimes all three of us. Unable to impose his will, he shouts in frustration, "This is my fucking house!"

I hear his words as both a warning and a threat. He can kick us out anytime. Desperate, I turn to Cal for support. He offers none, says I'm over-reacting to normal teenage girl behavior. Newly married, he prefers every-other-weekend visits and the pursuit of his own marital bliss. Who wouldn't?

I return my legal pad to the file marked Teaching, turn off the lights in my office, and head home. An evening of walking on eggshells combined with tiptoeing around topics that could lead to an evening of arguments—yuck. I take advantage of the calm, peaceful drive home, quietly singing to the radio.

✳✳✳✳✳✳

Football blares from the television, grandkids play, and the noise level is at an Amoroso all-time high. Thanksgiving is usually my favorite holiday: everyone gathered with good food, family, and gratitude. This year is different. I am not feeling thankful at all. Lost in thought, I look out the large

window to the patio where Alec is talking with my dad, politics and world issues, I'm sure. His mood is greatly improved these days, and I resent him for it. I wonder when or if Ken will show up today. Tired of my rules and expectations, he moved out after his eighteenth birthday, saving all of us any further debate about curfews and responsibility. I left him a message; said we'd be at Grandma's.

My sister-in-law Linda plops down on the sofa next to me. Innocently she asks, "Where's Tara?"

I haven't prepared an answer for this question, so I keep it brief, "She's with her dad."

"So, she's coming later?"

I open my mouth to speak and cannot. I cry, burying my face in my hands. Worried, and not sure what to do, she continues, "What? What happened?"

Sobbing, I make weird hand gestures trying to indicate that she's okay, and I'm okay. But I'm not okay. I have never missed my girl's birthday or celebrated Thanksgiving without her. Finally, I manage, "She's moved in with her dad and her stepmom. She won't talk to me."

Linda puts her arm around me, but I cannot be consoled. My daughter hates me; she told me so. After an argument one night, she ran away, landed at her dad's house, and hasn't spoken to me since. During that time, she learned about my affair with her uncle—the secret I tried so hard to keep. Her aunt told her, felt it was her duty to let her niece know the kind of mother she had.

1997

I sit at the horseshoe table in the back of my classroom. The custodian pops his head in for a final check, and I tell

him I'm leaving in five minutes. The end of a long day, and I have completed my very first parent-teacher conferences. I am proud, exhausted, and hungry. I'm sure Mom set aside some dinner for me, and that thought comforts me. I never imagined moving back home after nineteen years. But then, I never thought I would be a teacher either.

In the months preceding our separation, Alec grew hostile. When life didn't work out at her dad's house, Tara came home, disrupting Alec's temporary peace. He was fed up, tense, and grouchy. We rarely spoke, and we never had sex. His affection for me had been waning, but now it was gone. One Saturday afternoon, he blew up after Tara slammed a door. Livid, yelling, and pissed off, he took very personal jabs at me and my parenting. When he finished his rant, I asked, "Do you even love me anymore?"

He glared at me and shouted, "I don't know!"

His eyes never left me. The words stung. And I walked away, knowing I would leave. I made a quiet departure late that night. Waking Tara from a deep sleep, I told her to grab a few things; I'd come back for the rest. We got the hell out of his house. I drove to comfort: my childhood home. Using my key, I let myself in, waking Mom and Dad in the process. Little explanation was needed.

Sitting at my desk, I wonder, is there a constant tradeoff in life? One dream comes true while another slips away. My whole young life, I dreamed of being a wife, a mother, and a teacher. With one divorce behind me, I hang on to hope that Alec will come around and accept my career as a teacher. I paid my share of the bills, and I liquidated my 401K to pay his bills, and support his job changes. The money wasn't enough. I don't know how to fix things between us.

My relationships with my kids are strained too. Tired of

my advice and opinion, Ken avoids me. Tara and I are always at odds. She only wants me to leave her alone. The rejection I feel from all three of them is excruciating.

Somehow, I have always managed success at work. Even as I begin my career in education, I know I am a good teacher, solid and strong. My students respond to me, and the parents and the principal praise me. I hold on tight to this success. It's all I have.

I pack my things. Before turning off the lights, I look around at my classroom. Tomorrow those little blue plastic chairs will be filled with twenty smiling faces, all happy to see me, all counting on me to be the best teacher I can be. I can do that.

CHAPTER 11

2001

We watched the ball drop in Times Square at least an hour ago. Empty wine bottles, remnants of a delicious feast, and dirty dishes cover the large kitchen peninsula that separates me from those lounging in the living room. Our neighbors Rick and Mary Ann lean into one another, feet resting on the coffee table. Catherine and Eric sit apart, holding empty glasses. Catherine was hired the year after me. We found common ground in choosing teaching as a second career and developed a friendship. Eventually, our husbands met.

Alec is spread out on the other end of the sectional, talking politics, the economy, and his goals for the new year. Brash and bold, he says out loud what most people keep to themselves. His political incorrectness knows no bounds. I listen and shake my head. His plans include things I vehemently oppose, like selling the house and leaving the country. He is not attached to people the way I am. At seven, he lost his dad and was sent to live in an orphanage for a time, while his younger sister continued to live with their mother. Stories of his childhood are peppered with tragedy. Using his

resilience as a standard of measure for others' strengths and weaknesses, he sometimes lacks empathy and compassion. He has no patience for human frailty.

He never misses an opportunity to tell the story of his immigration from the mid-east to the United States: just seventeen with thirty-five dollars in his pocket. After touring Europe, he landed in the dean's office of a New England University on the second day of the fall term. He begged for a scholarship and a job. An exceptional athlete with academic strength, he got both. Between his studies he played sports, mowed lawns, and worked in the cafeteria, and then graduated with an engineering degree.

Alec and I have been together nearly eleven years now— six years dating and five years of marriage. While we couldn't sustain the bliss and adventure of those first two years, at the moment we feel steady. I know better than to think it will last for long. He is restless, still changing course on a whim, risking financial security for the next big thing. In some ways, I admire him. I always play it safe. And though he criticizes my aversion to taking chances, he counts on my practicality— and my steady income. Currently working on my master's and administrative credential, I'll be a principal in a couple of years, which means more money. I provide the freedom in which Alec can play out his dreams. Tonight, this version of us works for me, and I am mostly content.

I pour myself a coffee and add Irish cream liquor, my drink of choice for wrapping up an evening. Eric pushes himself off the sofa, comes into the kitchen, and pours himself another glass of wine. He makes a wisecrack only I can hear, and I laugh. We enjoy a similar sense of humor and teasing each other. Leaning against the counter, I drink my spiked coffee and playfully argue with Alec.

I feel a tug on my waistband and then another. My voice catches, but not enough for anyone to notice. It's Eric. What is he doing? I don't react. I continue to talk as though nothing is happening and move out of his reach. Out of character and undeterred, he moves closer and rubs his hand from my hip to the top of my thigh. I shift my body once more. Is this a joke?

Instead of smacking his hand away or threatening him through gritted teeth, I ignore him. I chalk it up to too much alcohol and avoid embarrassing him or Catherine. I ask Alec what he'd like to drink and pour the requested brandy. I deliver it with a kiss and snuggle up to him. Eric stays in the kitchen. I don't look back.

An hour later, I am leaning over the bathroom sink brushing my teeth and trying to maintain a conversation with Alec between rinsing and spitting. He is already in bed, and I am praying for sex. *Please, please don't fall asleep.* I climb into bed, but I am already too late. I try all my usual tricks—not even an erection and then snoring. I roll onto my back and stare into the darkness at the ceiling, wide awake and undesirable. I try to remember the last time we had sex, two weeks, maybe three.

An active sex life is important to me and was certainly present at the beginning of our relationship. Our physical attraction was strong, but it waned, quickly. I wrote it off as stress related to having or not having a job depending on his current employment status. Eventually, I decided it was me. I needed to work harder at being funny, sexy, pretty, smarter, something.

When we split a few years ago, I had a chance to end things for good. After Tara and I left the house, Alec never looked for me, never checked with my parents or friends to see where I was. Weeks passed. He didn't call me, and I didn't call him.

When I needed something from the house, I snuck in while he was out. He caught me one day, pulled up in front of the house as I was loading my car. My heart pounding, I hurried to leave. I wasn't ready to talk. His hand gently on my arm, he asked, "What are you doing?"

My first thought was, *What do you think I'm doing?* Breathing deeply, I regained my composure and reminded him of the events that led to my leaving. He listened and didn't deny his actions or blow off my feelings. Then he asked if I would come home. Head down, staring at the fast-food trash floating in the stagnant gutter water, I cried. I wanted to come home, but with conditions. After some quiet arguing, he agreed to marriage counseling.

I loved our therapist, Tammy. She helped me articulate my thoughts and feelings. We talked about my kids, communication, and expectations. I found it very difficult to be specific about my needs, the words a painful lump in my throat. Instead of spitting them out, I cried, and Tammy probed. Wiping my tears, I insisted I was just a crier, emotional. But she kept at it. And then she asked the mother of all questions, "What is your it? Every couple has a reason to be together, the thing that makes them a couple. For some couples, it's their kids. What's yours? What is your it?"

Alec and I stumbled over our words. We were failing the pop quiz. I felt Tammy's gaze on us. We declared our love, listed things we had in common, but never answered her question.

During our final session, Alec announced that I was moving home. Surprised, Tammy asked how that had transpired. He was quick to answer, but she interrupted him mid-sentence, looked at me, and said, "I want to hear what Christine thinks."

I looked toward the ceiling, searched for words, and said, "I think it's time."

She accepted my answer with a gentle nod and then asked if we had any further questions. It was now or never. In our last moments together, I found these words, "Um, he never wants to have sex with me."

There it was. The elephant that sat on my lap every session was finally lifted. What a relief! But Alec was unmoved. No denial or making excuses, he was silent until she asked, "Why is that, Alec?"

His response put an end to any more of my speculation, any more discussion; his tone matter of fact, "It's not that important to me."

I had my answer. I could have shouted, "That won't work for me! I love sex! I need it! It makes me feel desired and loved!"

But I didn't.

Three years since those fateful words were spoken, I lie in the darkness, horny as hell, desperately wanting a man who doesn't desire me, and still believing I can turn this ship around. Happy New Year . . .

December 2002

Alec likes to save money by cooking meals at home, meals he says taste better than anything in a restaurant. It's not far from the truth, but I've convinced him to wine and dine me, even though I'll foot the bill. It shouldn't matter; it's our money. But I'm sometimes self-conscious. He doesn't even reach for his wallet anymore. His credit cards are generally maxed out from covering "business" expenses. I sweep our financial issues under the rug and enjoy the moment, delicious food, and Alec's good mood. Empty nesters for a few years now, our time together is more relaxed. We no longer argue about the kids.

There is more reason for our lightheartedness. As I finish my master's degree and complete my administrative credential, high-paying career opportunities are on the horizon. I can contribute more to the household fund, and Alec can explore other employment options. In the last few years, I have tried to be his cheerleader, a better wife and partner, and less of a naysayer. Tonight, I listen intently as he explains his latest project and bite my tongue when I'm dying to shoot holes through his ideas.

He finishes, and I give an encouraging smile. After a few seconds of acknowledging his plan, I launch into a progress report on my master's project. I take a break from my monologue, giving Alec a chance to respond. His expression changes, and he says, "I'm sorry."

For what I wonder.

"I wasn't supportive when you decided to go into teaching. I can see you love it so much, and you're happier."

An apology. I'm speechless.

2003

Three desks are covered with student art, writing journals, and dinosaur fossils made from plaster. Three students didn't come to tonight's Open House. The seventeen that did attend beamed as they showed off their hard work to parents and grandparents before taking their treasures home. It made me sad for the kiddos who missed the chance to do that. They are often the ones who need recognition and praise the most.

I tidy up the classroom. Lost in thought, I am happily interrupted by a couple of former students and their families popping in to say hello. Checking the time, I'm guessing they'll be my last visitors tonight. We talk about how quickly

time has passed; how much their children have grown. The boys look around their former classroom and reminisce about their second-grade year so long ago, and I'm feeling nostalgic. I'll be looking for a principalship in the fall. This will be my last Open House as a teacher, a job I have loved. But I am looking forward to being an administrator and the challenges that lie ahead. I hug the boys and their parents and say goodnight.

The intercom crackles, and the principal announces the end of the evening and thanks everyone for coming. I scan my lesson plans one last time, and another visitor arrives. I'm surprised to see Eric. He says Catherine has a few stragglers in her classroom, and they are not showing signs of leaving anytime soon. He thought he'd come by and say hi. I laugh, "Should we rescue her?"

He assures me she is fine. He would know; he attends this event every year without fail, the supportive husband. Alec came once. One and done is more his style.

Eric, Catherine, Alec, and I spend a lot of time together. I have learned a lot about Eric through Catherine, probably more than I should. Women tend to share marital woes. Although I say very little, certainly nothing about our lacking sex life—only Ev knows that secret. It's hard for me to hear women complain about their horny husbands, see them roll their eyes at the mention of sex. I'm sure they'd feel differently if their husbands lost interest. With an audience, Alec is sexy and macho—lots of public displays of affection. I love his attention and laugh at his sexual innuendos, and then pray that he'll follow through in the bedroom. But it never plays out that way.

Eric and I talk about his work and recent travel. For a second, I'm distracted by the memory of that New Year's Eve. Nothing like it has happened since, and I'm glad of that. I

catch the end of his question, "What's Alec up to tonight?"

"What? Oh, you know, Open House is not his thing."

I gather my things and reach for the lights. "I think it's time to rescue Catherine."

2004

The campus is empty, and I'm working late in my office, paying bills. I was hired as an assistant principal at McGaugh in Los Alamitos School District a year ago. With a substantial salary increase, I carry the financial load. I fight growing resentment and stress as my income is not enough. I continue to cash out my 401K to cover Alec's latest accumulation of credit card debt, all related to his business schemes. When I want to cry foul, scream that this isn't fair, the words "for richer or poorer," play in my head. This could be the business deal that sticks, the one that is finally lucrative. What if I give up on this marriage too soon?

The last time Alec and I talked about taking a real job, as an employee earning a salary, was a year ago. I had gone downstairs into his office in tears. Without knowing why I was crying, he pushed his chair away from his desk and pulled me into his lap. My arms wrapped around his neck, I cried snot all over his T-shirt. Between sobs, I told him I was overwhelmed with responsibility and begged him to get a regular job to help me. He was sweet and gentle and held me close. He rubbed my back and promised we were in this together. It would all work out, we'd be okay. We could do this. "We're a good team," he whispered.

He never said he'd look for a job, and he never did. No promises made, no promises broken, and we have not spoken about the possibility since.

❈❈❈❈❈❈

I browse through the row of hanging blouses and skirts. I check prices, careful not to spend too much. Holding a blouse to my chest, head tilted away from the hanger, I ask Mom, "What do you think?"

She gives an approving nod. I tell her I'm watching my pennies, and she casually mentions a loan between Dad and Alec. Heat rises from my chest to my neck and face. Mom's expression changes as she realizes I had no idea. Furious, I interrogate her. She reluctantly tells me that Alec asked my dad for ten thousand dollars. Mom isn't clear as to whether it's a loan or a gift. It doesn't matter. I'm furious.

❈❈❈❈❈❈

My tears are hot and angry this time. "How could you ask my dad for money? Behind my back! I have never, EVER, borrowed money from my parents."

"Babe. Your dad was happy to help."

"That's not the point!"

As I fume, he asks, "So, you are upset? You think less of me because I asked your dad for money?"

Yes, that's it. That is exactly it. I didn't want to think less of him. I didn't want anyone to think less of him. He had betrayed me and exposed our financial problems. I was losing respect for him. I may have lost it a long time ago. But today, it felt real. I knew it, and he knew it too.

Over the next few days, I learn that Alec had also asked friends, former business associates, and my siblings for loans. While I was grateful that most of them turned him down, I was so embarrassed.

It was hard to be angry with Dad. In my heart, I knew he was doing it for me. He didn't want money troubles to cause strife in my marriage. He genuinely liked Alec and wanted him to succeed. I wanted him to succeed too. But I was afraid Alec was taking advantage. He knew my dad would do anything for me.

2005

I've been coming to Matsu for years. The sushi chef knows me by name. He knows Alec and Eric and Catherine too. Tonight, it's just Eric and me. I lean forward in my chair. Looking into the display case of fresh fish, I ponder my next selection. Aware of his fingers lightly stroking the bare-skinned small of my back, I don't move away or tell him to stop. We flirt and drink sake while our respective spouses are out of town, work stuff. The sushi chefs say a few words in Japanese and laugh. They catch me watching them and end their obvious exchange. I ask for salmon sushi.

Stealing notes from the Clinton playbook, I justify my behavior; I haven't had sex with him, so I'm not cheating. I'm sharing a meal with a friend. This is what friends do. We told our spouses that we would be grabbing a bite together, super casual, no big deal. Naively, I want only exactly what is happening right now. Someone to flirt with me, to pay attention to me, someone who is a little turned on by me. I know better than to go down the road of a sexual encounter. That won't happen again.

Eric does most of the drinking; I am the designated driver. Shy by nature, alcohol changes him. He becomes bold and uninhibited. I don't do a thing to stop the inappropriate touching or the conversation. I lead him on, playing coy and

pretending to be surprised by his behavior. He knows I don't shock easily, but he plays along.

Spending as much time as I do with Eric and Catherine, I've had plenty of time to study their dynamic. He is more willing to spend time with Catherine if Alec and I tag along. She's happy when Alec cooks, freeing her of domestic duties. But now, with Alec spending so much time in Colorado with his new business venture, I'm left alone. Not wanting to spend weekends by myself, I would text Catherine, asking to meet up. She rarely checked her phone, so I'd text Eric. His Blackberry was always attached to his hand. Before long, Eric and I left out Catherine. We texted regularly about random stuff, jokes, funny observations. I'd read them to Alec or casually mention them to Catherine. I had nothing to hide. But something changed, and I'm not sure of exactly when, or why.

On the drive home, Eric entertains me with his tipsy antics. He is giddy, as though he hasn't had this much fun in a long time. It's hard to imagine the depressed, moody Eric that Catherine has described. At the stoplight, he leans in for a kiss. I jump away from him, put my hand over his mouth, and push him away, giggling. I can hardly be taken seriously, and he tries again. I bat him away, making light of a dangerous next step. The more I protest, the more he tries, and we laugh until we are breathless. At the next stop, I tease him, lecturing him about the dangers of kissing me. He catches me off guard mid-sentence and kisses me on the lips. I elbow his chest, swearing that that can never happen again, and all the while, I'm laughing. I don't think of Alec or Catherine. This is harmless drunk behavior. Eric won't remember a thing. I drop him in front of his dark house, shushing him as he stumbles out of the car, and I drive home. Shit. That cannot happen again.

❊❊❊❊❊❊

Bent over boxes in my new office at Brywood Elementary, I unpack books, professional journals, and personal mementos I have accumulated. Slow work as I thumb through old yearbooks and staff photos from my last two schools. I reread old thank-you cards and farewell wishes of good luck—the story of the last nine years of my career contained in a few boxes.

The school is quiet and empty, everyone on summer break, giving me a chance to get my bearings. I take a break from the dust and memories and sit at the head of the conference table: a new district, my first principal job, my very own school. A dream come true and no one to share my success with.

The phone's ring startles me. I'm quick to answer. The assistant superintendent of human resources welcomes me. Dave and I worked together in Los Alamitos, and he helped me get hired here—a lucky break for me. A step up, more responsibility, and more pay. Everything about this job seemed right from the very first interview, there were three, and here I am.

After some small talk, Dave's next words are awkward. He wants to tell the staff and community something about me, my background, my personal life, some kind of introduction. I'm forcing him to pry because I have not offered any personal details—a customary gesture when new to a district. His apprehension indicates he knows something about changes in my personal life, but he's not sure. Embarrassed by the crack in my voice, I tell him I am recently separated. He apologizes. We agree on language to use. We'll highlight my work experience, state that I have two grown children, and make no reference to my relationship status. He asks if there is anything I need, anything he can do to help with my transition. I assure him

everything is fine, that I am happy and excited to be working here in Irvine. He's glad I'm here too.

Hanging up the phone, I wonder what he would think of me if he knew the unsavory details of the last year of my life—the shiny new principal pretending to be a person of integrity and strong character. Instead, I am a woman who cheated on her husband. So clever as I ended my marriage before Alec ever discovered the truth. What would my new boss think of the real me? What would anyone think?

I rest my head on my folded arms and close my eyes. I've taken words Catherine told me in confidence and used them against her. She's unhappy in her marriage, sick and tired of Eric and his moods. I'm justifying my behavior. Cheating is exhausting.

Alec had been commuting to Colorado for nearly a year. The business he purchased is in Denver, it made sense to keep it there. He took up permanent residence in early spring after a painful late-night discussion in our kitchen. Hours before his flight to Colorado, I told him I wanted to separate. I unleashed every resentment, every hurt he had ever committed. Once I started, I couldn't stop. Bawling, I told him I was tired of the financial instability and uncertainty. Never getting ahead, paying for his business expenses, and now his apartment in another state. The burden was too much for me. The kitchen where we once entertained friends, shared wine, food, and laughter was cold and sad. There was nothing left of those happier days.

I took a break from my litany of grievances and waited for some response. His jaw clenched; its muscles twitched. His eyes cast downward. I could not read his face. Slowly he lifted his head, and I saw the weight of his sadness and maybe his exhaustion too. He always said responding to my emotional

needs was a lot of work. After a few tense moments, he made a sincere and quiet plea; he would do anything to make our relationship work, anything. He said I was important to him. I shook my head. There was nothing he could do. I was done.

I needed the answer to one more question: "Since you moved to Colorado, you haven't initiated sex with me once. Do you know it's been an entire year?"

"It would have helped if you had shown interest."

My mouth hung open in disbelief. His silence indicated surrender, not even he believed his bullshit answer.

The truth is once I started having sex with Eric, I never initiated sex again with Alec. I never reached for him in the dark, never wished for his touch, but always felt his rejection. I used that negative energy to fuel justification for my affair. He never noticed or cared about my loss of interest in intimacy or even steamy, hot sex.

Because Alec was clueless about the affair, I deemed our split a clean break. I hadn't complicated the end of our marriage with any messy drama. As far as Alec knew, I had merely had enough of his escapades, and that was certainly true as well. We agreed to work things out civilly. In a weak moment, he even said I could have the house, conceding that I had been paying for it anyway.

He left for Colorado early the next morning with no plan to return. We hugged for a long time, and I cried and cried. In his matter-of-fact way, he told me to calm down; it wasn't good for me to be so upset. I know he cared about my well-being, in his way. I had been a good business partner, which was worth something to him. Since then, I've been regularly shipping his clothes and other belongings to him and giving away or selling the things he no longer wants. The next step will be filing for divorce.

Eric provided a safety net of sorts, making it easier to end my marriage. Though he has no plans to leave his wife, our limited time together prevents me from being completely alone. I can live with that for now.

I get up from the conference table and survey my office. Elementary school principal—another career milestone achieved. I am true to my professional path, so sure of my way. And yet I am a complete mess in love and intimate relationships. I open another box.

CHAPTER 12

November 2006

Driving in circles, I summon the parking angels. A space opens, and I nab it. Racing into the lobby of the hospital, I see them. Two lone figures sit huddled together in the otherwise empty waiting area: my parents, small and fragile in their sorrow. Dad's head rests on Mom. She is tucked beneath his chin, against his chest. Wadded tissue in hand, her eyes swollen from crying, she wipes her tears. My heels click against the tile, and Dad looks up. He swallows hard and takes in a deep, sharp breath, holding back tears. Mom follows his gaze, and I see the anguish of her heart.

Their first words are to tell me I should not be missing work. They try to convince me that running an elementary school is more important than Mom's newly diagnosed cancer. The notion is ridiculous, but that's the way my parents think. They don't want to burden me. I force a laugh and tell them this is where I belong.

Holding Mom's hand, the three of us sit in silence, absorbing the magnitude of today's news. I have never been this close to cancer in my life. I replay the events of the last few

hours, days, and weeks inside my head, searching for answers. Less than an hour ago, I took a phone call in my office. A short silence after my hello and then my sister Mary's tearful voice.

"Christine, Mom has cancer."

"Where are Mom and Dad right now?" I asked.

"They don't want anyone to come."

Fuck that. I'm going.

Driving to the hospital, I recalled Mom's complaints of bloating and gastrointestinal issues. The symptoms were not terribly unusual for her, particularly in the last couple years; irritable bowel seemed to be the problem. We were concerned, but nothing set off any alarms. In hindsight, the cancer clues seem glaring, especially the last two weeks. We kids and Dad were hell-bent on going to Vegas to celebrate Thanksgiving. Mom protested; she wasn't feeling well. We persisted, convincing her that her stomach bug would pass. In true Mom fashion, she acquiesced, not wanting to disappoint us or disrupt Thanksgiving.

Throughout the weekend she needed quiet places to sit or lay down. Her stomach distended, she had to unzip her pants to get relief from the pressure and the pain. The doctor had taken some fluid from her abdomen earlier in the week. We assured her that a remedy would be found, and she would feel better.

No amount of looking back will change today. We can only move forward. So, I ask, "What's next? What do we do next?"

Mom shows me a small piece of paper, the name of an oncologist. She'll be admitted here for a day or two, and a specific diagnosis will be made. I look for Dad's reassurance. He is silent. I realize my sisters, my brother, and I will be the strength and courage our parents need in the difficult days that surely lie ahead. I kiss them and tell them I love them.

I hope they understand they can lean on their children now.

Too late to go back to work, I call Eric. Tearfully I tell him about my mom's diagnosis. I ask him to share the news with Catherine. "Just tell her I texted you because she never checks her phone, and I wanted you both to know as soon as possible."

Even in my grief, I am careful to cover my tracks. Eric tells me to meet him at our usual coffee shop, hidden in a small professional plaza, a place where we are invisible to the world. The hospital parking lot empties around me. I watch and wonder if others have received similar news today. I am angry about the unfairness of Mom's diagnosis. I want her to have enough good Karma points to receive the Get out of Cancer Free card. I suppose God doesn't work that way, though I have no idea how God works. I've spent most of my adult life questioning His existence, His power, and His will. Faith was so easy as a girl. Prayers were simple: I only asked that God not let anyone in my family get sick or die. When life got complicated and prayers went unanswered, I lost faith, and my way.

During the sixteen years I was with Alec, I worked hard to be a good person, mom, and wife. I never returned to Sunday Mass, but I found my way back to my old self, my integrity. It wasn't easy. Alec could be such a dick at times, short-tempered and unkind. I half-jokingly called it his default mode. When I got frustrated with his brutish behavior, I'd complain, "Knock it off. You are fucking up my Karma!"

He'd laugh it off and reply, "Oh Christine, you do enough good for the both of us."

In Alec's experience, this was true. Up until our end, he had not seen me any other way. He knew first-hand that I gave second and third chances, and in some cases, too many

chances. I was always willing to help, love, or forgive one more time. Good deeds, public service, and clean living were the best way to refill my Karma bank.

Until Eric.

It's impossible to reconcile my compassionate heart with willful behavior that could surely crush another woman and her family.

I have not completely given up on God, and I hope he hasn't given up on me. I beg him to overlook my mistakes and save my mom. I tell him that the strong faith of Mom and my siblings should be enough to heal her. I start my car. Eric is waiting.

February 2007

For more than twenty-four hours, no calls, no texts, not a single message from Eric. No doubt, Catherine has found out about us. I imagine their confrontation, Catherine peppering Eric with questions. I flash back to Catherine's fiftieth birthday party a week ago. In hindsight, it's easy to identify all the signs that the walls around our secret affair were beginning to crack.

At first, I wasn't going to attend her party. I had been creating distance between us, friends drifting apart. But my desire to socialize with mutual friends and Eric's encouragement drew me in. Catherine's greeting was chilly, her mood morose. Any time Eric came within a foot of me, she raced to his side, leaning against him, touching him affectionately in ways I had never seen before. All the while, she looked straight at me. I pretended I had nothing to hide. I fought the urge to take responsibility for their damaged relationship. I was not the cause of their problems.

❋❋❋❋❋❋

The sun sets while we sit in the outdoor patio. Warming my hands on the hot cup of decaf, I listen to Eric lay out the details of our unraveling. A couple weeks ago he neglected to delete a string of text messages between us. While he showered, Catherine checked his phone and found the proof she needed. She suspected an affair, but she never suspected me. She held her cards closely, sought the help of a therapist, and confronted Eric with the evidence and a plan to save their marriage. Teary-eyed, quietly and slowly, he tells me he agreed to ending our affair and all contact with me. He was going to marriage counseling and staying with his family.

He didn't choose me. He said he loved me more than anything; still, he didn't pick me. Blowing my nose and wiping my tears with a snotty, mascara-smudged napkin, I look away. Eric takes my hands, holding them to his lips. He kisses my fingers and says, "I'm sorry."

My car on autopilot takes me directly to my parents' house. A stop I make nearly every evening since Mom's diagnosis, stage three primary peritoneal cancer. I enter their home like any night, smiling and cheerful.

Here with Mom and Dad, I feel the unconditional love of my longest and most successful relationship. I check on Mom first. She is in bed, saying her prayers. I ask how she is feeling and the latest side effects. She doesn't hide her discomfort. I tuck her in, kiss her goodnight, and go downstairs. Dad is pensive these days, always alone working in his study. I wander in and try to kiss the worry from his face. Impossible.

On my way home, I cry because Mom is in pain, because Dad is so damn sad and powerless, and because I continue to make stupid mistakes.

I open my front door; the house is dark. I don't bother turning on a light, and I climb the stairs to my bedroom. The sound of my boots hitting the marble floors echoes, emphasizing the hollow in my heart. I fall into bed and leave the weight of this day behind me.

Waking in the middle of the night, I search for my phone in the darkness, hoping for a message, a change of heart. Nothing. I read old texts and imagine that mine have been deleted from his phone, part of the deal: a clean break and fresh start with his wife. I beg for sleep to end the torture of my grief. I ask God if today's news, the end of my affair, will change anything. Can my mom please be part of the 50 percent that live for five years after diagnosis? Can she have a miracle, please?

Awake before sunrise, I am disoriented; yesterday's events come into focus. I need a shoulder to cry, but who? During my affair with Eric, I spent little time with girlfriends. When I did see them, I limited our talks to my pending divorce and pretended to have sworn off men. Weighing options, I decide to keep my secret. It's possible Catherine never tells a soul, and no one ever learns the truth.

<p style="text-align:center">❊❊❊❊❊❊❊</p>

My friend and neighbor Teri sits with me in my parked car. My shoulders shake, my sobs uncontrollable. She begs me to tell her what is wrong. "I can't tell you. I can't tell anyone. You'll find out soon enough, and you won't be my friend anymore."

"Christine, there isn't anything you could do or say to stop me from being your friend. I'd do anything for you. Anything— I'm your girl. You can tell me. I won't judge you. Honestly, I hate to see you so upset. Sweetie, please talk to me."

Since Catherine's party, Teri had been chasing me down to have dinner. I avoided her. She and Catherine are close now. I had introduced them a couple years ago. Now I wasn't sure if she was genuinely worried about me or fishing for information. She had to know. Testing the water, I say, "You probably already know, anyway."

"Know what?"

Emotionally exhausted and tired of hiding, I tell her everything. "I never planned for any of this to happen."

I justify my mistakes by pointing to the cracks that already existed in Eric and Catherine's marriage. I tell her I understand if she wants to end our friendship. I had put her in an awkward position. Sucking in a huge breath, the weight lifted off my chest, I wait for Teri's judgment and disapproval.

Gently holding my hand, she tells me about her faith and how prayer has helped her through difficult times. She assures me that I am loved and will be forgiven by God. The words are not new to me, but they are not for me. These are words for other people, faithful people. I give a nervous laugh and tell her I lost my faith a long time ago. God stopped answering my prayers. I tell her I am in charge of my life, and I decide my fate, not God. I will not be a hypocrite, turning to God when I haven't been faithful. She smiles and shakes her head, telling me simply that I don't have that kind of power; no one does. She assures me that this mess will work itself out, everyone will survive, and maybe all of us will be better for the experience. I want to believe her.

❊❊❊❊❊❊

Weeks pass, and I immerse myself in work. I'm a good principal. My days are filled with problems I can solve and tons of little

victories. I am dedicated to service. It's never easy and always rewarding. On most days, I am proud of my accomplishments and able to escape the burden of guilt.

It's the nighttime, the darkness, that I find impossible to manage. My brain works overtime sorting through a stream of negative thoughts and useless wishes. I fight anxiety, toss, and turn, unable to sleep. My phone rings, late for a call. My heart races. Is Mom okay?

"Eric" appears on the small lit screen. I answer with a questioning hello. He quietly replies, "Hi, sweetie."

He is on a business trip and wants to know how I am. I don't want to talk about us. Instead, I give him the latest news about Mom's progress. He reminds me that he is on the email distribution for her regular health updates. I never deleted him.

I ask him how things are going for him, at home. He is following the plan, and says his heart isn't in it—the marriage or the therapy. But he promised Catherine three months, and he is committed to following through. He professes his love to me, and I stop him. "I cannot be an occasional late-night call or your escape plan. If you're going to leave your wife, you need to leave because you want to end your marriage, not because you are running to me."

And then I ask, "If I got hit by a truck tomorrow, would you still leave Catherine?"

He is quiet. I tell him, "I have to move on."

"Please. Don't."

❋❋❋❋❋❋

Eric's voice is weak, barely audible on the phone. I end the call and run the seven blocks to his new apartment. The door

wide open, I push past the boxes in the entry to find him, head hanging, standing in the middle of the empty living room. His phone in hand, he hasn't moved since I hung up. He tells me that saying good-bye to his kids and walking out the door was the saddest moment of his life. He underestimated their reaction and the pain it would cause him. I go into rescue mode and offer a litany of comforting words and phrases. I cannot console him. I am not surprised by his utter heartbreak; his relationship with his kids has always been a source of happiness for him.

He is sure they will never forgive him for hurting their mom, for leaving their family. I don't try to convince him otherwise. That outcome is a possibility, and I don't want to give him false hope. I'm afraid to ask him if he thinks he has made a mistake. I change the subject and ask if I can help him unpack or clean. He shrugs his shoulders, walks toward the boxes, and starts to unpack. I grab cleaning supplies and do what I do best.

❋❋❋❋❋❋

Slowly, Eric and I make our relationship public. Swift excommunication from his family and friends came as expected.

Friends Catherine and I once shared bolted to her side. Their silence spoke volumes. Even Teri, who had pledged her allegiance to me that night in my garage, had cut me loose. I had crossed a line. Apparently, cheating with a friend's husband was forgivable, but the actual breaking up of a marriage was not. She had said God would forgive me—she never said she would. Now when we pass each other to get our mail or take out the trash, she doesn't even look at me.

I struggle to understand why friends who have abandoned me make an effort to stay connected to Eric. Teri even sent him an email saying she missed his friendship. And when Eric goes to his former home to celebrate birthdays and holidays, he is welcomed by these same friends. It's as though I am solely responsible. I know the drill. I let those friendships go and cling to Eric.

My own family and close friends are a mixed bag of reactions. Some keep their opinions to themselves while others shake their heads and say, "What the fuck, Christine? Eric?"

None have cut me off. All quietly accept Eric into the fold. They see him look after me during this difficult time with Mom. My parents ask few questions. For a split second, they may have wondered how it all happened. But in the grand scheme of things, Mom's cancer and her treatment consume their lives.

As for Eric, he lives in a constant state of guilt. He juggles keeping me happy, salvaging his relationship with his kids, and maintaining civility with Catherine. Thirty-five years of marriage doesn't end quickly or easily. She hangs on, using any excuse to keep him close to home. I give Eric the space he needs to manage this new territory. It's easy.

Preoccupied with Mom, I join my siblings in carefully monitoring her success markers and keeping hope alive. I don't have the energy to defend my honor. This scandal will blow over. Eventually, the Eric and Christine story will be old news.

CHAPTER 13

2008

Tomorrow is Dad's sixty-ninth birthday. For years he dodged any celebration, usually planning a business trip or a getaway with Mom. As a child, I didn't understand his avoidance. Later, I wondered if it was because he didn't want his children to honor him out of obligation. He had been a tough dad. Quick-tempered, his angry outbursts and profanity-laced rants were not uncommon. Growing up, I worked hard to win his approval and stay in his good graces.

I remember an evening at the Shell Harbor house years ago. My parents, Susy, Mary, and Nick had just returned to California after living in Oregon. I was telling a funny story and noticed Dad smiling, amused. He said, "Christina,"—as he often called me—"I had no idea you were so animated."

To which Mom replied, "Orlando, meet our daughter Christine."

During that seven-year separation from my family and Dad's powerful force, I had come into my own. I had grown up to be myself. Mom told me later something Dad said to her, "Judy, the kids are so close to you. They share their interests

with you and come to you with their problems. They don't come to me."

Mom replied in her gentle way, "Orlando, you criticize them, their decisions, their ideas. What do you expect?"

She said he really listened. I pictured him, small nods in agreement, biting his lower lip—a habit we share. Dad didn't change overnight, but he did change. For me, it started with screaming matches without fear, then civilized discussions and agreeing to disagree, and finally genuine admiration for his wisdom. I sought and appreciated his advice.

In more recent years, Dad has softened. He allows us to honor him on his birthday though he still prefers a celebration without gifts. His only wish is that his children and grandchildren gather to share a meal, usually prepared by Mom.

With Mom so sick and all of us involved in her care, it's hard to muster happiness. While my siblings and I talked about how we might celebrate Dad, he had already decided.

Email
Sent: Thursday, January 31, 2008
Hi All, I would be grateful if we let my
birthday pass unnoticed. Love/dad

Sent: Friday, February 1, 2008
Hi Dad, At a minimum, I must say
Happy Birthday and that I love you. As
hard as this is for all of us, I can't begin
to imagine how hard this is for you. I'd
do anything to help you.
xoc

Sent: Friday, February 1, 2008
You are doing it.
L/d

I put my face in my hands and sob.

✿✿✿✿✿✿

I sit close to Mom as she lies on the guest room bed. She is resting, eyes closed; her skin is golden and smooth, bathed in the sunlight that peeks between the tilted slats of the shuttered windows. How can someone so sick, so full of cancer, look so peaceful, so beautiful?

My mind wanders to the more hopeful days in early summer when the experimental drugs appeared to be working. True, there were days when she was exhausted and sick from the chemo, but her lab results showed promise. My routine of dropping by the house every evening highlighted my day. First, kissing Dad hello and then running up the stairs to see Mom. Propped up with pillows, solving crossword puzzles, still able to challenge her mind, she enjoyed all types of wordplay. Looking over her cheaters, she greeted me with twinkling, clear blue eyes. The silver waves that once fell past her shoulders had been replaced by a platinum pixie cut. A hairstyle determined by chemo. Funny, she had always wanted her hair very short, but Dad loved her thick wavy locks. Now we love her short hair, Dad most of all.

During those visits, she spoke of her progress, determined to beat the cancer. While she spoke, I massaged her hands, arms, feet, and calves. She relaxed under my touch. When silence fell between us, I imagined I had a superpower, able to massage the awful cancer from her body. A faithful woman,

a compassionate soul, Mom deserved a miracle. Back then, I believed one would be delivered.

Today, Mom accepts her fate, and I must accept that there is no miracle. Instead, on this dreary February day, I sit holding her hand. The telephone rests between us. It rings, and her eyes open. I answer and set it on speaker. My siblings and Dad are in the doctor's office. I imagine them standing around a desk where the doctor sits, all eyes on the phone. I hear paper, or feet, shuffle as the doctor outlines my mother's declining condition, her current treatment, and hospice. Mom wants hospice. She told us that she is ready to die, but the question must be officially asked, and answered. The doctor asks; Mom replies, "Yes."

There is a brief silence and then the sound of six hearts breaking, maybe seven. Mom doesn't want to leave us.

✽✽✽✽✽✽

My Valentine's Day experiences rarely lived up to my girlhood fantasies. I wanted romantic gestures and proclamations of love played out in written words or thoughtful gifts. But I didn't know how to ask for them. To avoid disappointment, I pretended I didn't care about the romance of the day. Today is no different. And with Mom's impending passing, it's easy.

Eric and I agree, no gifts, no celebrating. Instead, we meet some of his single colleagues for happy hour. As he navigates the end of his marriage, and I finalize my second divorce, we hold up our glasses to toast the bullshit of the day.

On the drive home, I ask Eric to stop by Mom and Dad's. The door unlocked, we enter. Familiar laughter comes from upstairs. Everyone is gathered in the large guest room around Mom. Dad stands near the dresser and proudly shows me a

teddy bear dressed in a bumblebee costume—a Valentine's Day gift for Mom. She beams, "It is the best and most thoughtful gift your dad has ever given me."

A little embarrassed at having exposed his sentimental side, Dad looks away. An open box of See's candies sits near the bear. Mom can no longer eat, so my sisters and I mash the chocolate into a creamy paste between our fingers and dab it on her lips and tongue. She hums, childlike, savoring its sweetness. We leave her to rest, each of us kissing her good night. Dad stays and lies next to her, two spoons in a drawer.

My sisters and I tidy up, washing dishes and folding laundry. Nearly ten o'clock, Dad emerges from his catnap with Mom. He is driving to Vegas tonight. He asks my brother-in-law, Mike, one last time, if he'd like to tag along. He declines, not this time. We've all done the late-night drive with Dad. He avoids traffic, and we enjoy time alone with him. He's meeting a realtor in the morning. He and Mom own a condo there, and Dad has decided to rent it. Without Mom, he won't stay there again. It's a quick trip, a couple days at most. I hug and kiss him and whisper, "I love you."

Walking toward the door, head down, he shouts one more good-bye to all of us.

Later in bed, Eric and I talk about Dad's sadness, the pain of losing his wife—his partner of nearly fifty years. I drift off to sleep, grateful that we were all together tonight. It's the truest Valentine's Day I have ever experienced, for better, for worse, for richer, for poorer, in sickness, and in health. Mom and Dad shed no tears for the days ahead, expressing only gratitude and love for a life well spent.

❋❋❋❋❋❋

Feeling sluggish, I dress for work. The day is gloomy, dark, and sad. Last night's happiness feels a million miles away. Mom will die any day. These are the emotional ups and downs of disease and dying. One moment I am in awe of my family's incredible strength, and the next I am shaken by our fragility and vulnerability as we break down in weakness and despair. I cannot imagine our family without Mom. None of us can.

At work, my mind drifts. Caryn, a special education teacher, comes in and sits in the chair next to me. We begin strategizing about an upcoming meeting. The phone rings. It's Mary. Between sobs, she manages to say my name. I interrupt her, "I know, Mary. It's okay; I'm on my way."

She cries, "No, no, Christine, it's not Mom. It's Dad. Dad died."

I replay her words in my head, trying to make sense of them. That can't be right. Not hearing a response from me, Mary repeats herself. I don't ask for details. I only say I'm on my way home. Disoriented, I tell Caryn, "My dad died. I gotta go."

Running past my assistant, Pat, and nearly knocking over the UPS man, I shout, "My dad died!"

Pat's confused look begs the question, and before she can ask, I say, "It's not my mom; it's my dad."

Speeding home, I call Eric. He too believes Mom has passed, until I scream, "It's not my mom. It's my dad! Why is this happening? Why is this happening!"

I call Ev, Randi, Michele, and Nili, and repeat, "No, no, it's not my mom, it's my dad. My dad died."

Susy had taken the call from the San Bernardino Sheriff. Asked about distinguishing marks, she described a long ropey scar that ran along Dad's right thumb and index finger. A scar he often showed us as little kids when we cried over what he thought was nothing to cry about, "See this. See this

scar?" He would ask, "When the doctor cut me open, you know what I did?"

To which we would respond, bawling, "Whaaaaat?"

And he would say, "I spit in his eye!"

Sometimes we mustered a tearful laugh; other times, we cried harder. As we got older, we would interrupt his story with pleas of "Daaaaad!"

Then the officer asked about a ring. Susy described Dad's gold and black onyx USC ring, worn since the day he earned his MBA in 1969.

Dad was found at 4 a.m. on the northbound Interstate 15, near Afton Road. When he didn't respond to the patrolmen tapping on the truck's window, they opened the door. He was dead; his heart, broken beyond repair, had stopped beating.

Now, huddled on the patio, Susy tells us to hold hands. We count to three, and the five of us cry out in unison, "DAD!"

❋❋❋❋❋❋

We surround Mom. And while the social worker advised us to keep this news from her, we feel differently. She would want to know; she would want to pray for Dad. Peaceful, she is somewhere between rest and sleep. Susy takes her hand, rousing her, and tells her about Dad. A great sigh fills the room. Too weak for many words, Mom says, "I could cry for five-hundred years. This was all just too hard for him. I prayed he would go before me."

All afternoon I make phone calls to Mom's family and close friends. Nick calls Dad's business associates and family in Italy. Between calls, we gather to compare notes and share words of sympathy and condolences. Over and over, having to say, "It's not our mom. It's our dad."

I call the funeral home. The director begins to discuss the plans we made for Mom. I interrupt him and tell him it's my dad we need to plan for now. I ask if we can have just one funeral, the two of them together. Without hesitation, he grants my wish.

The saddest day of my life ends in my kitchen with Randi, Nili, and Eric. There is nothing left to say. I feel their love and wish for it to relieve my pain. I know it will come, but not today.

Before going to bed, I listen to my phone messages. The quivering voice of a young woman, Deputy Lay from San Bernardino Sheriff's Department. She must speak to me, it's important. Then my friend Gina, her voice cracks, "I am so sorry. I love your family, and I'm praying for all of you."

And then Dad's voice, "Christina, this is your dad. Congratulations. I'm proud of you. If it's not too late, call us. Mom and I would like to take you to dinner."

A message from nearly two years ago, Dad congratulating me on my first principalship. I saved it and have listened to it more times than I can count. No one will ever call me Christina again.

❊❊❊❊❊❊

The house is quiet. Mary and Mom are sleeping. I sneak into Dad's den, find his Mercedes keys, and take it for a spin around the block. The smell of diesel fuel and old leather, the back seat littered with empty Starbucks cups, the only thing missing is Dad. I think of the many evenings Mom and I sat at the dining room table under the dim amber light. One of us stopping mid-sentence to acknowledge the engine's rumble as it entered the neighborhood. Dad would walk through the

door any minute. Several times Alec asked Dad to sell him that car. But Dad always said no.

"It was a gift from my best friend when he died. His soul is in that car."

I say aloud, "Dad, is your soul here with me now?"

Mary is in the kitchen making herself breakfast when I return. "Weird, I thought I heard Dad's car," she says.

I tell her I was driving it. She chuckles and shakes her head. Her mood changes, and she says, "When Mom woke up this morning, she asked, 'Did Dad really die?' I had to tell her, 'Yes, he really did.'"

I spend some time reading the hospice literature, the signs of impending death. Changes in skin and breathing, fewer moments of consciousness and lucidity—yes, all present in Mom. I try to predict her eventual end. Soon, I think. She'll want to be with Dad in heaven. But then, maybe it will take longer as she clings to the family she'll leave behind. Mom thinks that way, and dying cannot change her.

<p style="text-align:center">✽✽✽✽✽✽</p>

Rounding the cul-de-sac, I park along the curb. Resting my hands on the steering wheel, I gaze teary-eyed at our family home of nearly forty years. In the fall and early winter of 1968, Mom and Dad, both twenty-nine years old, loaded the station wagon with us five kids, ages nine, eight, seven, four, and three. We made several visits from our apartment in Lomita to our home in progress. First the foundation, then the frame, stairs that led to a second story not yet complete, and finally a large, five-bedroom, Spanish-style home. We moved in December of 1968. My parents were happy and proud of their first home, in a town they considered ideal for raising their children.

Our happy beginnings are far away. Nearly a week since Dad's passing, Mom still hangs on to life. I run my tongue across my lips, catching the salty remnants of my tears. I dry my face with my sleeve and look in my rearview mirror for traces of sadness or runny mascara. I flash a smile to see if I can look convincingly happy. The strength I gather to put my aching heart aside comes from Mom. Cancer has ravaged her body. I can certainly force a smile.

I tiptoe into the guest room. For a second, I regret moving Mom from her beloved bedroom. But the lower bed made it easier to care for her and keep her comfortable. A mostly finished portrait of me sits on an easel in the corner of the room. Mom began the painting in 1969, when I was nine years old. She also went back to work that year and never finished it, leaving it stored in a closet for decades. When her body was responding positively to the chemo, when we believed she'd win this fight, she asked what I wanted for my birthday. I wanted her to finish the painting, reminding her that only a few details were needed. She agreed. But cancer moved faster than her paintbrush. Unfinished and unsigned, it will be in my home soon.

I lean over the bed, trying to determine if Mom is asleep or resting. I sit beside her and hold her hand, cool and soft. She doesn't open her eyes. I study her hair, its short white wisps; her skin, olive and smooth. I imprint her sleeping face on my heart and soul. Soon, I will never see her again. Her eyes open, and she is slightly startled. I smile and say hello. Her hand relaxes in mine, and we are quiet. Then she tightens her grip and pulls herself up and onto her elbows. Struggling to speak, she asks, "Are you happy?"

Her words are jagged and slow. I don't respond immediately. She stares intently, and forcing the words this time, she asks again, "Are you happy?"

"Yes, yes I am, Mom. Yes, I am happy."

She sinks back into the pillow, her gaze fixed on the portrait now. Waving her hand in paint stroke fashion, she complains, "Your hair is the wrong color. I have to fix that."

I smile, "Mom, it's fine. I love it just the way it is."

Too tired to argue, her eyes close, and she drifts into sleep. I tuck the blankets around her and smooth her baby soft hair. And I tell her I love her. Standing now, I ponder the question. Am I happy?

✻✻✻✻✻✻

All of us exhausted and the end so near, we girls stay the night. Nick heads home to his young family.

I lie in Dad's recliner nearest Mom. Patty sleeps on a cot at the foot of the bed. Susy and Mary sleep in our parents' bed. Patty's snores keep me awake, and I listen to Mom's uneven breathing. Between sleep and consciousness, my body begins to buzz—a steady, low vibration from head to toe. A beautiful swirl of energy envelops me, and I am lifted weightless. I hover near the ceiling. Surrounded by a dusting of light I am sure is Dad, I call to him. He has come to tell Mom it's time. The vibration slows, I slowly float back down into the chair, and I whisper, "Don't go."

✻✻✻✻✻✻

Mom's lungs gurgle and rattle. She frowns, brow furrowed. We wonder when we'll see the hospice nurse today. We need help; Mom needs peace. There's a knock at the door.

A tall, young woman with spiky platinum hair, multiple piercings, and several visible tattoos stands before me. She

smiles and introduces herself, Cara. She is the hospice nurse stepping in for our regular nurse, who is unavailable today. She follows me upstairs, takes one look at Mom, and says, "Gosh, we've got to change this up."

With our help, she creates a makeshift hospital bed. We push pillows between the mattress and box spring to elevate Mom's legs. Her breathing changes instantly, slow and even. Cara says it won't be long now. I'm sure she is an angel.

In the last nine days, Mom could have died any time. Not once did I think I was witnessing her last breaths. Until now. We call Nick and keep him on the phone. All of us telling her we love her, until she is quietly gone. Tears flow, and Mary says, "It's perfect, a Sunday. Mom would have liked that."

✽✽✽✽✽✽

The church is at capacity. It could be any Sunday, but it's not. It's a Friday, Leap Year Day, my parents' funeral. I walk down the center aisle toward the altar and search the pews. Not looking for anyone in particular, I see childhood friends, neighbors, coworkers, guys from the soccer club. So many people loved our parents. I find my place in the first pew, among my siblings and our families. My parents' coffins side by side. There was no viewing; I can only imagine them lying inside. Mom dressed in jeans, a flannel shirt, a suede fringe jacket, and her signature cowboy boots, exactly as she requested. She asked that Dad be buried in a beautiful navy pinstripe suit. She loved him in that suit and thought he would want that too. I don't like that they are separated by wooden boxes, so I picture them in beautiful angelic light, their souls entwined, floating above us all.

Last night I practiced my parents' eulogy with Eric as my audience. He said it was perfect. Now I read it for everyone.

Today, we celebrate the lives of our parents, Judy and Orlando. In honoring them, we would like to celebrate what they valued most—their family. In our home, family always came first. Responsibility for ourselves, our siblings, and to our family was instilled in us from the beginning. I can think of countless times when I would ask my dad if I could go somewhere with a friend. He would always strongly suggest that I bring one or two of my siblings along. While this annoyed me greatly as a kid, the lesson learned was so important. Your brother and your sisters are your friends, they will be the ones you turn to in your greatest hour of need, and it is the relationship you have with them that is most important. He certainly prepared us for what we could have never imagined.

Our dad was strong, tough, and demanding. But behind the tough exterior, he loved his family more than anything. Everything he did, no matter how annoying or intrusive, was done because he loved us so very much. He could never bear to see any one of us sad or hurt. When we were in trouble, he defended us, standing by us, no matter what, because he was our dad, and that was his job. Our dad worked hard and played hard. And when he played, he included us. I remember our dad rounding us up and heading to Edison High School for a game of basketball. Later, it was soccer. His leadership was unparalleled. Whether it was on the basketball court, the soccer field, in

the military environment he loved so much, or in his home, our dad had a commanding presence that everyone admired greatly.

Our mom was more subtle. Guided by her faith, she guided us. If we spoke badly about someone, she would point out the good in them. If we complained about what we didn't have, she reminded us of all we did have. What we all remember most about my mom is how she befriended everyone. She taught us that appearance, money, or things did not make a person special or important. She valued people who were loving, caring, and kind. She had a particular fondness for the quirky and unique. She could find good in everyone and everything. Even when her kindness went unappreciated or unacknowledged, she was not deterred. Her ability to forgive knew no bounds. She gave and forgave because it was the right thing to do, never expecting anything in return, except perhaps to make someone else's life a little better. Her commitment to her family and faith is an example for all of us to follow. We are blessed to have been loved by such a giving spirit.

My dad was bigger than life, an amazing charismatic soul. When he entered a room, he was immediately surrounded by those who wanted to hear his stories and learn from him. My mom was happy to let him have the spotlight, as she was quiet and even a little shy. As much as my dad enjoyed people and places, the place he loved the very most was in the warm hold of my mother's loving eyes. She was his soulmate, his angel, his

home. My parents' passing says so much about their great love for one another. Together since the age of nineteen, they would have celebrated fifty years of marriage this September. My father told many of us he couldn't imagine life without our mom. We are grateful that he never had to. They belong together.

> *We are so proud to be their children, so proud to be what they called their greatest accomplishment: a strong, loving, and loyal family. When we were all very small, my dad would let my mom sleep in on Saturday mornings. Using the oven, he would make us big trays of cinnamon toast. When we finished eating, he would tell us to wake up our mom by smothering her with kisses. All five of us would run down the hallway to her bedroom, jump on her bed, and proceed to smother her with lots and lots of kisses, kissing her everywhere, until she couldn't take it anymore. I believe that when my mom finally found peace, she was received with open arms by my dad, who then smothered her with kisses.*

My nineteen-year-old niece Jamie follows with a scripture reading. Then my eight-year-old niece Siena reads another with her dad, my brother Nick, at her side. Their voices strong without a quiver.

Father Christian speaks of my mother's devout faith and my father's strength. Then he reads a beautiful poem written by Dad for Mom after her diagnosis.

> *OCASO OSCURO EN BAJA*
> *The autumn Sun off the port bow*
> *sinks through the haze of an opaque horizon,*

as a frigid Moon at nine o'clock,
by a jaded Venus tailed,
labors to win the waning lights of Day.

Punta Esperanza barely beams ahead
for two troubled souls by troubling cares distressed
numbly imbuing the gloom of the sunset.
And as we drift untested in this uncertain Sea,
by melancholy assailed and by nostalgia seized,
with trembling heart and teary eyes I plead
that for a little longer He may let you sail with me.

In the days before the funeral, we kids had gone through our parents' belongings, finding a small spiral notebook of our mom's poems and musings, along with other poems Dad wrote—the tenderness of their relationship revealed as we uncovered their most personal possessions.

The final hymn plays, the caskets leave the church, and we follow. If not for the constant dull ache in my chest, I would think my heart had simply left me to find solace in a less painful place.

A twenty-one-gun salute for Dad. My sister Patty receives the folded American flag. Placed in her lap, she rests her hand on the stars and gives a sad, proud smile. Dad would have loved the tradition of this ceremony. I hear mariachis nearby. Looking over my shoulder, I see they are playing for a service across the way. I smile; our parents would have seen humor in this.

✸✸✸✸✸✸

My sisters and some girlfriends shout my name from the kitchen, and I see a bottle of Tequila held high—the rallying

cry for celebration and drowning our sorrows. Shots are poured and I take two, welcoming the alcohol's burn. I move into the dining room and sit at the table with Brenda, Mom's dear friend. She was close to Dad and planned to help him through Mom's death. She lets out a teary laugh and says that Dad loved to be in control, and his death was no different.

I find Eric on the stairway and sit next to him. I rest my head on his shoulder, and he pats my knee. I consider taking off the heels I've been wearing for hours. A familiar voice gets my attention. Judy, one of Susy's childhood friends, greets me. She has lived out of state for years, but she comes around once a year or so, usually Christmas. I introduce her to Eric, and after some quick catching up, she asks, "So, how did you two meet?"

Eric and I stumble over our answers. Given the notoriety of our story, we haven't had to explain it to anyone. But Judy doesn't know. I am casually vague, hoping that my words fade into another topic. But she presses, genuinely interested. For the first time, I realize that it's not a story I want to share.

Nili swoops in with more tequila, and I am saved. We hold our shot glasses high above our heads and toast my parents once more.

CHAPTER 14

Summer 2008

Mike drives the rented van, Mary sits shotgun, and Eric and I sit behind them. Our cross-country road trip is winding down. We spent a week in Wisconsin visiting family and then hit some tourist sites as we headed west toward home. Mount Rushmore, Deadwood, and the Badlands were amazing places Eric and I had never been. As we embarked on this trip, I imagined this experience would be remembered fondly as the beginning of our life together.

But right now, the car is filled with quiet tension, and my stomach is in knots. Eric has taken a call from Catherine; we all listen as there is nowhere for him to go. She tells him about some unpleasant task she had to handle in his absence. Not an emergency, but a reason to call, I guess. I can only hear his side of the conversation. Even though he whispers and mumbles, responding with as few words as possible, he is unable to hide the caring in his voice. He is sorry he was unable to come to the rescue. He finds his worth in fixing people and things. We are alike that way. He quietly thanks her and ends the call. He sighs and stares at his cell phone. I'm sure he wishes he was

home being the man of the house, the guy who takes care of his family.

The last six months have been rough for us. On the evening of my parents' funeral, Eric spent the night with me and never slept in his apartment again. The following month, he lost his job. Renewing his lease didn't make sense. Money was tight, and he wasn't living there. He moved in with me rent-free, at least until he finds another job. This arrangement has created more tension between him and his family. His kids won't come to my house, so he visits his former home, often.

Between grief and anxiety, I force a smile and act as Eric's eternal cheerleader. He is passed over interview after interview, and he is moody and depressed. I tell him repeatedly that everything will be okay. I'm not sure if I'm trying to convince him or me, and I am exhausted by the constant song and dance. A road trip seemed like a good idea, a way to forget our troubles and lift our spirits. Sitting here in silence as we traverse the country, I'm not so sure.

I think about a conversation with my neighbor Rick a few weeks ago. Drink in hand, he stopped me as I was coming in from the garage, walking between our two houses. He asked how Eric was doing with the job hunt. I was brief and positive with my reply. He gave his drink a swirl, ice cubes clinking against the glass. Lifting his head, he chuckled, "Woman,"— he liked to address me that way—"You ruin men."

Taken aback, I didn't respond. Did he think I ruined Alec? Did I? I shrugged my shoulders, gave a weak laugh, and headed to the front door.

I brush aside the discomfort of the memory and look at Eric. I cannot read his thoughts as he stares out the window at the vast western landscape. Rick's words replay in my head. I feel responsible for Eric's unemployment. Our affair took a

toll on his focus and drive. All the drama distracted him from doing his best work. Did I ruin Eric too?

�??�??�??

The first Christmas without our parents, we move through the festivities like zombies. I watch my siblings as they are supported by their spouses on this significant and difficult first. Eric left this morning to be with his family. I'm embarrassed by his absence.

The sun sets, the sky darkens, and I am alone. I'll never come first in his life. The front door opens, and he steps inside looking guilty—guilty for wanting to be with his family and not me.

2009

In the darkness, my chest tightens. Overcome with feelings of doom and loss, I bolt out of bed and pace the length of my bedroom. Unable to catch my breath, I run out onto my balcony, desperate for fresh air to fill my lungs. I lie on the chaise lounge and look to the moon for her calming glow. Desperate, I plead with God to help me breathe, repeating The Lord's Prayer and Hail Marys over and over. I talk to Mom and Dad and beg them to intervene as my angels. I crave the light of day. Eric checks on me, worried about my mental state. My anxiety is out of control.

The episode escalates, and I fear losing my mind. I rush back inside, find my purse, and empty its contents. The recently prescribed Xanax tumbles out. Hands shaking, I manage the childproof cap and take my first dose. I had been reluctant, sure its side effects would cause more damage. My

therapist said I would feel relief in a half hour or so. I count the minutes, and slowly calm finds me. My breathing becomes regular, deeper, and my body relaxes. Irrational thoughts slowly disappear. I climb into bed and cuddle up to Eric. He reaches for my hand. And for reasons I cannot explain, I ask him something that has been eating at me. "Do you ever feel like going home?"

He whispers, "Yes."

I knew he was unhappy, a kind of unhappy I could not fix with pep talks and good sex. Besides, my current mental state had been eating away at my rescuer qualities. It was impossible to save him as I was trying to save myself. This year following my parents' death had broken my spirit, my will to love someone into happiness. I want to continue the conversation, but the Xanax is working its magic. Emotions numb, eyelids heavy, I fall asleep.

❊❊❊❊❊❊

A little groggy, I dress for work. Eric sleeps. Last night's question and his answer come into focus. I cannot pretend the conversation never happened. Since discovering weeks ago that he stopped his divorce proceedings, I have not been the same. He doesn't know I know. We've never had a secret between us. I did discuss it with my new therapist, Dr. Green, who pointedly asked, "So, what are you going to do?"

"Talk to him, I guess."

I will see Dr. Green in a few days. Always the model student, the overachiever, I must return to my next session with a report of good progress.

So, this morning, I press Eric. Perhaps his answer last night was spurred by my anxiety. Before I lose my nerve, I

sit on the edge of the bed and touch his bare shoulder. He turns toward me, wide awake. I ask, "Do you really want to go home? Because if you do, you should go."

Tears well in his eyes. He says nothing for a very long time. I have my answer. Still, I wait for his words.

Finally, he replies, "I think I just needed someone to tell me."

I remember him telling me about the day he left Catherine. Wincing as he described her face and her pain, he said she looked as though someone punched her in the stomach. Today I am her. The punch is returned with vengeance.

I resent his weakness. I'll stay with friends until Sunday, giving him the whole weekend to get his shit out of my house. My head spinning, I throw together an overnight bag. All the while, I want him to shout, "Stop! Let's talk about this."

He doesn't. He just lies there, crying. I make a last attempt to gain his sympathy, to change his mind. I want him to understand all I have given up for him: a marriage, friends, huge chunks of my character. Hearing my pathetic tone, I stop begging. And Eric speaks, "I know I'm probably leaving the best thing that ever happened to me, but I have to go."

I snap. "It took you two years to leave Catherine. Then you got an apartment, and it took you another year to move in with me. You've been here eight months, *eight months*, and you are running for the door! Your heart was always with them."

I speed to work, swearing at drivers and blasting my horn. Angry tears burn my face. I am sick and sad, pissed off that I invested in something I had to know would fail. I did this! I chose this! I deserve to be left behind.

Entering the school neighborhood, I slow way down. I pull into my parking space and regain my composure. The campus is buzzing with activity; it's Friday Flag Deck. In minutes, I

will face seven-hundred smiling students, parents, and staff in our weekly celebration of pride and school spirit. Students honored for showing responsibility and integrity will join me on stage, and I'll shake their hands. And maybe, for the first time, I can do so without feeling like a hypocrite.

❀❀❀❀❀❀

Dr. Green suggested that I volunteer my time helping others to get out of my head, to stop ruminating about Eric. He stopped short of saying I was feeling sorry for myself, but I knew I was. It was time to move on. The Friday Night Fun Time Dance came up in my internet search. Unlike other inquiries I had made, there was no interview and no application to complete. A willingness to help was the only requirement—something I could do.

The community center looks the same as it did when I was a teenager. It was never my hangout, but I did play racquetball here with Dad. In the lobby, several volunteers prepare for the dance, hanging decorations and setting up tables and chairs. A few guests have arrived early. They are adults of all ages with intellectual and physical disabilities. They come to dance and socialize on the third Friday of every month.

I pop my head into the central office and ask for someone named John. We spoke on the phone a few days ago. He assured me I would love working at the dances.

A handsome, silver-haired guy jumps up from his chair. He smiles, "I'm John."

He introduces me to Delores. She started the dance years ago for her son Martin and his friends. Chaperones are needed to help with check-in, collect the two-dollar admission fee, and serve refreshments—donated day-old donuts and fruit

punch. I meet her husband, Joe; her daughter, Yvonne; and son-in-law, Chris—all of them volunteers. I'm given quick instructions and put to work. Guests write their names and phone numbers on a list and are assigned a number. I am to write that number on their hand in marker, a safety precaution. I select an orange marker and get to work.

For the next thirty minutes, I help men and women aged eighteen to well into their fifties sign in. Some can complete the task on their own, smiling broadly as they push their hands toward me to receive their number. Others pull small, folded pieces of paper from their wallets and copy what someone has written for them. Some need my help to spell their names or even write them. As I mark their hands with numbers, I say, "Lucky number twelve!" Or "Lucky number forty-three!"

No matter the number, I always say it's lucky. A few of them notice that I am a new volunteer. They ask my name and say I am pretty. Some welcome me with a bear hug. Then the music starts, and everyone dances. They invite me to dance too. Midway through the evening, the lights are turned on. I serve refreshments with the other volunteers, many of them parishioners from Saint Simon and Jude. One couple's daughter grew up with my sister Mary; they knew my parents. I meet a gentleman in his eighties, Frank. He charms me with compliments and captures my heart as he tells me about the recent loss of his beloved wife. I'll come back. This is exactly where I need to be.

CHAPTER 15

2009

Sandy's bar is noisy and crowded. I spot my girlfriend Lori first and then the rest of the gang comes into focus. She planned this happy hour of old high school friends. Before I am noticed, I size up the crowd. Hard to believe we'll all be fifty next year. The women wear sundresses and faded summer tans, the guys in shorts and flip-flops. My casual Friday attire feels stiff. Now I wish I hadn't come straight from work. Oh well, I'm here now.

I'm the last to arrive, and the party moves onto the patio, perfect on this warm autumn night. I sip a fruity umbrella drink while high school tales are recounted. We are familiar, and uncomplicated. And I realize I am happy. My cold, achy heart of last winter has melted. It seems sudden, but it was nine months of healing. Weekly therapy saved me, as did prescribed anti-depressants that I slowly weaned out of my life a few weeks ago. I am more myself, the fog has lifted, and my priorities have changed too. Family and good friends come first. I value the integrity and longevity of these relationships. My life is clean, no stories to hide. When people ask what

happened with Eric, I tell the truth. "He missed his family. He missed his life. In the end, he realized he loved them more."

It's an honest answer. I no longer see him as weak. It took a lot of courage to leave me, to go home. I did see him once or twice after he left. There were lingering texts. He was checking on me, to ease his conscience, perhaps, or feed his ego. I'm not sure which, but his messages left me feeling awful. One day I decided to stop the slow, painful pull of the Band-Aid, and I ripped it clean off. I deleted every email, threw out every card and letter, and left the past behind, no more contact. Without communicating my plan, he somehow got the message. Or maybe he had decided to do the same. Either way, he stopped calling.

Glasses empty and appetizers finished, we head upstairs to Duke's for another round. Susy, Michele, and I sit together at the end of the crowded table. I'm distracted by a guy watching me, smiling. I maintain the conversation with the girls, but my brain works overtime to place him. His confident stride tells me he's an old friend. Ah, it's Jake—a brief boyfriend, freshman year of high school. I stand, and before I can say hello, he pulls me in for a tight bear hug. He is tall, strong, and handsome as hell. He relaxes his hold on me and greets the others. Grabbing a nearby chair, he forces it into a too-small space, right beside me. He looks healthy, says he gave up smoking, and jogs regularly now. A significant change since I saw him last—twenty-plus years ago at our high school reunion. He was a mess, high on I didn't know what.

We catch up, count divorces between us—two apiece—and clink our glasses. He jokes, says he spied me as the only woman in the room without a ring. I give him shit about dumping me in high school to go back to his previous girlfriend who was a bit more experienced than me. He tries to deny it, but I won't

let him off the hook. Under the table he moves his hand, slow and deliberate, along the length of my thigh.

Happy hour is long over; Michele, Jake, and I walk along Main Street to our respective cars—only Jake doesn't have one. He asks for a ride, says he lives nearby. I reluctantly agree and ask Michele to tag along. I want to avoid the whole kiss goodnight thing—ugh. But she is not reading my facial or intonational queues and declines. I'm on my own. In ten minutes, Jake and I are sitting in front of his house. He says, "Come inside."

I shake my head, "I've made a lot of mistakes, and I don't want to make any more. I think you've got something in mind, and I'm not ready for it."

But I can't resist his flattery, or his sexy good looks, and he gets his way.

A small studio, his place is tidy and modern. We lie on the sofa, and before long, we are making out high school style. We take things slowly, until we don't. I give in to physical attraction and months without sex and decide to write this off as a one-time thing. I want to have fun, to enjoy myself. We've already declared that neither of us is looking for anything serious.

I excuse myself to the bathroom. The toilet seat lid is down, and there is a note on it. A woman's handwriting. I glance at the signature—I recognize the name. I walk out and hand the letter to Jake and ask, "Is there something you want to tell me?"

He takes the note and reads it. "Shit. It's my ex. I've been seeing her off and on. We're not getting back together. She needed some help and one thing led to another. It's nothing."

He waits for a response, and I don't mince words, "Fuck. I don't want to get mixed up in your relationship drama."

and proceed to get obliterated. Seeing it is boys only, I leave him and his crew to their vices and start cleaning. I collect red Solo cups and trash and pile dishes in the sink. Exhausted and too tired to drive home, I head to Daniel's bed and collapse. Much later, I feel the mattress sink with his weight, followed by loud, drunken snores.

❊❊❊❊❊❊

Daniel calls it "fireplace time." Our stocking feet rest on the coffee table. The fire crackles, and we share a bottle of wine and talk. He showed up at my doorstep after a pub crawl. Silly and affectionate, with alcohol-induced courage, he tells me he loves me. He's too drunk to be taken seriously, but there is something else on his mind. He wants to move in with me, to live at the beach again.

Caught off guard, I ask, "Can we talk about this in a few months? After the holidays?"

I don't want to live with him, ever. I want to keep things as they are: casual, separate homes, and sleepovers. I don't have the courage to tell him that he's not my forever guy.

Daniel is too drunk to read my hesitation. He slurs, "Look, I'm a realist. I'll move my things into the back bedroom. That'll be my room. I'll pay rent. When you get sick of my shenanigans, I'll just move into the back room."

Quite pleased with his drunken logic, he flashes a big smile, certain he has convinced me. I change the subject and hope he doesn't remember any of this.

CHAPTER 17

2012

Email
So great to see your name come
through on my LinkedIn.
Would love to connect sometime.
Andy

I read the message twice and let the words sink in. We haven't spoken in more than twenty years. The last bit of news I heard was through a mutual acquaintance about ten years ago. Ed was his name; I bumped into him at the gym. He gushed on about Andy's success, living large, great job, great life, blah, blah, blah. He would be attending Andy's fortieth birthday bash in his newly remodeled Malibu home. Ed didn't ask for any details about my life, and I didn't offer a thing. Instead, I smiled and said, "Please give Andy my best. I am happy for him. And of course, wish him a Happy Birthday. Great to hear he is doing so well."

Now, staring at the screen, I wonder how my name came through on Andy's LinkedIn. When I joined the social media

see drunk Daniel. I cared a lot about what my parents thought of my decisions. I still do.

Making the last leg of the drive through Orange County, Daniel wakes and tells me he had a great birthday. I pat his leg and feel guilty for running breakup scenarios in my head. It comes down to a few simple sentences: "I don't want you to live with me anymore. I want to break up. This is not the life I want."

I convince myself this is more complicated than it really is. I make excuses: The holiday season is coming, and I don't want to be alone. I don't want Daniel to be alone either. I'm not ready to admit this relationship was a mistake. Then there will be the pain of watching him move his shit out of my house. I don't have the stomach for any of that right now. Maybe things will improve. Wishful thinking is always easier than hard decisions.

❊❊❊❊❊❊

Friday, late afternoon, I drive north on Pacific Coast Highway. With winter solstice approaching, the sun is already setting. I look forward to the shortest day of the year; it announces that every day after will be longer, at least until June. I am meeting Andy at The Red Table in Huntington Harbor. He is in Orange County once a month, but it took four months to find a date that worked for both of us. I told Daniel I was having a drink with an old friend; someone I dated a long time ago. If he cared, he didn't show it. He's never been the jealous type.

I spot Andy reading the menu in the far corner of the restaurant. There is no mistaking him. He glances up as I walk toward him. He smiles and seems a bit awestruck, and

that makes me smile too. We exchange a kiss on the cheek and hug. I'm surprised by the familiarity of his scent and its ability to unearth some buried memories, the happy ones. I sit down, and he says, "You look adorable, like always."

Generous with compliments and deliberate with his words, he hasn't lost his knack for making me feel special.

There are no awkward moments. We talk about our work, our kids, and our lives. I gloss over past relationships, hoping he doesn't notice the list of exes. I tell him about Daniel, that we live together. I also mention our eleven-year age difference. As the words leave my lips, I am embarrassed that I shared this detail. Is it supposed to make me seem more attractive? I am purposeful about not mentioning any personal drama, just the highlights. He listens and then says, "I'm sorry about all of that. What happened between you and me."

It seems as though it's something that he's wanted to tell me for years. I brush it off, reminding him that was a long time ago. I change the subject and ask about his wife and married life. His expression changes, maybe a look of resignation, and he says, "I don't know because I'm no longer married."

I reach for his hand, "I'm so sorry."

After twenty years of marriage, there was someone else. He was blindsided, had no idea his wife had been unhappy. I can see he still carries the hurt a year and a half later. And then he says, "I've been in love two times in my life, Christine. First you and then my wife. I'll always love her."

He is the same Andy in all the best ways, only older and wiser. Remembering I told Daniel I would be home early, I tell Andy I have to go. Our time together feels unfinished, but I don't know why. We hug for a long time, and I breathe him in once more. He gives me an extra tight squeeze, like the old days. We promise to keep in touch.

When I arrive home Daniel is in front of the television, finishing a bottle of wine. I know the drill; he'll be asleep in minutes. I'm annoyed. I could have spent more time with Andy. Daniel would have never noticed or cared. Instead, I'm sitting on the sofa, watching crap television. I am quiet, and Daniel asks if I'm okay. I lie, "I'm a little tired. Long week."

The holidays are not a good time to break up.

❅❅❅❅❅❅

On our way to San Diego for a Christmas gathering with Daniel's family, we make a brief pit stop. My elderly friend Frank has been sick, unable to come to the Friday night dances, and now he lies in a nursing home. His son has kept me informed of his condition. It's not good. I navigate Daniel to the care facility and tell him I'll be just a few minutes, enough time for a quick hello and to give Frank his Christmas gift.

I wander the corridors looking for Frank's room. The doors are adorned with silver garland and holly wreaths, others are covered in Christmas cards. Still, the place is sad and quiet, with no sounds of holiday cheer. I tiptoe into Frank's room where he is sleeping soundly. I put his gift on the bedside table and linger. His breathing is very shallow, and he looks terribly small. He had been so healthy this past year, spending last Christmas, Easter, and Thanksgiving with my family. He loved the noise and chaos of our big gatherings. He has no idea I am standing here. I lean down, kiss his forehead, and whisper, "Merry Christmas."

Back in the car, I tell Daniel I'm sure it won't be long before Frank passes. Once you've seen someone die, it's easy to tell when the end is near. I say a small prayer and try to be happy that Frank will join his beloved wife.

❊❊❊❊❊❊

Friday night dances are not the same without Frank. Losing him reminds me that life is too short to waste time with placeholders.

CHAPTER 18

2013

Daniel has a knack for sensing when I've had enough. I don't yell or get angry; I just quietly create distance. He stops drinking for a day or two, and I excuse the disaster he can be. I don't discuss Daniel's alcoholism with anyone, as if not talking about it keeps the details from being true. I delay our inevitable end by shifting my attention to a new project, something else to fix: my son.

Ken's troubles are not new. Recreational drug use in his twenties morphed into an on-again-off-again relationship with meth. He denies he has a problem, and I want to believe him. His girlfriend grew tired of his bullshit and cut him loose. With no place to go, he asked to move home, temporarily. He swears he's clean. I give him a room, rent-free, and a chance to clean up his finances. I set clear boundaries and rules, cross my fingers, and hope he makes the best of this fresh start.

When I tell Daniel that Ken is moving home for a while, his response is less than enthusiastic. He shrugs his shoulders, "He's your kid, and it's your house."

Ken and Daniel have never warmed up to one another. With only a seven-year age difference between them, they behave like mildly tolerant stepbrothers. Now, living in the same house, it doesn't take long for their hostility to grow. Each believes the other takes advantage of me. They're both right.

When I was dating Jake, a friend suggested I attend an Al-Anon meeting. I scoffed, "I am not that girl. I don't have those kinds of relationships."

❊❊❊❊❊❊

I walk the beach trail north toward Bolsa Chica State Beach. My phone vibrates in my pocket, a text from Daniel's friend Monica. She had no idea things had ended between Daniel and me. *So sad*, she says. Daniel's buddies converged on the house this morning to help him move to his new apartment, five blocks away. I text back, telling her I'm sad too.

I don't offer any reasons for the breakup. I don't tell her about the night I came home to Daniel passed out on the couch with the entire contents of a bag of chips emptied on his chest. Or the red wine splashed on the wall and spilled in my bed because he fell asleep with a full glass in his hand. Or about my smoke-filled kitchen, remnants of exploded cooked egg stuck to the ceiling because he passed out while eggs boiled on the stove. The more we drifted apart, the more often I came home to find Daniel in the midst of some drunken disaster.

One night, unable to sleep, I went to the back room where Daniel was sleeping. I climbed into bed with him and cried. It was the end, neither one of us willing to make concessions for the other. A few days later, he called me at work, said I would be receiving a call from a rental agency, checking his

"rental" history with me. He expected to move Memorial Day Weekend.

I slip my phone back into my pocket, take off my flip-flops, and walk in the soft sand toward the shoreline. The saltwater cools my feet. I am content to stay here for a while, avoiding the house until the moving crew has finished.

I cross Pacific Coast Highway and look down Twentieth Street. The truck is gone, no sign of anyone going in or out of the house. Tentatively I open the front door—all is quiet. No indication that Daniel ever lived here. His photographs are gone from the refrigerator gallery. A single house key lies on the kitchen counter. I pick it up and rub it between my index finger and thumb. First Eric, then Jake, then Daniel; no more giving keys away. With the remainder of the long weekend ahead, I wish I had taken Andy up on his invitation. A road trip to Santa Fe, New Mexico, to visit our old friend Kurt may have been exactly what I needed.

Since meeting up last December, Andy had been texting now and then—smiley faces and quick hellos. I responded in kind, no details about my messy life, until a well-timed text arrived on a particularly difficult night. He innocently asked how I was, and for the first time, I was honest. "Sad. Daniel and I are splitting up. It's been tough, but it's the best thing for both of us."

He reminded me to breathe and assured me that everything would be okay. He was right, of course. After that, his communication was more frequent. When I read his text about a road trip to see Kurt, I was so tempted. "Come!" He said, "We'll laugh, we'll cry, we'll tell stories."

Romantic me wanted to go so badly. But staying home to deal with my problems was more in line with my new priorities. No more escaping from one man to another.

A memory comes to mind. Andy and I had just seen *When Harry Met Sally*. Exiting the theater, he turned on his heels and pulled me close. "Christine, it had to be you."

Something brought us back together again, and I want to believe that we are meant to be. But I have work to do.

✳✳✳✳✳✳

Susy and I visit Mary in Utah. I'm having fun, but I'm preoccupied with home. Daniel sends me updates from the US Open of Surfing, something we always did together. I don't miss the teenage summers or the unpredictability of living with a drinker, but I do miss sober Daniel. Unfortunately, it's a package deal.

I fight bouts of anxiety and find temporary relief with Xanax. I consider antidepressants again. Messages from Andy brighten my days. He wants to get together, but I haven't been available. My mental well-being and helping my kids are higher priorities right now. I worry about them constantly, which only increases my anxiety.

My ex Cal has lived with Tara for the past two years. After an ugly divorce and an unfortunate turn of economic events, he lost his home. He landed at Tara's after Luca was born and never left. He helps with the baby but doesn't contribute to rent or household expenses, putting a strain on her marriage. She wants him out but doesn't have the heart to tell him. Hearing the desperation in her voice, my rescue wheels start turning. I offer him a room in my home, *gratis*. I've done the right thing, helped my family, and maybe, moved a step closer to balancing my Karma account. My ex-husband, my son, and me under one roof; a chance at a do-over, I think.

❋❋❋❋❋❋

Snug in the soft leather booth, we share sake and sushi. Andy talks with Mary and Mike, who sit across from us. He hasn't seen my sister in over twenty years and just met Mike tonight. Their children are roughly the same age and all college students. They light-heartedly share the woes of keeping their kids' lives based in reality as they navigate adulthood. Warm, funny, and sincere, I am captivated by Andy, the sound of his voice, and the salt and pepper stubble on his chin. For the second time in my life, I have fallen in love with him. We hadn't planned to see each other tonight, but here we are, meant to be.

Mike and Mary invited me to stay with them in Sunset Beach for some quiet time after the Thanksgiving feast at my house. Andy called this afternoon on his way home from San Jose; he wanted me to meet him in LA for dinner. Instead, I convinced him to come stay with us at the beach house.

Slowly, I've let my guard down with Andy, and I share more personal stuff. He knows my son and my ex live with me, and if he thinks it's weird, he hasn't said so. I don't invite him to my house because that feels weird. We split our time between LA and Orange County, meeting up for movie dates, dinner, and drinks. My physical attraction to him is strong, though we haven't had sex. After breaking up with Jake and Daniel, both were interested in continuing with a purely sexual relationship, booty calls only. I wondered what signal I had given to indicate I'd be okay with such an arrangement. Whatever it was, I did not want to send that message to Andy.

At the house, after dinner, I am nervous because we are going to sleep together. I don't have a plan, but I hope we can continue to take things slowly. In my best underwear, I climb

into bed and curl up next to Andy—same scent, same soft skin. He reaches for me, "You know I've seen you naked?"

Embarrassed, I nudge him, "I know."

I think about the naked young woman Andy remembers; 1989 was a long time ago. He hadn't broken my heart yet. I trusted him. His breathing slows, he falls asleep, and I'm relieved that I don't have to explain any hesitation. Maybe sex wasn't even in his plan. Perhaps he doesn't need a plan at all. He seems comfortable, allowing life to gently unfold.

CHAPTER 19

December 2013

I wait outside the movie theater for Andy. He literally slides into view, hands in the air, and comes to a complete stop right in front of me. He knows how to make an entrance. Straight from a business meeting, his suit impeccable, necktie neatly in place, he grins, and I laugh. The show starts in minutes. Inside we have wine and cheese. I have only one hand free to eat and drink because he never lets go of the other. Is he my boyfriend?

We grab a nightcap at R&D Kitchen. Talking to the bartender, he refers to me as his girl. He says and does all the corny, sappy, romantic shit I love. I don't want our date to end, but it's late, and he has the drive back to LA. When we get to his car, he says he has something for me. He retrieves a small book, *The Prophet*. In our younger days, we poured over its pages together, believing it answered all of life's questions.

There's an inscription: *Christine, You are my Angel. Andy*. Encouraged by his words, I broach the subject of holiday plans. Before I can finish my sentence, he says he'll be busy, first Christmas Day with his daughters and then a cruise to

see the Northern Lights. I suddenly realize that this evening is—or was—our holiday time together. This is it. We kiss goodnight, and he feels a million miles away. I want to shout, "Wait, wait! Don't go. I'm your girl. I'm your angel."

✤✤✤✤✤✤

I sit in my parked car. I'm early to meet friends for drinks. With my phone in one hand and a pink post-it with a list of talking points in the other, I'm working up the courage to call Andy. We haven't spoken since he announced his Christmas plans a week ago, and I've been ruminating ever since. I want clarity. What am I to him? What the hell does it mean to be his angel? The phone rings, and my heart races. His hello is cheery. The quiver in my voice gives away my nerves. I tell him I have something weighing on me. "Tell me, baby, what's on your mind?"

His warmth disarms me, and I open up, "I have really loved having you in my life again. I want to spend more time with you. You in LA and me in Orange County, it's going to take some effort, but we did a good job when you lived as far as San Jose, so I think we can do it again. Right now, we are pretty random about meeting up. I'd like to compare calendars, and you know, make regular dates."

An uncomfortable pause follows. Then his voice, sure and clear, "You are so brave. I respect your courage and your honesty. But you should know I'm dating other women."

Unprepared for his response, I blurt out, "I feel sick. I gotta go."

Without waiting for his good-bye, I end the call. I've been foolish, and now I'm late to meet my girlfriends.

❋❋❋❋❋❋

It's Christmas Eve, and Mary and I walk the trail along the beach. She asks about Andy and the holidays. I clear my throat, "He's leaving town. I won't see him. I'm not sure I'll ever see him again. Seems he's dating. I had it all wrong."

She puts her arm around me, "I don't get it. He loves you."

"I know," I say. "I know."

Andy was never shy about telling me he loved me. Each time, I'd smile, kiss his lips, or squeeze his hand. But I never said it back. Not because I didn't love him; I was guarding my heart.

I spend Christmas Eve with friends, hoping to be distracted by holiday cheer. Instead, I envy the happy couples. I want Andy to call. I'm not ready to give up on the possibility of us.

At home, sitting in front of the Christmas tree, lights twinkling, Mac in my lap, I compose an email. I tell Andy that I love him and that I regret not telling him sooner. I'm not trying to change his mind; I only want him to know. At least that's what I say.

2014

I sit in the far corner of Il Farro, nervously drinking water and wondering if I'm chasing happiness. Andy's response to my email was encouraging. I zeroed in on the words that fit the narrative in my head, the one that said we would be together: "I'm not exaggerating when I say I think about you every day, and I love you." I ignored the missing words, "I want to be with you, only you." I collect my thoughts. I want to succinctly propose the type of relationship Andy and I might have. I don't need an exclusive arrangement. A new year, a new me—I can compromise.

His approach is tentative, and unnatural. But my familiarity is stronger than any reservations he may have about me, about us. In no time, he is holding my hand, comfortable in my presence. Our dishes cleared, Andy empties the remaining Chianti into my glass. More than I can finish, I protest and pour half into his glass. We toast, and he says, "I'm so happy you are back in my life. I truly am. Until I got your email, I wasn't sure I'd ever see you again."

Am I back like a girlfriend back, or back like a friend back, or just back, back? I keep these thoughts to myself as he keeps talking. He opens up about his life after the end of his marriage. He was devastated, crushed. And now, he is enjoying the attention of women. He says this with surprise in his voice. And although these are not words I want to hear, I understand the lure of being desired, especially after being discarded.

I listen and note the clear differences between us, the way we process our experiences. Andy expresses gratitude for all his relationships, even those that have failed. He walks with intention into his future, confident that life will work in his favor as long as he is true to himself. I, on the other hand, cringe thinking about my past; I hang on to regret. Equipped with lessons learned, I tiptoe forward, careful to avoid the landmines as I try to command my destiny.

He tries to control the emotion in his voice, and I ask, "What is it?"

He clears his throat, "You could really hurt me."

I'm confused. Hadn't he been the one who hurt me? I assure him that we can go slow. I can do this on his terms. He'll see that I am genuine. He doesn't say no, and I take that as a yes.

An unusually warm winter night, we walk on the Newport Beach Pier and then wander into Sol Kitchen. A young man

sings and plays guitar, and I whisper-sing into Andy's ear. He points to his cheek, a gesture that takes me back; it's the signal for me to kiss him. And I do. My lips linger. He closes his eyes and hums. Have we sealed the deal? I ask him how it is that no time ever passes between us. He laughs, "It's just how we are. We'll always be this way."

Is he like this with all the women he dates? Does he point to his cheek waiting for their kiss, or do they have some other silly secret romantic cue? Does he make them feel special, hopeful for something more?

✻✻✻✻✻✻

Andy is spending Presidents' Day weekend with an old friend on the Central Coast. He texts pictures from a beautiful winery captioned, "You should be here."

To which I answer, "I wasn't invited."

"Fair enough," he writes.

He keeps me at a distance, occasionally pulling me in with messages like this. I keep my promise, staying casual, no demand for commitment—and no complaining. After a few more texts, he invites me to his house; he'll be home in a few hours.

I walk through the open door and call to him. I look down the hall, and he appears in the doorway of his bedroom, wet hair, a towel around his waist. He is more fit at fifty-one than he was at twenty-six. We meet halfway and kiss. I consider removing his towel. Instead, I pull away, leaving him to get dressed.

The first time I came to his home was last summer. Driving through the Brentwood neighborhood, I felt puny and small, out of place in its opulence. His house, hidden

behind a wall of ivy, was difficult to find. He came outside to help me navigate. When I rolled down my window, he asked with surprise, "Are you nervous?"

Heat rose to my cheeks, "No, not at all."

I lied. I didn't want Andy to see I was self-conscious. This time I am comfortable and relaxed in his living room. The television is on, but we're not watching, we're kissing, and I am lost in the possibility of us. It's getting late though, and I want to be the first to initiate the end of the evening. I start gathering my things, and he asks if I want to stay with him. Yes. Yes, I do.

We slide between the sheets. I straddle him and kiss his neck, and he whispers, "Are you sure you're ready for this?"

I freeze, and instead of answering the question, I ask, "Are you?"

Honestly, I don't know if I am ready, but in this moment, my desire for him is stronger than my fear of heartache. I answer with my body, and he responds. I'll win him over with good sex. He'll remember why he wanted to be with me.

I wake up early for the hour drive home. I kiss his sleepy head and say good-bye. He hardly stirs. I want him to pull me back into bed, tell me I am exactly what he wants. He mumbles and rolls over. Later that morning, he sends a sweet text, thanking me for a nice evening. I feel better, but then I remember that he always had excellent manners. Of course he would thank me.

✵✵✵✵✵✵

Wandering the concourse at McCarran Airport, I receive Andy's text, "Where are you?"

His flight arrived a bit after mine, and I'm trying to find him. I call him and describe my surroundings. He spots me

and tells me to look up. Scanning the second-level railing, he comes into focus, arms waving, laughing. It's been a month since I've seen him—too long for me. I run up the escalator, drop my bags, and hug him. I tell him my flight was a cinch. The first time I've flown without Xanax in two years. I'm getting a handle on my anxiety, and it feels good.

A few weeks ago, Andy accepted my invitation to join my family and me in Vegas. Susy, her husband George, Mike, Mary, Uncle John, and Aunt Irma will be here. On the cab ride into town, he confesses that he doesn't really like Vegas. I promise him this trip will be different because we're here together. He agrees.

Mike and Mary meet us in the lobby of the Wynn, and we take the elevator to a beautiful two-bedroom suite we'll share. Andy appears to be impressed, not at all the Vegas he remembered. He's happy too, and that makes me happy. I've successfully swept him off his feet. *Keep it casual, Christine. Keep it light.*

The next forty-eight hours are filled with lovely words and gestures. We have breakfast in bed, sunbathe poolside, gamble with everyone, and venture off on our own. He engages me in another favorite exchange from our past, and I happily oblige. He asks, "Did I tell you yet that I love you?"

"Yes, but not today."

"I've gotta fix that. I love you."

He leans in and points to his cheek. I know what to do. We have found our way back to the good old days, and all is right in the world.

I'm staying another day, but Andy has an afternoon flight. We have brunch, spending our last couple of hours alone, just the two of us. We drink mimosas, and he jokes with me about my flirty personality. I deny his allegations, telling him, "I

absolutely do not flirt, I'm friendly to both men and women. I like people."

He playfully rolls his eyes, holds his hand in the air Beyoncé style, and sings "Single Ladies." I ask him, "What does that mean?"

"You know, unless I put a ring on it, I don't have the right to say anything about your flirting. You can do what you want."

I hear, I'm never putting a ring on it. Don't mistake this weekend for anything other than a good time. My cheeks burn. I'm pissed. "Why did you find it necessary to say that? I get it. You don't have to remind me. We're *not* a couple."

Neither one of us can take back what we've said. I don't think we want to; we've made our feelings clear. Andy is content to keep things light, and I want more. I do my best to recapture the magic of the last couple of days, but it's difficult to hide the hurt. I am mad and sad and stupidly hopeful.

I stand on the curb. From the back of the cab, Andy uses his index finger to give me the tiniest of waves. He makes kissing lips and mouths the words, "I love you." Sometimes love is not enough. *Don't chase him, Christine. Keep it light.*

❋❋❋❋❋❋

The main level of my home is gutted, stripped to the studs and the floorboards, no plumbing or electricity. A year in the making, my remodel is finally underway. The transformation will take a few months, wiping away all physical reminders of past lives and loves. I stand in the middle of the room with the last bits of daylight and assess the progress.

Long plastic sheets nailed to the ceiling drape the opening to the staircase, keeping the dust from wafting up into my

room. I push the plastic aside and head upstairs. I fall onto my bed fully clothed and release a heavy sigh. My ex and my son still live here. My plan to save Ken has failed miserably.

When he moved in a year ago, I started attending Al-Anon meetings and working with a therapist. I found comfort in both, and then it got hard. I have learned two important lessons about the work of change and self-improvement. First, I must be honest. The best therapist and support groups cannot help me if I tell one-sided stories or blame others. I have conquered that part, and I take responsibility for my mistakes. But part two, ditching old patterns, setting boundaries, and putting a stop to the behavior that makes me sad and anxious, I can't do it. I've tried. Equipped with effective strategies, I am determined to change the dynamic between Ken and me. I try to stick to the script; I ignore his excuses and protests. And then I crumble. Within minutes I am yelling in frustration or bawling, begging him to get help. And we start all over again.

I whined to my therapist that this was all too difficult. She said, "Christine, the day you realize that the kind of help you are giving your son is only hurting him, is the day you'll stop helping."

I wept, and she asked, "What's the worst thing that can happen?"

"He could die!"

Quietly and honestly, she replied, "He could."

I quit going to therapy.

My sensitive, kind-hearted boy is buried in his addiction. We rarely speak. My only communication is to remind him of the number of days remaining until the remodel encroaches on his room completely. He'll be forced out, leaving in worse shape than when he arrived. His absence will be a relief.

Cal tries to understand my roller coaster of emotions. He is devoid of worry, as our boy's life could end at any moment. He doesn't have dad guilt the way I have mom guilt. He assures me I am not to blame for Ken's addiction. Yet, he feels compelled to tell me that our son does blame me. That hurts. Sad and exhausted, I fall asleep.

�֍✖✖✖✖✖

Given my current living arrangement, it is impossible to be completely private. But today, I've asked Cal and Ken to make themselves scarce. Andy and I are spending the day together. A walk on the beach, breakfast, and then "A Taste of Huntington Beach" with Lori, her husband Dwayne, and some friends. I haven't seen Andy since Vegas last month. Other than a few texts, it's been quiet between us. Preoccupied with self-improvement and home-improvement, I don't obsess about the direction of our relationship. Emotional and physical distance has been easy.

With Ken's exit near, my load is lightened. I can't wait to see Andy. He texted yesterday asking when he should arrive. I asked him the same question the first time I went to his home. He charmed me with his response, "How about now?"

So, I replied to his text, "How about dawn?" He missed the reference entirely and said he'd see me at nine. Not the response I had hoped for.

I get dressed, choosing an outfit that says, "Look at me. I'm cute. I'm fun!"

A couple raps on the door and his echoed hello alert me to his arrival. He opens the dusty plastic drapes and peers up at me. "Wow! A lot has happened since I was here last."

"Yes," I say, "a lot has happened."

✾✾✾✾✾✾

We walk along the beach path. He squeezes my hand and says, "I need a little more Huntington Beach in my life."

I return the squeeze and wonder what he means. I want more Christine in my life, more relaxing fun times, less Los Angeles hustle. She makes my life better. I wish I knew, but I don't ask.

At breakfast, he tells me about work, his waning interest after twenty-plus years, and possible options ahead. He proudly shares the latest news about his daughters. Then he asks, "Do you ever wonder what life would have been like for the two of us if we had stayed together?"

His question surprises me. I never think of Andy as a person who considers the past or what could have been. He is the master of living in the moment. I avoid answering and instead offer, "Well, if we were together, you wouldn't have your girls."

"True," he says.

My insides wince. Of course, I've wondered. But saying so would reveal regret about so many things. I honestly think my life would have been better.

We ride bikes with Lori and Dwayne to Central Park and "A Taste of Huntington Beach." We stuff ourselves with delicious food from local restaurants, and we drink lots of wine. My friends love Andy. This only makes me love him more.

We ride back to my house for time alone. Lying naked, we sleep off the alcohol. I wake to the setting sun, the white linen curtains dance in the gentle ocean breeze. Andy is awake, but there is no talking, only our breathing. I want many more days like this. Everyone needs a little more Huntington Beach in their lives. Andy stirs. Time to go. A casual "See you soon" is the only indicator of a future date.

CHAPTER 20

June 2014

It's my birthday. Over dinner, Andy and Nili make up for lost time as they share the Cliff Notes version of their past twenty-five years. I add my two cents when either of them is too modest about their success. I notice the relaxed tenor of their conversation, comfortable in their skin, proud of themselves, but not in a boastful way. I envy their ease and miss the wonderful freedom of being myself. I haven't been my true self with Andy. I wish to start over, to spend my birthday alone with him.

When Nili suggested this trip to Sonoma, I asked if I could invite Andy. I thought he'd be more willing to celebrate with me if I packaged my birthday around a little adventure, just three old friends exploring the wine country together. Once he got here, I was sure that the beauty and romance of the setting would bring us closer together. Watching them now, I see my plan has backfired. The two of them are having a lovely time.

I stop listening, and my mind drifts to a discussion Nili and I had this afternoon before Andy arrived. I updated her

on the current living arrangements in my home. Ken is out, and Cal still lives with me. He guards my house while I am out of town. When I'm gone, Ken breaks in through a window and uses my home like a motel. His dad being there keeps him out and gives me peace of mind. Nili offered tough-love advice, and I felt like a failure. Her life is so different than mine. She has built strong relationships with her husband and son. They are solid, a house of bricks. My house of straw is always on the verge of collapse. I turn my attention back to Andy and Nili. They've moved on to discussing the finer things in life, delicious cuisine, and exotic travel. Andy rests his hand on my leg, and I find calm.

Dessert arrives with a single lit candle. I make a wish—Andy and I together, always. He pulls a long, rectangular box from his coat and pushes it toward me, "Happy Birthday, babe."

Gently unfolding the tissue, I reveal a beautiful necklace of blue-green stones, not fancy, but very me. I love it and thank Andy with a kiss. He clasps the double-strand around my neck. Pressing my hand against the stones, I think of the pearls he gave me a lifetime ago. He could hardly contain himself, so happy to make me happy. Now he is quiet, and I wonder what's on his mind. I want him to be as excited about giving me the necklace as I am to receive it. There is an awkwardness between us, and we have never been awkward.

✿✿✿✿✿✿

Saturday morning, we get an early start—first a farmers' market and then off to Healdsburg for shopping and lunch. Andy and Nili tool around the market together. They admire the beautiful, fresh produce and even choose a gift for Andy's friend. The two of them lost in conversation, I wander off on my own.

We arrive at The Shed, a beautifully curated restaurant and home store. Nili introduces Andy and me to the proprietress, a friend of hers. The woman's husband joins, and the discussion turns to business. The four of them engaged, I float away.

The drive back is more of the same, the two of them talking and me silent. Nili tries to pull me into the conversation. I'm bitchy, "You two seem to have it handled."

Nili attempts to smooth things over, "Christine, c'mon."

I don't respond. The car is quiet for the remainder of the drive.

Back at the house, Andy naps, and Nili reads. I take off for a power walk and pound the serenity out of the country road. I try to reason why I am so upset. They aren't trying to hurt me; they're just having fun. I, on the other hand, am impersonating a wet blanket. I want Andy to be more attentive toward me. Anyone watching would guess that he and Nili are a couple. I have one more night to salvage the weekend. I check the time and jog back.

Andy lies diagonal across the bed, still asleep. I peel off my sweaty clothes and jump in the shower. Under the hot steamy water, I try to reset my head.

✿✿✿✿✿✿

A large pig roasts on a spit over an open fire. Across the sprawling green lawn are long rows of elegantly set tables. Handwritten place cards mark our seats. Wine flows, and we mingle with other guests. A woman talking with Andy refers to me as his wife. He doesn't correct her, and I see that as a good sign. But something is different. No glancing up, no little finger waves—distance grows between us. I feel it.

❋❋❋❋❋❋

Our clothes pool at our feet, and we stand naked at the foot of the bed. Andy's hands graze my waist, then my ribs and breasts. I shiver as he runs his fingers lightly down my back. He pulls me close and presses against me. Taking his cue, I climb on the bed and crawl toward the bedside lamp. He grabs my hips from behind, "No. Don't turn out the lights."

I let him take charge. This is different for us—down and dirty, hurried, no time to spare. He releases, then rolls off me. I scoot toward him and kiss his neck. He reaches for the lamp, lights out. I lie awake, alone with his indifference. I agreed to this arrangement, a woman in the rotation. I said I could be casual. I could do this. I really can't.

❋❋❋❋❋❋

Andy stirs and stretches in the morning light. He asks what I am reading. I set the book aside and give him a brief summary of *The Good Earth* by Pearl Buck. Uninterested, he springs from the bed and heads to the kitchen. He shouts a greeting to Nili, "Good morning, sweetheart."

Is he doing this on purpose?

After breakfast, Andy says good-bye to Nili, and I walk him to his rental car. Facing me, he holds my hands and thanks me for inviting him to Sonoma. He hugs me for a long time. "I love you," he says. He drives away. The weekend was not at all what I had hoped for or imagined. We still have two dates on the calendar: a beer tasting in July at Lori and Dwayne's and the horse races in Del Mar in August. In the meantime, I have plenty of shit on my plate—my remodel, a stack of self-help books, and a return to therapy.

❋❋❋❋❋❋

We sit at Ray's in LA. I had a meeting with a decorator, and Andy was free for an impromptu lunch. On this blue-sky summer afternoon, we share a Margherita pizza and hold hands. He's sweet and attentive. Perhaps the Sonoma trip was just a rough patch. We never talked about it. He pulls his cell phone from his jacket pocket and shows me a photograph embedded in a text from his daughter. A picture of a glass building, the sunset reflected in its windows. He said, "Look right here."

He points to two tiny words beneath the photo and reads them, "Golden Windows."

"When my girls were little, I would tell them the story 'Golden Windows.' Do you know it?"

I shake my head. I don't. He goes on, "A boy lives in a village. His family are farmers, and they work long days in the fields. As he works, the boy sees a village on a distant hill and notices all the homes have golden windows. Day after day, he looks toward the hill and envies the people whose homes have golden windows, and dreams of living there. One day, the boy's father rewards his hard work with a day off. He decides to journey to the village on the hill. He begins at sunrise and walks for hours until he arrives, exhausted, late in the day. He looks around but cannot find the homes with golden windows. He must have lost his way. Confused and discouraged, he ventures home as the sun begins to set. Before he leaves, he sees a young girl and inquires about the village and the homes with golden windows, hoping she knows the way. Happy and excited, she points to a valley below, her face beams. To his surprise, he sees his village, and all the homes have golden windows."

He looks at me, eyebrows raised, and smiles.

Is there a lesson there for me? Before I can ask, he tells me how happy he is that I am back in his life and kisses me. Back in his life again? What does that mean? He never attempts to see me. The time we spend together is always initiated by me.

Last Saturday at the beer tasting, he passed on staying the night, saying his daughter needed him at home. The excuse felt weak, but I accepted it. I invited him to stay after the horse races this Saturday, and again he declined—another excuse, an early bike ride. Something isn't right.

❊❊❊❊❊❊

I carefully reread my text message:

> Me: I haven't been able to tell you about
> my heavy heart. I've not been brave at
> all in expressing my needs or my hurt. I
> haven't lied, but I have hidden the truth,
> mostly from myself but also from you.
> I'm not sure I can be brave enough to
> talk about it today, but I wanted to let
> you know. I've been brave about one
> thing. Expressing my love to you. That is
> real. That is true.
> Xoxoxo

I hit send. Within minutes, he replies.

> Andy: Let's connect today by phone.
> Let's create time in our day to share our
> feelings. It's important.

We agree on a time in the afternoon. The morning hours drag on, and my stomach churns. I organize closets and dresser drawers. Conversations play in my head, conjuring alternate feelings of hope and heartache. I sit in my blue bedroom chair and try to pass the time reading.

My cell rings, I take a deep breath. Our hellos bump into one another, and I don't know where to begin. Then Andy asks, "How are you?"

"Okay."

He encourages me to speak my mind, and I find the words I've rehearsed, "It's been clear to me that you don't want an exclusive relationship, but it seems like you don't want any relationship. The last two times I've asked you to stay the night, you've made excuses. It seems purposeful, like you don't want to sleep with me, have sex with me. It's not only that; I'm not a part of anything in your life."

Before I go on, he interrupts, "It is purposeful. I've tried it on, tried to imagine a life with you, forever, and I just can't."

He says he loves me; says he always has. This declaration softens the blow. I want him to stop talking, but he won't, "I have been in love two times in my life, Christine: with you, and my wife."

His voice catches. I try to speak, but he interrupts again, "Wait, let me finish."

I am silent as he regains his composure, and then he adds, "But loved back only once, by you."

I cry, "Why would you give that up? Why?"

I hate the sound of my voice, my begging heart. He doesn't answer. Instead, he asks me to stay in touch. I sob, "I don't want to be your friend and watch you fall in love with someone else."

"I'll reach out to you anyway. You are that important to me."

Important how? What does that even mean? I hate that I ever loved him, that I love him now. I bawl, my face and T-shirt soaked with tears. I don't want someone who doesn't want me. I push myself out of the chair. The book I was reading falls to the floor, *The Happiness Project.* Fuck you.

CHAPTER 21

August 2014

After the slow pace of summer break, my brain adjusts to the hectic days before the opening of school. Buried in work, I can forget that I'm sad. But on the drive home, or in the quiet before sleep, my mind wanders free, and I ruminate over a useless list of things I cannot change.

Not a word from Andy, no follow-through on his promise to stay connected. It's better this way. I'm worn out. I've declared an indefinite hiatus from dating. Spending time with Luca and chaperoning the Friday night dances, I find love, and I feel love. But I cannot deny a deep longing, a big hole I cannot fill.

I end my days reading in bed, searching my library of self-help books for the secret formula to a happy life. My heavy head falls forward, and the book slips from my hands. I turn out the light and sink into my pillow. Too late, I've already lost my drowsy stupor. Instead of drifting off to sleep, I think of Andy. I had hoped he would rescue me, make me happy. All these years rallying behind the men in my life, pushing for their success, it felt so good to be with someone who didn't

need anything from me. All the books I've read say we make our own happiness, our own path. It's time I make mine.

The books also say that mistakes are part of life—I can learn from them or let them define me. I tend to focus on the past, people I've hurt, and pain I've caused. My critical inner voice is loud and clear. I don't give myself credit for the good stuff. The books say every day is a chance to change my story.

<p align="center">❋❋❋❋❋❋</p>

I pull a tattered journal from the stack. Flipping through its pages, I skim the entries and cringe. Self-conscious about my vulnerability, I tear out the pages that make me seem pitiful and sad. I have never been comfortable with my sensitive side, my weakness. Most people would not know I'm sad. Though recently I did tell a virtual stranger, a guy I knew in high school. We weren't friends back then but connected on social media a few years ago. Insomniacs, we found our way to exchanging messages in the middle of the night. It was him I first told about my achy heart and my desire to let it all go. He suggested writing about it and sent me a link to his friend's blog. I was surprised that he thought I could do something creative like that. But then, why not me? I jot down notes and brainstorm ideas for a name. I settle on *Bare Naked in Public*, a place to tell my stories.

Blog Post
August 31, 2014
What it means to be Bare Naked in Public . . .

The name of my blog has nothing to do with its content, no photographs of naked people casually

running errands around town. Sorry, instead, Bare Naked in Public refers to a phrase I've used to describe my inhibition toward creative expression. I don't think of myself as a creative person. I'm more practical, a problem solver. I like to help people by finding or knowing the answers. I am very comfortable in the concrete, the known.

I do think there is a creative soul inside of me. I spend quite a bit of time daydreaming, writing stories in my head, scribbling in journals, and taking pictures. I have ideas for stories I might write, and I have considered telling stories with photographs. For me, stories, pictures, music, art, and nature evoke powerful emotions, thoughts, and memories. I want to create for that reason, even if I am the only one who grows from the experience. Until now, fear has kept me from creating anything. It's ridiculous to think I can spend so much time being afraid of something I haven't even attempted. Other than goofy little snippets on Instagram and Facebook, my creations remain in draft form in my head and in my heart. All this ruminating over ideas happens when I am doing something else, driving, standing in line at Trader Joe's, or taking a shower. During sleepless nights I write in my journal. I've told many of my friends that I feel like I have more to do in this life, something to say. For years I have been satisfied with keeping these ideas to myself, until recently.

If you knew me, you might wonder why this is such a big deal. I am not a shy person. I am an extrovert. I strike up conversations with strangers.

I laugh loud and hard. I joyfully squeal when I bump into friends around town. I kiss and hug people I've just met. I can tell a stranger she is beautiful, and I always smile at passers-by. I am comfortable telling funny, and embarrassing, stories to friends and people I barely know. My poo stories are legendary. I love to make people laugh, and I cry easily, serious ugly crying. I am an educator, and I'm proud of my work. I am a confident leader and communicator. I make difficult decisions that don't always make everyone happy. And sometimes, I have to be the bearer of bad news. More often, and gratefully so, I witness and share in the tiny triumphs of childhood: becoming a reader, tying a shoe, or being the best handball player in third grade. I love my job.

My family and dear friends are most important to me. I love them. And they love me. With all the stupid shit I have done (and some of it is truly unbelievable), they still love me, unconditionally. They believe in me, and more than anything, they want me to be happy. I want to be happy too. So how is it that I can have a job I love, the encouragement and love of my family and friends, and still lack the confidence and courage to put my creative self out into the world for all to see? I think my spirit has definitely been shaken, even crushed, by some difficult life experiences, some out of my control, and others of my own choosing.

Sometimes shake-ups are needed to get our priorities straight. Right? My most recent heartache made me realize, FINALLY, that I'd

been putting important parts of my life on hold. Instead of pursuing my dreams, improving my life, and becoming a person that I can love and admire, I've been chasing happiness, thinking it could only be found if someone thought I was worth loving. As my former therapist would say, "How's that working for you?" UGH! I actually had to find a new therapist because I couldn't bear the thought of telling the old one that I repeated all the same stupid mistakes! I see now that I've allowed my self-worth to be determined by the success or failure of my relationships with men. I've spent a ridiculous amount of time trying to convince men that I am worth loving. That sentence is so stupid, and sadly that WAS me. Years of that behavior knocked the confidence right out of me. I lost myself.

Of course, none of this is rocket science. It's been the topic of a zillion self-help books. The good news is I'm done wasting time. So, no naked pictures (at least not yet), instead a place where I can practice being my creative self, share my personal stories, find encouragement, and maybe inspire others to do the same.

There is an anonymous quote floating around the internet, "What would you attempt to do if you knew you could not fail?" I would tell stories about life and love with pictures and words. It starts now. I'm sure that the Universe will provide an abundance of opportunities for personal growth, maximized potential, and true happiness, IF I am willing to be brave, take risks, and stand

bare naked in public. This is slightly terrifying for me. But I'm doing it.

I am so happy to be here.

xoc

Bleary-eyed from reading and editing, and scared shitless, I breathe in courage and hit publish.

✳✳✳✳✳✳

I hear them before I see them, a group of upper-grade boys race from their classroom toward the playground. They slam on the breaks as soon as they spot me coming around the corner. Hoping I won't send them back, breathless, they ask, "Oh hey, Ms. Amoroso. How was your summer?"

Shaking my head, but smiling, I remind them to slow down, "You don't want to knock anyone over, especially the principal."

They laugh and continue toward the handball courts, speed walking and then running again. It's a losing battle. Kids like to run, and being first on the court, or anywhere else for that matter, is something all kids aspire to be. Recess is drama free these first few days. Students are happy to see one another; the grudges of late spring have all been forgotten. In a week or so, they'll settle back into schoolyard trash talk and tattling. I love the return of predictable routines and being busy.

My phone pings, and pings again, alerting me to comments on my blog. I'll read them later. The playground is reaching full capacity, and I'm on duty; my attention is needed here. A group of girls, confident and strong, challenge some boys to a game of handball. I remember those days, so sure of myself.

Blog Post
September 5, 2014
On Being Twelve . . .

I remember being twelve years old, smart, brave, funny, with endless energy and always hungry. When I looked in the mirror, I liked what I saw, especially my long straight hair. I wore it like Cher and thought I looked like her. My girlfriends thought so too. In the early '70s, that was a huge compliment. I loved school, my friends, and my family. A teacher is what I wanted to be, maybe a singer, and definitely a mom.

In elementary school, I ran with a pack of girls who spent recess chasing boys on the playground and taunting them with songs about kissing in trees. I was super boy crazy. But in early middle school, I gave it all up, left the crazy behind, and began to genuinely like boys. They were my friends and sometimes my best friends. I loved them, but not in a puppy love, I want to be your girlfriend, kind of way. Nope, it was a hormone-free zone. Sex and relationships were not even a blip on my radar screen. It was that tiny window in a young girl's life when love wasn't earned, won, bargained, stolen, or lost. Love was love, pure and simple.

I was attracted to sandy-haired boys, tanned surfers. Smart boys with a good sense of humor were my preferred seat partners in class, and they liked to sit with me too. We were quick to finish our work so we could hide behind our textbooks

and Pee-Chee folders, eating salted pumpkin seeds, telling jokes, and suppressing laughter until we snorted, making us laugh even harder.

Some of my favorite boys hung out with my best friend's brother and lived in her neighborhood. I spent weekend nights at her home, enjoying the freedom of loose house rules and absent parents. We played hide and seek and Ding Dong Ditch, watched scary movies, and ate a lot of crap, most of which we cooked or baked ourselves. The best part was the late-night conversations. Some nights we didn't sleep at all, spending the early hours just before dawn helping the boys fold and band newspapers for their paper routes.

My memories are vivid. I close my eyes and see their faces, hear the chatter and the laughter. I can conjure up the feelings. I don't know a way to describe it other than I felt powerful, worthy, and strong. I knew who I was and who I wanted to be. These feelings are so deeply rooted in me that when I observe young girls interacting with friends, I can sense in an instant if they are in that place—that space that I remember so well. I want to whisper in their ears, Think of how good you feel about yourself, right here, right now, memorize it. Lock it into your heart because life is going to happen. The whole boy-girl thing is going to get really complicated. You want to remember who you are: smart and talented, beautiful, and strong. You have a purpose.

There are a million reasons why we lose our way. Maybe for a minute it's important to examine

how and why that happens. But for me, right now, it's more important to find my way again, to spend my love and energy on people and work that keep me true to myself.

Over the years, I have lost and found the spirit of that twelve-year-old girl. The kind of love I experienced then was never meant to be fleeting, only to be remembered fondly. I can have it again.

You see, it isn't enough for me to find her; I have to be her . . . worthy and strong. Twelve-year-olds are so damn smart.

xoc

❋❋❋❋❋❋

Cross-legged on the sofa, my hands rest on the keyboard; I'm deep in thought. Cal walks into the living room, "What are you doing?"

I don't look up, "Working on a blog post."

"I checked out your site. It looks pretty good, clean."

After our divorce, Cal went back to college and made a career change more suited to his creative talents. He works in branding and design and has an opinion about the aesthetics of everything. He stops short of saying that he's read my blog. I don't care one way or another. I'm encouraged by the positive feedback I have received. It's more than the kind comments that keep me going. I'm exhilarated by the process. I've managed to take a simple thought or memory and tell a story. I mean, can I call myself a writer?

Cal makes a big bowl of cereal and joins me on the couch. I suddenly remember one of his pet peeves when we were

married; he hated the sound of the fork hitting my teeth when I ate. Without realizing it, I chuckle.

"What?" He asks.

"Nothing, something I'm writing."

We behave like an old married couple, comfortable with few words between us. Only we don't reminisce. And while I'm sure we could manage some sweet memories between us, there simply isn't any reason to go down that path. When people find out we live together, they immediately assume we have some sort of roommates with benefits deal. Gross. The thought makes me want to throw up. I'm sure Cal feels the same way. He dates very young women, like our daughter's age. And though he is older than me, I am way too old for him. I have an inkling he is dating someone now, but I don't ask. I'm not the least bit interested in his private life. I'm hoping he moves out soon, but I'm not pushing it, not yet anyway.

He eats his cereal, and I write.

Blog Post
September 21, 2014
At Seventeen . . .

I run across Pacific Coast Highway to the beach trail and am greeted by the sunset. I squint my eyes, take a deep breath. This is peace. My body finds its rhythm, its pace, and my legs lead the way, allowing my mind to wander.

I think of my parents every day, on every walk. I see Mom and me strolling along the shore in winter, picking up sea glass, sand dollars, when we could find them, and unusual rocks and shells. She had a knack for finding unique treasures

with interesting textures and colors. I loved that quality in her, the ability to see beauty where no one else could or when it wasn't obvious. I see Dad and me running on the trail together. His pace always pushed me, until he was nearly sixty. One evening we ended our run at his house. As we came through the door, he said to Mom, "Judy, it has finally happened; I can't keep up with my kids."

It made me a little sad, so I made a point to slow down. Eventually, our runs became walks. Either way, our time on the trail always included discussions of history, politics, current events, books, movies, and music. He had an unbelievable depth of knowledge. I miss them both.

As I channel surf through the memories, one catches my attention, a favorite photograph, my dad holding my sleeping ten-month-old son. I pause here and allow a story to unfold. My mom took the picture during our trip to their new home in Oregon. She skillfully and beautifully captured the tenderness of the moment, a tenderness I didn't believe existed in my dad, until I had a tiny crisis the year before the photograph was taken. A little shake-up in my life compelled me to grow, learn, and appreciate my parents' unique gifts. I was seventeen, and I was pregnant.

By today's standards, with Reality TV making teenage moms celebrities, a pregnant teenager is no big deal. However, in my case, it was 1978, and my dad was going to be pissed! I couldn't imagine telling him that his seventeen-year-old daughter,

star student, overachiever, when I ask you to jump, you say, "how high?" . . .

Yeah, that daughter WAS PREGNANT. Anyone who knew my dad could understand the magnitude of this deed. He told me what to do, when to do it, and how to do it. To give you an idea of his control, he required all his children to graduate high school in three years. He made our class schedules—always a full load. We took summer school and night classes at the junior college in order to complete the coursework on time. I recall a confused college student asking me in class one night, "How old are you anyway?"

I was fifteen! I recall being exasperated by the question, "Why is your dad making you graduate in three years?" He had a plan; he wanted us to get busy with college as soon as humanly possible. Our career paths were carved in stone by the time we graduated.

His plan started out great! I turned seventeen just before starting my first year of college. I got good grades, and my dad was happy, and proud. Against my dad's wishes, I got a part-time job. But I was only allowed to keep it if my grades didn't suffer (Cs were NEVER allowed), and I managed that easily. As strict as my parents were, and as busy as my schedule was, I still managed to have a pretty active social life, including finding a time and a place to have sex with my boyfriend of three years. We thought we were so careful. We learned the hard way that thinking you are careful and being careful are two different things. Honestly,

it's surprising that I didn't get pregnant sooner. Now that it was later, I was late, and definitely pregnant. I was pretty sure a pregnant teenager was not a part of my dad's plan.

How the hell was I going to tell my parents? After all, I had spent the better part of seventeen years doing my best to win their approval. AND I did a good job, never giving them a moment's worry. I fretted over the possible consequences. Would I be kicked out of the house, be disowned, be forced to put the baby up for adoption, and the list goes on. But I was mostly sad, imagining my dad's disappointment. The stranger part of all of this was that I didn't see being pregnant as the problem at all. I was never afraid of having a baby or being a mom. All my fear was wrapped up in the telling, my parents' reaction, and their disappointment.

As my belly grew from sexy midriff to "Oh my God, she's pregnant," so did my level of anxiety. Entering my second trimester, I still managed to keep my pregnancy a secret. And then, without fanfare or drama, it happened—completely unexpected and not at all how I had imagined. My mom and I were alone in the kitchen, unloading the dishwasher, and she just asked me, "Are you pregnant?"

She didn't bat an eye, wasn't mad or sad. A quiet and quivering "yes" made its way to the space between us. The relief I felt was overwhelming. Somehow in that very difficult moment, she graciously accepted our new reality. She was wise

and calm. My mom was thirty-eight.

I prayed that she would tell my dad, but she wasn't volunteering. My boyfriend was on his way over, and there was no way to send out a warning text since we were years away from that technology. Once he arrived, it didn't take him long to figure out what had transpired. There we were, the three of us, standing in the dim kitchen light. Now what? My dad had been in his den, out of earshot, all along. My mom didn't waste any time. She told my boyfriend that he had to take responsibility, tell my dad, man to man. I felt awful for him. But I'm not going to lie. I was so glad it was him and not me.

I watched him walk into the den, and I ran upstairs to my bedroom. I couldn't bear to eavesdrop. I stood in my closet, for what seemed like an eternity, pushed around the hangers, and looked at the clothes that no longer fit me. My heart was racing, pounding in my chest. I wanted the earth to swallow me whole. And then I heard them, my dad's footsteps coming up the stairs. They were hurried, but light. Still in my closet, I turned, crying. His arms around me in an instant, holding me close, so tight. His voice low and calm, "I'll bet you were worried, scared."

My face buried in his chest; I nodded in agreement. My dad was kind and understanding, a side of him I had not seen, and again, completely unexpected.

In my first year as a mom, I came to appreciate my parents. My dad continued to be my toughest

critic. But now, I welcomed and respected his advice. My mom and I were always close, and our relationship strong, but our bond was strengthened by the shared experience of motherhood. She was, quite simply, an amazing mom and grandmother.

I returned home from my walk and started my search for the photograph and found it in a box in my closet. Mom's handiwork is evident as she beautifully captured the essence of the man she knew and loved, the man his children didn't always see back then. I am grateful that, over the years, my relationship with my dad continued to evolve.

xoc

Cal rinses his empty bowl at the kitchen sink and then walks past me toward his bedroom. I give a raised eyebrow, "Goodnight."

As he passes, he says, "Ummm, I read your blog."

I look up and catch the back of his head as he disappears down the hallway, and I smile.

CHAPTER 22

Fall 2014

Lynda pours tea for the two of us. Steam rises from our cups, and I take a bite of her delicious pumpkin bread. We first met eight years ago when I began my principalship in Irvine. An excellent teacher, a warm and kind person, I admire her. It wasn't unusual to see her quietly talking with a colleague, or simply listening. During the difficult days of Mom's cancer treatment, Lynda would pop by my office to check on me. She knew exactly what to say and do to lighten my load. She retired several years ago, but we've stayed in touch. I'm hoping she can provide me with some of her wisdom today.

I clear my throat, "I once overheard you talking to another teacher about yoga. You said you were amused when people spoke about their great yoga workout, as though exercise and getting a good sweat were the focus of yoga. You saw it differently, much broader, as a practice to live a balanced life. It was a long time ago. Do you remember the conversation?"

She smiles, "Sounds like me."

"Your words stuck with me. It's why I'm here. I've never

practiced yoga, but from the little I know, I think it might help me manage my anxiety."

Vulnerability is still hard for me. I'm embarrassed that I cry so easily. Lynda puts her hand on mine. Her knowing expression has me believing that perhaps my troubles are not as big as I imagine. She tells me about her years of yoga practice and the positive impact it has had on her life and suggests I meet her teacher, Diane.

Before I leave, she gives me a small book, *Inviting Silence*, a guide to meditation. I open it and find a post-it note in my handwriting stuck on its title page—a thank-you to Lynda. In an instant, I recall Lynda loaning me this book after my parents died. I suppose it's true; when the student is ready, the teacher appears. I wasn't ready the first time, but I'm paying attention now.

❈❈❈❈❈❈

I list the ways I've tried to reduce my anxiety: Al-Anon meetings, therapy, meds, and physical activity. Diane listens and nods. She tells me about her life before yoga. Overworked in a high-pressure job, she was grinding away her existence. As I observe this woman, this picture of serenity, I cannot imagine her ever being anything like me. She assures me I can change. I leave with homework: simple exercises to relieve neck and back pain, breathing methods to clear my head and slow my heart rate, and a *bhavana*—a simple phrase to calm and quiet my mind. "I am peaceful. I am present. I accept what is."

I am to say this aloud three times each morning and night.

Diane and I meet two more times privately, and I join her weekly group yoga class. I read *Inviting Silence* every day and practice meditation. Small, steady shifts in my outlook on life

make regular appearances in my day. I am more calm than anxious.

I stay committed to writing weekly blog posts. They have become a kind of therapy. I used to identify winners and losers, good people, or bad people in the game of life. I am starting to see there is no one to blame, only human beings doing their best to figure it all out, to get it right. Sometimes we hurt each other along the way. I am learning to acknowledge the parts of me that are good and accept the parts of me that are flawed. And when writer's block makes an appearance, I meditate or take a walk, and I breathe. Some stories I may never tell— they require a level of vulnerability I'm not ready to explore, and that's okay. I try not to write late into the night; it's not conducive to keeping a healthy mind and body. But old habits are stubborn.

❀❀❀❀❀❀

Lights out, I lie in *shavasana*, corpse pose, my body heavy, relaxed against my yoga mat. The breathing of my fellow yogis is the only sound I hear. I successfully release the stress of the day and find peace. Diane prompts us to roll onto our sides and slowly come out of the pose as class ends.

Most days are steps forward. I slow my pace and mind my boundaries. Meditation and yoga are priorities. Change is hard though, and I take steps backward too, giving too much attention to the negative aspects of my life. But, instead of ruminating, I push through and replace those thoughts with the good stuff: family, friends, nature, my home, and health. I'm making a habit of finding gratitude and joy. All this brighter side and silver lining thinking has me cautiously optimistic about Ken.

Blog Post
November 30, 2014
Here and Now . . .

I spent many, many years dancing the same dance with my son. We had a pattern, a rhythm to our words and interactions. I counted on him to make mistakes, and he counted on me to fix them, to rescue him. And like clockwork, I came through, every time. I convinced myself that my help, disguised as love, was all he needed. I could make him see the light, and he would be the man we both knew he could be.

As long as we engaged in this dynamic, we denied the severity of his addiction and hastened the deterioration of his self-worth. A friend asked me tonight, "What made you stop? When did you decide enough was enough?"

Hmmm, I remember when it happened, but I couldn't recall why it happened. Reflecting now, I think I finally saw how my behavior stood smack dab in the way of my son's success. My actions robbed him of the opportunity to change his own life. Why would I knowingly do that to someone I love?

For my son, the change was harsh and unexpected. He went down hard and fast, and I had to say, "I cannot help you; I will not help you."

Days turned into weeks, and I didn't hear from him. Through the grapevine, I learned of his jail time, his release, and stories of the emotional and physical pain he suffered. Painful images haunted me, but I was not responsible for his fate.

More news arrived; he was working a program, getting help. I allowed myself to be hopeful and vowed to keep my boundaries intact. I took a chance and invited him to Thanksgiving at my sister's home, texting him the details. No reply and I had zero expectations. On that morning, he called to let me know he needed a ride. I told him if he got himself there, I would give him a ride home. He followed through, and he arrived on time. He looked good, healthy, and strong. I found myself glancing at him throughout the day. He behaved in ways I had not seen in years. He sat with his aunts, uncles, and cousins, attentive, speaking calmly, and listening. He showed genuine interest in our family, visiting for hours. He was humble and even quiet at times.

We didn't say much to one another, but each time we passed through crowded rooms and spaces, I touched him, patting his back or his arm. At the end of the evening, I kissed and hugged him. I wished I had engaged with him more, shown more interest, asked more questions, and been more lighthearted. I simply couldn't. A new dance would take some time, but it would be real and true.

Later in the evening and over the next few days, my family had so many nice things to say about my son. They saw effort, change. We were hopeful and proud. I'm working hard to change the way I respond to life. I've let go of trying to control my surroundings. This allows me to enjoy the good moments when they present themselves.

All that is happening with my son right here, right now, is good. I hope for him that it continues and improves with each passing day.

For now, I will not second-guess: no intervening, no predicting, or analyzing. On Thanksgiving, I enjoyed seeing my boy, the boy with the creative soul who loved art and marveled at the stars, black holes, and far away planets.

In an Al-Anon meeting the other night, a woman explained how she couldn't be proud of her son's hard work because she had nothing to do with it. Instead, she was proud for him. I love that distinction. My boy, I am proud for you. And don't forget . . . all the buddies love you.

xoc

I can see my curly-headed, blonde boy. I hear his toddler voice as he says, "all the buddies" instead of "everyone." Words that remain in our family's vocabulary.

I wipe my tears. Yes, there has been joy. I click publish and close my laptop.

�֎֎֎֎֎֎

Standing in line at Anthropologie, I shift my weight from left to right; high-heeled boots are not meant to be worn for twelve hours. I peruse the items on a low shelf: monogrammed ceramic dishes, jewelry, and fragrant soaps. After mentally checking my Christmas list, I decide on a couple of stocking stuffers and add them to the pile balanced in my arms.

I stood in this same spot last year with Andy and watched him thoughtfully select two tiny bottles of perfume for his

daughters. For a second, I wonder what his Christmas plans might be. And then I let it go. I think of Luca, his wide-eyed wonderment as we drove slowly down the decorated streets of my neighborhood last Friday. He makes everything better. Next in the queue, I pay for my purchases, give the salesgirl a cheery "Happy Holidays," and head out into the cool winter night.

Ignoring my pinched toes, I wander the outdoor shopping mall and do my best to lose myself in merriment and cheer. Poinsettias and twinkling lights adorn the walkways. Couples pose for selfies, in front of the enormous Christmas tree while parents corral their families long enough to snap the perfect holiday photo. Christmas classics provide the soundtrack for the evening, and Bing Crosby sings, "I'll Be Home for Christmas." Geez, some of these lyrics are so damn sad. I stop pretending to be happy and acknowledge my aching heart. I call Luca to say goodnight.

❈ ❈ ❈ ❈ ❈ ❈

Kneeling on the hardwood floor, I wrap the last of the Christmas presents. I arrange the gifts under my first fake tree, a twiggy white aspen with knotted bark and tiny white lights. My back stiff, I stand slowly and admire my gorgeous remodel: a reflection of me and the direction of my life, fresh and uncluttered. My phone pings from the kitchen. A text from Daniel, he asks if he can stop by for fireplace time.

Every couple of months I meet him for breakfast or happy hour, just friends. We talk about work and family, no personal love-life stuff. He reads my blog, and sometimes texts a sweet compliment. I have a Christmas gift for him under the tree, so I give him the green light to come over.

Rosy-cheeked and glassy-eyed, he manages to maintain his balance as he climbs the stairs to the living room. Straight to the kitchen, he pours us each a glass of wine. I carry them to the sofa—I don't want any spills. Just like old times, we sit close; our stocking feet rest on the coffee table. There is a peaceful quiet between us. I give him his gift—a hoodie in his favorite color, green. He grins as he holds it up to his chest, genuinely happy, and that makes me happy.

It's late. I walk him outside, and we hug in the light rainy mist. He pulls his hood over his head and tucks his gift as best he can under his sweatshirt, hops on his bike, and rides away. It's been a year and a half since our breakup. Loneliness keeps him coming back. It's my reason for letting him in. I know this is the last time I'll see Daniel, the last gift I'll ever give him. It's not a sad ending. It's the natural order of things.

CHAPTER 23

Winter 2015

Magazines lie scattered on the living room floor and coffee table. Some of us sit cross-legged on the rug, others lounge on the couch as we search through the stacks and flip through the pages. We're making vision boards for the new year.

It's the first gathering of the Illuminators, a circle of like-minded women choosing to "live in the light." At first, it sounded a little too New Age, but it's also something I want in my life—more light. My gut told me to give it a try. Rachel invited me; a friend I've watched grow from teenager to accomplished woman. She and her girlfriend Kelsea had the idea for the group. I thought Randi might be interested, so I invited her.

Kelsea speaks briefly about what she envisions for the Illuminators. There are plans for group meditations, full moon celebrations, and guest speakers. Meeting every couple months to share ideas and support each other's journeys resonates with me: a good way to stay committed to my path.

I am familiar with vision boards, but I've never actually made one. Kelsea suggests we select images and words that

speak to us, even if we are not sure why. I cut out several pictures: a healthy woman with strong, six-pack abs exposed wearing boxing gloves, a naked woman in a modest yoga pose, a turquoise sea against a Mediterranean landscape, a pile of ancient gold coins, and a simple line drawing of a woman stepping out of a transparent box into blue sky. I choose the words *beauty, love, wisdom, raw, purpose, and exceptional.* I select the phrases *positive change, nowhere to go but everywhere,* and *the next big thing is here.* I arrange the clippings on a twelve-by-twelve canvas and glue the pieces in place. I admire my handiwork and notice there is not a single picture of a man, no loving couples, or anything that suggests a search for true love. I take it as a sign; I am meant to work on myself.

We lay the completed boards on the floor in quilt-like fashion and share the meaning of our chosen symbols and our plans to realize our visions. It's not simple magic and wishes. Chosen paths will be difficult, and at times seem impossible. This is where faith is needed. Faith continues to be a struggle for me. The books say that even unwanted outcomes can bring me nearer to my dreams.

On the drive back to my house, Randi says, "Seems like a great bunch of women. You seem happy."

"I am happier. Better, for sure."

"How is Kenny?" she asks. His godmother still uses the childhood version of his name.

It's hard for me to talk about my son, even with my best friend. "Umm. At Thanksgiving I was so hopeful. But now, I don't know. He's up to his old tricks, and I'm not consistent with boundaries. Sometimes I'm all tough love. Other times, too tired to fight, I'm a total pushover. I give him money when I know I shouldn't."

The strength I felt in fall was zapped by the exhaustion of the holidays. When I don't hear from Ken, it's usually a sign that he's in trouble. I pretend no news is good news. Randi sighs, "Don't beat yourself up. You're doing the best you can. And Cal? What's he up to?"

I roll my eyes, "He doesn't seem to have any plans to move out, but in my mind I've given him until June. I met his strange girlfriend a week or so ago. She might be thirty? Cal says she has trouble believing our relationship is platonic. Seriously? I want to tell her, 'He's all yours.' I don't want this bullshit drama in my life."

Randi laughs, not at all surprised at Cal's most recent choice in a companion.

I prop my vision board on the dresser where I will see it every morning. I examine the pictures once more. The delicate drawing of the woman stepping out of the box and into the blue sky speaks to me most. Christine, it is high time to move away from what was and step into what will be, something new. You are ready for this; you are ready for big changes. Have faith.

✸✸✸✸✸✸

I read the email. A friend and former colleague, Karen, has passed away. It wasn't unexpected, but sad just the same. I consider not going to her service. I'm not sure I want to be faced with my past. Diane, in particular, comes to mind; once my master teacher, then teaching partner, and dear friend. Amid the Christine and Eric scandal, she quietly ended our friendship and never spoke to me again.

Diane and Catherine were friends before the affair and became closer in the wake of its dramatic discovery. There

will be people attending who know the sordid details. It's been more than six years, and I pray it's old news. I decide to go, to honor Karen.

Friends and family spill into the foyer of the funeral home. Karen's reach was far and wide. An amazing mentor, she guided and encouraged me during my journey into educational leadership. She was so proud when I shared the news that I had been hired for an administrative position in Los Alamitos. We stayed in touch until a rare form of dementia stole her mind. That was nearly eight years ago.

The funeral home staff quietly hustles to add more chairs, and I take a seat in the back. The service program in my hand, I stare at Karen's photograph. Her smile and her twinkling eyes so vibrant and alive. Life has cheated her, and all of us.

I lift my head and survey the room, so many familiar faces. Some names come easily, and others I struggle to recall. I search for the folks I expected to see and the ones I hoped to see. It's funny—when you know someone well, they can be easily recognized by the back of their head. Diane sits a few rows ahead of me.

My heart races, and I work to slow my breathing. Eyes closed; I focus on the beautiful words of one of Karen's closest friends. Calm again, I open my eyes and listen as one person after another speaks of Karen's joy, compassion, and exceptional career.

After the service, guests crowd into the reception area. I stand feet from Diane. I pretend to be preoccupied with my phone while I wait patiently for an opportunity to approach her. In my head, I compose all that I will say. I hear words that indicate her conversation is ending, and I gently touch her arm.

She turns and faces me. Surprised, she smiles broadly and

hugs me tightly. I want to cry. Has she forgiven me? She backs away and asks about me and my family. I struggle to find the right words and manage a couple of "okays," and then I say, "I really miss you."

She tells me that despite everything that happened, she wishes me the very best, and she repeats herself several times, "Only the best."

"It was all just too close," she says.

She thanks me for a card I sent her a few years ago, an attempt at mending our friendship. "So thoughtful," she says.

"It was all just, too close."

Standing in the periphery behind Diane, there is a woman. Her gestures are exaggerated, grinning and bobbing her head in agreement as she talks to someone. I realize it's Catherine, and I let her fade into the crowd again. Diane is my focus, yet there is nothing left to say. I tell her again that I miss her; I hug her and say good-bye.

I had hoped that Diane had forgiven me. After seeing her, it was clear she had, years ago. Her good wishes are sincere, but she is not going to be my friend. She had let me go. Wondering about Diane and wishing for a change of heart will never occupy my mind again. I let her go.

Walking to my car, I think of Catherine. I didn't see her again. Maybe I imagined her wanting my attention. Perhaps, she is happy. I hadn't ruined her life after all. I laugh to myself; I don't have that kind of power.

I'm glad I came today to honor Karen, and I learned something: No one is talking about me. No one is dwelling in my past. Neither should I.

✳✳✳✳✳✳

I sit and watch Luca play on a beautiful March day. Loving his sweet face, I count three perfectly placed freckles on his cheek and revisit memories of being a young—perhaps too young—mom. I want to remember that I was patient, that I lovingly gazed at my toddlers and memorized the magical moments of their childhood. But that wasn't the case. I rushed them to their grandmother's house while I attended classes all day. Then I picked them up, raced home, and stuffed them with five-minute meals. Bath time was followed by bedtime, and all the while, I scolded, "Hurry, hurry, hurry!"

I survived on little sleep, dragged myself out of bed, and with my eyes half-closed poured milk into waiting bowls of Cheerios. Enjoying the moments seemed an impossible task as my brain was always calculating hours of study versus hours of sleep. I could never get enough of either.

As a single mom with a full-time job, I rushed them through childhood while I raced through life and racked up a list of achievements. I got the memo that said, "You can have it all." But I missed the follow-up, "You just can't have it all at once." I hope my kids know I did the best I could.

I take lessons learned to shape my time with Luca. I let him rule the day, following his lead as he experiences the world, his way, at his pace. He plays in the rocks and marvels at spiders and pincher bugs, and then insists we clean up trash. We walk the alleys of my neighborhood and collect it. I tell him green cans for plants, blue for recycling, and brown for trash. He tells me, "Mommy says I am a big helper."

For each piece of trash he gathers, he announces which color bin he will use. He looks for reassurance, "All the people will be happy that I am cleaning up all the trash?"

I tell him, "Yes, they will be so happy. You are helping our world."

He proudly repeats, "I am helping our world."

Looking at his chubby hands, he wrinkles his nose and says, "My hands are filfy."

I laugh at his sweet mispronunciation.

I remember the many times strangers looked longingly at my children and me. "Cherish these moments, the years fly by, enjoy the simple things." They would say.

I thought it was simply polite chatter offered by older people. I wish someone would have grabbed me by the shoulders, given me a good shake, and screamed, "LISTEN!"

I have all the time in the world for Luca. I answer his questions and sometimes ask, "What do you think?"

I want him to believe his thoughts are important too. I back my words with actions because he is watching me. He turns to me, cocks his noggin, and asks, "Why are you smiling on your face, Nonna?"

Until that moment, I didn't know I was smiling. I answer, "Because you are here with me, and I love you."

I lean in and kiss his dirty face.

Because of him, I want the things I do and the life I lead to be worth watching.

I think of Ken and Tara, in their thirties now; they had been watching me too. I try not to take responsibility for their choices as adults, their mistakes, or sadness. Tired old patterns have me drawing imaginary lines from their problems to something I did or could have prevented during their childhood. It's time to let that go too.

CHAPTER 24

Spring through Summer 2015

My fingers click away, typing words that don't belong to me. I've been working on this Mother's Day post for hours. My musings about motherhood sound stupid and contrived. What the hell am I trying to say? I put my laptop aside and text my kids. "Mother's Day breakfast at my house. No gifts, please. Your presence is my present. Love you."

❋❋❋❋❋❋

It's early—too early. I rub the sleep from my eyes and reach for my phone. Ugh, not yet six o'clock. Rather than drift back to sleep, I peruse Facebook. Already so many photographs of moms and touching Mother's Day tributes. I add my own. If mom were alive, the whole family would gather at her home today. I see her, donning her heavy, white, cotton baker's apron. Long silver waves of her hair are pulled away from her face, and her hippie earrings dangle just above her collarbones. "My sprouts," she called us. And then I get out of bed before I get lost in missing her.

I stay in my pajamas and get busy in the kitchen. Before long, the smell of bacon fills the house. I hear Luca's tiny knock. He peers through the narrow pane of glass that runs the length of the door. He sees me and giggles in anticipation. I swing the door wide open and kiss him all over. Tara reaches for me, and we hug. Her first Mother's Day since she and her husband separated, she feels weightless and small in my arms. Before I can ask how she is, Luca sniffs the air and demands bacon.

Ken arrives. Luca runs to him and is scooped up and tossed in the air. We haven't talked much lately. His living situation is a mystery. I don't press for details. I'm happy he's here with us now. He walks toward me and leans in for a kiss.

We talk, eat, and are extra-lighthearted for Luca's sake. His young heart cannot make sense of why his daddy had moved out of their home, but his old soul knows life has changed. It's been rough for his mama too. I want to kiss away their pain.

But motherhood is more complicated than that. Maybe writing about Mother's Day is difficult for me because I don't believe I am worthy of giving advice or sharing anecdotes. Perhaps I'm struggling because I don't have the answers.

The day ends the way it started, lying in bed, thinking about motherhood. Today was a good day. Everything is going to be okay. My kids have seen me rise from the ashes time and time again. I've shown them by example that no matter how bad things seem, there are brighter days ahead.

❈❈❈❈❈❈

I lean on the doorjamb of the guest bedroom. Sunlight pours through three huge, east-facing windows. The space is bright and beautiful, fresh, and somehow new. All traces of Cal's two

years of living here with me are gone. I am relieved; another chapter closes, and a new boundary is drawn.

Cleaning and emptying my home of his stuff was not how I intended to spend the precious remaining days of my summer break. But, after I asked him to move out, he vanished—no communication, never answered my calls or texts. It was as though he had been abducted. The mess he left took two full days to clean up. Now neatly boxed and stored in my garage, he can get his belongings anytime. I'm not completely heartless.

I'm pretty sure he lives with his girlfriend. When her drama started impacting my life, he had to go. I didn't feel bad. His choices were not my responsibility. Over twenty-five years since our divorce, and I finally get it. All those years, all those choices, were his. I didn't owe him a thing.

I straighten the pillows on the bed and smooth the duvet. Cleanliness and order restored. If only clean slates in life were as simple. I pick up the last box for the garage and head downstairs.

I open the garage door and run my hand along the inside wall and try not to think of spiders as I search for the light switch. I catch the switch and give it a flip. I stack the box with the others and wipe my dusty hands on my shorts. I should shower, but my stomach growls for breakfast.

My pink beach cruiser bumps along the pitted, potholed alley. I check left for oncoming traffic, pick up speed, and hit the street. A perfect Southern California day, breezy and warm, and not a cloud in the summer sky. I prop my bike against the lamp post and take my place at the end of the line at the coffee shop.

A young man in front of me looks familiar. With his build and his mannerisms, he is the ghost of Andy past. I listen as

he places his order, amused by the similarities. And then he gives his name, Andy.

I am startled out of my fascination by the proprietress's grouchy demand for my order. I usually preempt her crabby ass greeting with a cheery hello. Lost in my daydream, I missed my opportunity, and she's already annoyed. I pay for my veggie bagel and mocha. She shoves my change at me, not even a "thank you."

I pull the local section from the newspaper and sit at my favorite table. I shove a couple sugar packets under one leg to steady its wobble. I lift my head in time to see Andy's time-traveling doppelgänger leave. Is this a sign? Or do I want it to be a sign?

For the first time in a year, I consider calling him. I compose a text instead:

> Me: I stand in line at the coffee shop, behind a young man. I notice his dark brown hair, thick and straight, and the way it falls around his ears. I check out his build. I think to myself, "Hmmm, from the back, he looks like Andy, twenty-five years ago." Then I read the words on his T-shirt. "Lucky Bastard." I smile and laugh a little. You were always lucky. He orders his coffee, an Americano. I smile again, your favorite. When asked his name for the order, he responds, "Andy."
> Weird, right? Would it be okay if I call sometime? I hope you are well.

I assess my motives. Friendship—I think. What if he does not respond? It's cool, I can live with that. Why now, why today? I'm feeling brave. I hit send.

The ponytailed server calls my name; I wave, and she brings my food to me. I peel white sandwich paper away from the bagel and do my best to keep the ingredients from spilling out. I take a bite and remember why I take abuse from the bitchy owner—it's so delicious. My phone pings, and I tap the screen, leaving an avocado smear. A text glows.

Andy: What? Are you kidding? Call me.

I hear the joking disbelief in his tone, and I laugh. I'll call in a day or two. His reply is enough for now. I wonder if it had been necessary to completely cut Andy out of my life. At the time, it was. I wanted him too much to settle for friendship. Maybe I'm ready to be friends, without benefits. My phone pings again.

Andy: Wait, were you asking to call
me, or the guy in the coffee shop? If it's
me, yes, call. If it's the guy in the coffee
shop, I'm going to say, no.

I laugh out loud, drawing the attention of the customers sitting near me.

Me: Very Funny; YOU, I'll call YOU
sometime this week. Xo

I stop and think: really, xo? But I write that to everyone. It's how I sign off. *Relax, Christine, be yourself. It's all you can be.*

✳✳✳✳✳✳

The classroom is noisy and chaotic. Teachers clutch their coffee and plan books as they find their places at student desks. The hosting teacher apologizes for the mess. Everyone laughs and shares stories about the disasters back in their own classrooms as they prepare for the first day of school. After a few more minutes, I ask everyone to find their seats. My phone rings. "Andy" flashes on the screen. I mute the call.

I welcome everyone and run through the first few agenda items. Then I turn the meeting over to our assistant principal and data expert, Molly. I turn off the lights, and the classroom illuminates with multi-colored graphs and pie charts projected on the large screen.

Standing at the back of the room, I peek at my phone. He left a voicemail. I'll listen to it later. It's been over a month since we last spoke. A conservation I put behind me, until now. It started fine; we exchanged friendly hellos, he told me about his girls, and I told him about Luca. Then there was a moment of dead air, and I unraveled. My nerves got the best of me. I talked incessantly about writing and my transformation year: yoga, meditation, the Illuminators, my ex moving out, swearing off men, conquering fears, blah, blah, blah, blah! A self-help zealot on speed, I couldn't shut up. Even as I spoke, I imagined Andy looking confused and thinking, "Okay, I get it, you're a new you."

I kept blabbing, never waiting for an acknowledgment or response. I was afraid to let him talk; afraid I'd hear disinterest in his voice. But I was also afraid of his kindness, his caring way. I was afraid of wanting him all over again. In the end, he was polite and sweet, said he'd stay in touch, how good it was

to hear from me, and he was so happy we were back in touch. And then, like always, "I love you."

After his "I love you," I waited for "And I want to be with you."

I hated that I wanted him to want me. What the fuck?

When we ended the call, I knew I needed to create emotional distance. It wasn't hard to do. Within days of our talking, Ken hit another low; he was homeless. And Tara's separation was heating up. Poor Luca was feeling heartache not meant for little boys.

I spent the remainder of my summer break keeping anxiety and depression at bay. I used my blog to work through rough patches. I wrote about Ken and coming to terms with the hurt we have caused each other. I do my best to love him without falling victim to his masterful manipulation. I wrote about Luca, the joy he brings me, and the second chance I have been given to help a tender heart stay intact. I evaluated my year of no dating and my desire for coupledom. I took lessons from the relationship lotto winners in my life. I wrote of vulnerability, unconditional love, gratitude, and the mantras I keep on the tip of my tongue. Yep, this self-improvement stuff is not for sissies. It takes practice, and there is no letting up because life will throw a curveball when you least expect it.

My brain returns to the meeting, and the data and charts come back into focus. I offer a convincing comment that has my staff believing I'd been paying attention all along.

✻✻✻✻✻✻

Almost dark, the campus is quiet. Alone in my office, I put my phone on speaker and listen to Andy's message. The familiar raspiness of his voice draws me in. The way he gives his first

and last name to identify himself, as if I would not know him otherwise, is sweet and funny. He says he was thinking of me and wanted to hear my voice. He pauses and then a quiet, "Love you babe, talk soon."

Aren't those words reserved for girlfriends and lovers? Aren't I just a friend? If I had taken the call and heard his words in real-time, I would have returned the sentiment. I don't know how to be any other way with him. He said once, "I love you, Christine. The words are a true expression of my feelings for you, and I give them freely."

I wanted to say, "But when you say those words, you give me hope that there will be something more. They have a hold on my heart."

But I don't say it because I love to hear them. I listen to the message again because it feels good, but I don't return his call. Instead, I send a text, *Thanks for the sweet message. Super busy day, first day of school tomorrow, xoc.*

Driving home, I repeat my small prayer three times, "I am peaceful, I am present, I accept what is."

And then I follow through with a promise I made to myself. I check in with my kids without giving advice. I call Ken first. I get his voice mail, "Hi sweetie, just wanted to say hi, would love to see you. Hope you are well. I love you."

I have zero expectation for a callback. Then I call Tara. We talk about Luca, her frustrations with his dad, and with her dad, and I listen. When I'm tempted to interrupt or judge, I chew on my lower lip. Tired and sad, she thanks me and says goodnight. I think I was helpful. My time and energy are best spent improving the important relationships in my life. I put Andy on the back burner.

CHAPTER 25

Fall 2015 through Winter 2016

I'm in the middle of a text and the night custodian, Frank, pops his head in my office. "Can I vacuum around you?"

I should have left hours ago, "Give me a few minutes to wrap up, and I'll be out of your way."

It's the anniversary of Andy's dad's passing and the day before Andy's birthday. During our year of silence, I didn't acknowledge either. I was mad and sad, and I didn't think he deserved my thoughtfulness.

But what about this year?

Text
November 11, 2015
Me: Sending a little love and light your way as you think about your dad today. I'm sure you have many happy memories that make you smile. He's smiling down on you for sure. Xoc

Andy: You are my angel xoa

Two years ago, when Andy first told me about the date of his dad's passing, I told him about the magic of numbers 11:11. The appearance of the consecutive numbers is a message from the heavens, the presence of spirits. I like to believe it's a sign of an angel. I hoped that he would think of his dad each time he saw the numbers. Months later, he asked, "Did you make up that 11:11 stuff?"

I laughed, "No. It's numerology. I read about 11:11, and it just stuck with me. I see it everywhere."

The very idea that Andy thought I made up the story, made me think that *he* thought I had some kind of magic, that I was special. These are the small, sweet details that really fuck with me. I tend to turn a small instance into a reason to love someone for longer than I should.

My ex Alec would say, "You can't separate the fly shit from the pepper."

I give Frank the all-clear signal and head for home.

❀❀❀❀❀❀

After midnight, I reach for my phone.

> Text
> November 12, 2015
> Me: Happy Birthday! Hope you spend
> the day doing the things you love with
> the people you love. xoc
>
> Andy: Thank you xoa

❀❀❀❀❀❀

The guys play ping-pong and corn hole, and the kids take turns throwing a slobbery tennis ball to Susy and George's Lab, Kimmo. I collect plates and glasses and carry them into the house. I'm sure Susy can use some help with round one of the Thanksgiving clean-up.

At the kitchen sink, she washes dishes as fast as she can, making plates and silverware available for the next wave of guests. Family events at her home are famous for getting a second wind and continuing until the early morning hours. I merge plates of appetizers and entree dishes, freeing up counter space for desserts, then I grab a dishtowel and start drying.

I hear Ken's voice before I see him. He has just arrived and greets his cousins. Passing through the kitchen, he gives me a casual peck on the cheek and then introduces me to his new girlfriend, Avery, a petite blonde and incredibly thin. Beneath the layers of bronzer, smoky eye shadow, and mascara, I can see she is a naturally pretty, young woman. Glassy-eyed, she takes my hand and looks straight through me. She is high as a kite; her words are labored and slow, speaking as though her tongue is swollen. I am gracious and pretend not to notice. She and Ken dish up plates of food and head outside. Will there ever come a time when I won't have to worry about my boy's well-being, when I'm sure he is safe and sober? I try to be grateful for his presence, that he chose to come here today, to be with his family.

<p style="text-align:center">✳✳✳✳✳✳</p>

Sitting at my kitchen table, I write my Christmas cards. When my kids were young, I always included their most recent school pictures, their ages scribbled on the back. I started a

new tradition with Luca—the two of us on my Christmas card. In this year's photograph, my arms are around him. He sits in my lap and smiles his little jagged-tooth smile, my joy captured.

I stack the completed cards and then search my phone contacts to make sure I haven't missed anyone. Scrolling the names, I catch a few obvious omissions. My memory is not the steel trap it used to be. I come to Andy's name, and I pause.

Even though we've cleared the air and left the door open for friendship, the path is overgrown with weeds. It's not that I don't want to talk to him; I do. But I'll want more. More time. More distance is what I need. So, I don't call, and he doesn't call me. Maybe he has problems of his own.

I admire the artful display of holiday greetings I have already received. The counter to ceiling travertine looks like a gallery wall, a shrine to years of love and friendship. Without a second thought, I take a fresh card from the stack and write, "A., BIG LOVE from my BIG heart, Merry Christmas."

A card to a friend. That's all.

Christmas morning, I wake up to a quiet, empty house. Before his parents split, I would have been at Luca's house, watching him open his gifts from Santa. Today he is with his dad. I'm sad that he has joined the ranks of children who are shared on holidays. Bah, humbug. I go downstairs and shuffle around the kitchen. In the living room, presents for my family wait to be opened. It's the calm before the best kind of storm, the chaos of my family eating, drinking, and celebrating. *See Christine, be grateful; there are so many reasons to be grateful.*

Before long, the house is full and loud. I gather dishes, replenish drinks, collect trash, and enjoy every minute of the craziness. I pick up my phone lying among the dirty dishes

and move it to a safe place. I see a text from *Andy, Merry Christmas xo.*

And then a second text that surprises me. *Love you.*

I respond, *Love you back.*

Without analyzing, overthinking, or creating a story in my head that paints me as desperate or needy, I accept the love of a friend. We can be friends. I let it be.

✲✲✲✲✲✲

After a long walk through Chrissy Field, Molly and I stand at the water's edge, looking toward the Golden Gate Bridge. Every time I visit the city, the weather is always unseasonably and unbelievably perfect, warm breezes and fog-free. I love San Francisco, and I have thought more than a few times about living here. But I'm a warm weather gal. These picture-perfect days won't fool me. I wouldn't last one summer here.

It's the long President's Day weekend and Valentine's Day too. Molly and I joked with our colleagues and friends about our romantic getaway. It was better to take a fun trip than be at home, dateless, on Valentine's Day.

We decide to walk the four miles to the Ferry Building, but first a cup of coffee for a needed boost. Waiting in line, I tell her about my Saturday meditation group. "I found them through the Illuminators. I told you about the Illuminators, right? Anyway, it is my solace, where I generate calm and clear my head. It's exactly what I need to keep my anxiety away and feel peaceful."

She asks, "Have you thought about dating again?"

"Well, I'm more open to the idea. But I'm not in any kind of active pursuit. I keep hoping for something organic. I thought

I might cross paths with a man who would make me think twice, or at least look twice, but no."

I chuckle, "Perhaps the Universe knows best; I'm not ready."

And then I'm honest. "Maybe my heart is closed for business because deep down, I still love Andy."

I fantasize about someone coming into my life. This new man has all the qualities I love; he sees my inner beauty, as-is. My cell pings. I pull it from my pocket and read the text. Unbelievable, I shake my head. I swear, I don't know how he knows when I am ready to move on, but somehow, he does.

Text
February 14, 2016
Andy: Happy Valentine's Day XO

I don't return the sentiment immediately, but I will. His hold on my heart is stronger than my will to let him disappear quietly into my past.

CHAPTER 26

Spring 2016

Frenzied, hurried days no longer rule me. Peace and solitude are the goal. I'm more grounded when my thoughts, actions, and decisions begin quietly within me.

I spend my leisure time in good company, and every chance I get, I steal away with Luca. The happiness he brings me lingers long after he goes home. I need him; I need all of this to put the hard parts of life into perspective.

Ken's problems pile up: unemployment, homelessness, and hopelessness. He and Avery made a brief stop at Christmas, staying long enough for me to see nothing had changed. They wander from friend to friend and couch to couch, burning bridges. Seems they are always the victims, getting the shaft. I can't hear it anymore.

Long periods of silence between us are a blessing of sorts. I use the time to build my reserves. I bank peace of mind and emotional strength. And I write to make sense of his struggle, our struggle.

Blog Post,
March 31, 2016
A Mother's Hope . . .

There is a boy I love. I dreamed of him and what he might be before I ever met him. Blonde and blue-eyed, smart, and funny, an old soul with the kindest heart I would ever know. Born long before ultrasounds were common practice or gender reveals became a celebrated event, my boy came into the world exactly as I had dreamed him, perfect. Good-natured and healthy, he rarely cried or fussed. I imagined a happy childhood, a bright future, a good life.

Barely eighteen, with a boy so sweet, I wished to be only his mom. When did I decide that I needed more? It's hard to remember now. But I do remember giving my baby a bath, every night. I washed his hair and combed through his wet curls while he hummed and chewed on bath toys. Wrapping him in a hooded towel, I buried my nose in the creases of his chubby neck and took in his sweet baby smell. I remember the small green wooden rocker in the corner of his room. Bought second hand, a chip on its arm revealed two or three coats of paint, yellow and white, I think. I rocked him to sleep, quietly singing songs my mom taught me. So peaceful. And I remember the weight of his baby body as he fell asleep on my chest, my hand gently patting his back. Happiness was so easy.

A grown man now, well into his thirties, I rarely see him. Though he occupies my thoughts

every day. I know little of his life and nothing of his pain. His random texts requesting a shower, or cash, suggest the possibility of rock bottom. Other clues come by way of mail or phone calls. Indicating that he is knee-deep in debt, and his addiction, with nowhere to go.

I've helped him in all the wrong ways, for all the wrong reasons, most often driven by guilt. Heartache gets the best of me, and I let him cross the line again. In weak moments, I cry out loud. Mad tears flow. I'm so pissed! Cheated by an addiction that is not mine. I wish we could begin again, the two of us.

I must accept what is, to find peace within me. I look for gratitude and expressions of love in the ordinary days of my daily life. But it doesn't keep me from waking up in the middle of the night, wondering if Ken is safe and warm, or alive. In the darkness, I ask the Universe to help my boy. I beg God, the angels, my mom and dad, anyone who will listen, "Please, please help him find his way, please help him find peace." I want the boy I remember, the boy who loved to make art and talk about the mystery of black holes and heaven.

It's hard to find that boy in my memories. So, on a quiet afternoon, I went looking for him in a dusty box of old photographs. And I found him. Laughing with his cousins, celebrating his First Communion, chasing goats on his grandma's Oregon farm, fishing with his dad, and kissing his grandpa. I saw him and remembered his happiness. How did we grow so far apart? When and how did

addiction sneak into our lives? How did I let this terrible thing infiltrate my family?

I've been accused of turning my back on him, being unsupportive. I don't try to defend myself. Instead, I've found people willing to support me, to share their pain and their vulnerability, and allow me to do the same. They remind me that I am not a failure, and neither is my son.

I want to believe my son's beautiful spirit lies intact beneath his pain. I want to believe there is still hope for my boy, hope for a good and honest life.

We have so much healing to do, my son and I. I love you, my boy, no matter what. I always have, and I always will.

xo

I think it was my mom who once said to me, "You are only as happy as your saddest kid."

✽✽✽✽✽✽

Scrolling social media, a post piqued my curiosity—a call for writers for a magazine, *Holl and Lane.* Applicants must provide a sample of their work. I send a link to my blog. I've got nothing to lose.

✽✽✽✽✽✽

I pay attention to the tide, careful to avoid soaking my tennis shoes. A few sunbathers brave cool spring temperatures, and kids build sandcastles. It won't be long before it's too crowded

for me to walk this close to the water, at least for exercise. That's the beauty of living at the beach; I enjoy it year-round, so summer crowds never bother me.

At the suggestion of my yoga teacher, Diane, I stopped listening to music or audiobooks while I walk. I don't miss the distraction. My senses attend to the sounds of breaking waves, the seagulls' shrill, and people noises. I pass a tall, lean surfer, squeezing into his wetsuit, and think of Cal. It's been months since I blocked his cell number and email. I had to. His girlfriend used them to harass me, and he let her. When I told him about it, he was less than concerned about me or my well-being. I didn't get angry or upset. I walked away, no hard feelings.

The tide rolls over my Nikes and soaks through to my socks. Shit.

❋❋❋❋❋❋

I sit with my soccer mates on the patio at the Old World German Restaurant, rehashing our morning game while a match plays on TV. The guys share pitchers of beer, and I drink a cold glass of Schofferhofer, a grapefruit beer. I'm torn between two fried eggs atop pork schnitzel and red cabbage or liverwurst on rye served open-faced with sliced tomatoes and pepper. I decide on the latter and place my order with the lovely Rita.

My soccer pals are family. They knew my dad. Many of them played with him for years. Konrad and Gary, in particular, were long-time friends. I'm caught off guard when Konrad asks, "How is Ken?"

I swallow hard, "He's okay."

Gary chimes in and presses for more information, "What's he up to? Why isn't he coming out to play anymore?"

He came most Sundays when his grandfather was alive. I choke up. Konrad puts his arm around me; I manage a few details, "He's having a rough time. Drugs. I'm not really in contact with him. I don't know how he is or what he's doing."

Neither he nor Gary ask any more questions. Both apologize. Not for anything they said or did, but because they can see how sad I am. I regain my composure, and if anyone noticed my weepy scene, they pretended otherwise. Thank God.

Tara arrives with Luca. She leaves him with me so she can have time to herself. I show him off to my friends. Polite and sweet, he greets everyone. His visit lasts about as long as it takes for him to circle the bar, say hello, and finish the chocolate treat Konrad has purchased for him.

At home, we watch YouTube videos about haunted mansions and sour candy-eating contests. Almost five years old, he has all kinds of ideas for his own YouTube challenges.

Happiness with Luca leaves less time for sad thoughts about Kenny.

<p style="text-align:center">�֍�֍�֍✖✖✖</p>

Saturday morning at Peet's in Belmont Shore, I sip my mocha and wait for Phyllis. Her black coffee waits too, steam escaping the tiny hole in the lid. Through the large glass window, I see her round the corner, and she flashes a smile. We became friends during my time in Los Alamitos. She supervised and trained paraprofessionals who worked with children with autism. I was attracted to her humor, laughter, and compassion for children with learning disabilities. I think she would say the same about me.

We share a hopefulness that is sometimes naive, and we love the mysteries and magic of life. A few years older, Phyllis

lived my stories before I did. She knows my happiness and sadness as if it is her own.

We hug across the table. "So good to see you," she says. "You got my coffee too!"

She removes the lid from her hot brew and blows away the steam. Then she looks at me. "Your skin looks great."

I grumble, "Really? All I can see are the giant bags under my eyes, and all my wrinkles."

I put my fingertips on my temples and pull my skin toward my ears.

She whispers, "Stop. A really cute guy just walked in."

Reaching for my hair, she arranges it on my shoulders and tells me to smile. I laugh, "What? No."

But I obey. I sit up straighter and smile. She frowns, "Shoot. Never mind, he's wearing a wedding band."

We both start laughing. I turn to take a look. He is pretty cute. Oh well.

My phone pings, a text from Ken. He needs money or gas or both. I don't respond. I tell Phyllis. She sighs because we've said all we can say on the subject of my boy. We finish our coffee and promise another meet-up soon. My Saturday guided meditation is a couple blocks away, and I've gotta run.

Skipping steps, I climb the stairs to the studio for an hour of breathing, grounding, connecting, and letting go. Ken's text gnaws at me. I'll respond after class, with a clearer head.

�֎✖✖✖✖✖

Renewed and refreshed, I agree to meet Ken at the gas station and put gas in his car—no cash. I remind myself to be pleasant, ask how he is, and not lecture. If I choose to help him, it comes from my heart, no strings attached.

I spot his truck. In the back, Bubba, a sweet pit bull mix, slobbers and wags his tail when he hears my voice. Ken emerges from the restroom. We hug, stiff and awkward, like we're out of practice. I slide my debit card; he lifts the nozzle and pumps the gas. I ask how he is, and he says, "I'm moving to Ohio."

Not sure I heard him correctly, I ask again. Yes, he is moving to Ohio. I take a deep breath and do my best to stay neutral. "That's quite a move. Why Ohio?"

"Avery has family there, and we'll have work."

My face gives away my worry, and he adds, "Mom, I have to go. I have to get out of here. We're both clean right now. We need a new start. I need a new start. We're leaving on Monday or Tuesday."

I listen to the details, "Sounds like you've really thought about this," and I wrap my arms around him, like the old days.

✿✿✿✿✿✿

He does not leave on Monday, or Tuesday. His truck is repossessed, with his phone and wallet inside. He blames bad luck but is still determined to leave. He begins work on Plan B and goes silent, no communication.

Two weeks since coffee with Phyllis, two weeks since Ken told me he was moving to Ohio. Maybe he'll call today—it is Mother's Day. I play a great game of soccer, enjoy a delicious brunch with friends, and then meet Tara and Luca at my house. No word from Ken. I sit with my girl, and we watch Luca play. He explains the imaginary functions of his latest Lego creation and my phone rings. It's Ken, "Happy Mother's Day!"

"Thanks. Where are you?"

"In Arizona, on our way to Colorado and eventually Ohio."

He did it. He made it happen.

He tells me about a herd of elk he saw and the crazy thunder and lightning he experienced. He sounds happy, really happy.

I wish I had had a chance to say good-bye, in person. And then, I remember. The day after we met at the gas station, he came by the house to collect some of his things from the garage. When he finished, he shouted up to my bedroom from the bottom of the stairs, "Mom, I'm leaving for the night. I'll get the rest of my stuff later."

I stood on the landing, looking down at him. A dull, achy lump in my throat grew. I walked down the stairs and stopped before reaching the bottom, making myself taller than Ken, who stands six-two. He reached up and hugged me tightly. I had to stoop down to hold him close. My body shook as I cried. "Mom, this is best for me. I'm going to be fine. This is going to be a good thing. I love you."

On those stairs, we were mother and son, our true selves. Both of us free to love, undamaged by years of addiction, blame, and hurt. Safe travels, Kenny P.

CHAPTER 27

Summer 2016

A quiet Friday afternoon, I could go home, but instead I stay late to delay the inevitable—the quiet drive home and a dateless night. Outside my window, a squirrel runs up a tree, and a smile forms on my face. Three years in, and I'm proud of the work my staff and I have done at this school. The ping of a text brings me back to earth.

Andy: Meet me for a drink. Xo

Nearly two years since I saw him last, without a second thought, I say yes.

Ridiculously happy, and fueled by nervous energy, I run up the stairs to the terrace bar. I stop short of the landing, apply fresh lipstick, and smooth my dress. A few more steps and I'm squinting into the late afternoon sun, methodically scanning the patio clockwise. There he is, his familiar profile and a little more silver in his hair. He enjoys the beautiful view. His tie loose, the sleeves of his white dress shirt rolled to his elbows, he is not looking for me. He knows I'll find him.

He hugs me for a long, long time. I relax to let go, but he tightens his hold. When he finally releases me, I shake my head, "Why does it seem that no time has passed, as if I saw you yesterday?"

He steals a phrase from me, "We're magic that way."

We move to the shade. Side by side, we swing and sway in wicker hanging chairs. I anchor myself with one foot hooked around his ankle and the other resting on his shin. We are easy. Unlike our phone call a year ago, I am calm and clearheaded. Remembering my big news, I lean forward, "Oh, I almost forgot to tell you. A small publication asked me to write an article about family, for their fall issue. I'm super excited."

"Babe, I'm so proud of you. So great."

I'm proud of me too, but I don't say that. Instead, I beam as my inner voice whispers, "You called me babe."

"Hey, let's have sushi. I'm not ready to drive back to LA."

Again, I say yes. I always say yes to Andy.

✵✵✵✵✵✵

We walk through beaded curtains into the dark bar. Amy, a fixture at Matsu for years, waves. She's seen the parade of husbands and boyfriends I've marched through here. The first time I came with Jake, she commented, "Oh, he so handsome. Better than the other guy."

She greets me as she always does, "You so beautiful, you look so good."

Andy smiles, "She is beautiful."

I pray the exchange stops here. I change the subject and ask for a table in back. She leads us to a private corner, and I wonder if she thinks I'm cheating on the handsome dude. I chuckle to myself.

We settle into the comfort of our booth, sake in hand, and toast.

"To us," Andy says.

"To us," I echo.

Feeling brave, I ask, "Why do we let so much time pass? It's not as though LA is in another state. I mean, first, we didn't speak for a year, and we haven't seen each other for two years. Why do we do this?"

He doesn't answer, and I keep talking, "You promised me you would call. You said if I didn't call you, you'd call me, but you never did. I called *you*, after a year!"

His breath warm as he whispers in my ear, "I couldn't. I'm sorry, I just couldn't. You were so hurt."

It's the truth. I was hurt. But is that a reason to not keep a promise? I suppose he thought he was keeping me from further hurt. I could press for more, make him explain, but I don't. I accept my interpretation of his words and let it be.

After a moment of quiet, I tell him, "I'm considering moving to LA, probably Venice. I want to be near the beach. I've been toying with the idea of out of state as well, or even out of the country. Italy maybe."

I go on, "I'm in the idea stage. There's lots to consider, work, family, stuff like that. I love my job, but I'm restless. I think I need a change."

He says he is restless too.

He points to his cheek, and I kiss it.

In the parking lot, we stand between our cars. Face to face, he pulls me close and presses hard against me. Our physical attraction has never waned. I grin, "I can feel you."

We kiss, and I see yesterday, today, and always.

❋❋❋❋❋❋

Surrounded by neatly organized bills and receipts, I sit cross-legged on my turquoise sofa. My laptop rests on a pillow between my knees and illuminates my makeshift home office. I click away, reconcile accounts, schedule payments, and catch up on work. The TV provides mindless background noise. The sun sets, and I notice the change in lighting—a pink dusky shade more suited for sharing a bottle of wine than paying bills. Maybe I'll have a glass.

Tara calls. The weekends tend to get away from us, and we find each other on Sunday evenings. Luca is asleep; she says he played hard today. I wish I had carved out some time for them. I am drawn back to her voice and her words. Her speech slows, and then stops. She is crying. Clearly, she had changed the subject.

Weeks ago, she and her dad had a big argument. At the time, she felt strong and justified in her resolve. She called him on his bullshit, his inability to keep dates and promises. She set boundaries to save herself and Luca from further pain.

Tonight, she struggles to make sense of his choice to be absent, his willingness to disconnect from her, and Luca. For the first time, my daughter realizes that her dad's mistakes are his own. His messy life is a result of his doing, the choices he made—not mine or anyone else.

Her epiphany does not bring me vindication. There was a time when I wished for the day she would learn that I was not so bad and her dad was not perfect. And while I am glad that I have grown beyond that selfish wish, I am not prepared for how awful I feel as she cries. During a year in which her marriage ended and her brother's addiction exploded, I am sure she hoped she could count on her dad for support.

She lets it all out. There is nothing for me to say, except, "I'm so sorry. I love you."

I lean back on the sofa and blow out the heaviest sigh. I have been divorced from her dad for nearly thirty years, yet my instinct is to take responsibility for his behavior and my children's hurt. I blame my twenty-something self for not putting her kids first. I wanted to spend my free time chasing happiness. But I'm here now, and that matters.

✳✳✳✳✳✳

Text
June 20, 2016
Andy: When are you moving to Venice?

Me: I'd move today if I could :-) . . .

Andy: . . .

Me: An ellipsis is punctuation that is used to show where the words have been left out. The ellipsis is usually formed by three periods (four if the ellipsis comes at the end of a sentence). What are you leaving out?

Andy: I didn't leave a thing out. It is known. I love you.

Me: I love you. A constant of my heart and soul

Text
June 25, 2016
Me: How are you on this beautiful day?

A few days pass, and I don't hear from him, not a peep. I am checking my phone far too often. I stop.

> Text
> June 30, 2016
> Andy: I'm in Habana, Cuba. Arrived on Saturday with my mom, brother, sister, nieces, and nephews. It's lovely, truly magical.
> Perhaps you can explain to me why you are in all of my dreams since I arrived. So tender, vivid, sweet, and intimate . . . I have very limited reception, but I wanted to ask you that question. And let you know you are in my thoughts constantly. I do wish you were here with me.
>
> Me: I love you, Andy, always have, always will. I'm in your dreams because I'm in your heart. And even though you don't see a place for me in your life, your heart knows the truth.
> I am with you.
>
> Andy: And I always feel your love. 8:30PM in Havana . . . You are with me.

Even in my smitten state, I am aware of the contradiction of my heart. I pretend I don't need him or want him. And yet, I want to be released from his dreams and invited into his life, for real. I want to be the one.

�֍�֍✤✤✤✤

We laze on the sofa, our bodies tired and heavy from the travel of the last few days. I flew in from Napa this afternoon, and Andy arrived from Cuba late last night. My skinny jeans and giant belt buckle are not conducive to making out on the couch. I borrow a pair of his sweatpants, so we can cuddle up more comfortably.

After a while, he struggles to stay awake. Time for me to go. I give him a quick kiss and go to the bedroom to change into my jeans. I neatly fold the sweats and put them back into the drawer where I found them. I notice a black and white photograph of his girls on the dresser. They are so little. I wonder when I'll meet them. In my underwear, I step into my jeans. Andy walks in, catches me in mid-dress, and says, "Don't move."

I know what he has in mind, and I don't even consider saying no. In seconds we are naked.

Beneath his weight, I catch my breath and playfully smack his ass. He rolls off of me and says, "I did not plan that."

With the emphasis on not. What does that mean? Defensive, I shoot back, "Well, neither did I."

I was perfectly happy to go home, to end the evening believing Andy wanted me without sex. Now, I'm pissed. And before I say something I'll regret, he says, "I don't regret it, at all."

✤✤✤✤✤✤

The tiniest sliver of light comes through the window. The soft rustle of sheets and my breathing should provide calm. I count to four as I inhale. I hold for four counts, and then

exhale for four more. I repeat this pattern several times to quiet my mind. But I cannot make it work. Annoyed, I reach for my cell phone on the nightstand and check the time, 3 a.m. Another hour lost to insomnia, three sleepless nights this week.

Lying on the right side of the bed, I sweep my arm through the cool sheets into the empty space on my left and imagine a better half. I look again at my phone, 3:20 a.m.

After a few more failed attempts at sleep, I give in to dwelling on the lack of development in my relationship with Andy. Sex didn't materialize into anything more serious, and communication between us has become sparse. His pattern with me is close, then far, close, then far. Away from work, his girls, and life in LA, he finds me, a soft place to land. But once he is back in his grind, I fall away. It's foolish for me to believe I can change people with love.

Three-fifty a.m., my lids are heavy. I stretch the width of my bed and retreat to my side again.

❈❈❈❈❈❈

Blog Post
August 7, 2016
I Choose . . .

Looking toward Catalina, I can make out its faint silhouette in the low summer haze. I wonder if the nearby French-speaking tourists know there is an island in the distance. To the untrained eye, it resembles a long and low hanging cloud on the horizon. While the skies overhead are beautifully

blue, a surer sign of clear skies is when the rough exterior of the island, its ridges, and fissures, appear close enough to touch. A sight seen in all seasons except summer.

I'm here for the sole purpose of meditation and a little self-love. Resting on my elbows, I push my toes into the sand and look down at my toned and tanned legs. Sure, they show signs of aging and too much sun, but not bad for a woman in her fifties. Long ago, I traded in my iodine-laced baby oil for sunscreen and a big hat, but I do allow my skin to brown.

Funny how we choose our vices. Flooded with information, the dangers of sun exposure, smoking, and poor eating habits, we still ignore the facts and make choices that suit our lifestyles. The same is true of the health of our minds, hearts, and souls. We pile up life lessons, some extremely painful, and hopefully gain wisdom. But, sometimes, we don't. We repeat mistakes, the same mistakes again and again. Certain that somehow, this time, there will be a different outcome.

In the last month, I have received several opportunities to respond differently to recurring challenges in my life. Each time a situation arose that tempted my heart or pushed my boundaries, I was keenly aware of the choices I could make to avoid suffering. But I reverted to predictable reactions, leading to predictable results.

With all the work I've done, meditation, yoga, Chakra classes, etcetera, one would think I moved

beyond stupid mistakes. But no. I fight the urge to feel failure. It occurs to me that perhaps the Universe is testing me, saying, "Hey, you have learned a lot about yourself: your underlying fears, the reasons you do the things you do, and what you can do to create the life you want. BUT, when you are tempted to repeat the past, will you use all you have learned to reset those relationships, to forgive, to love unconditionally, and keep your power as the creator of your destiny? Or will you do what you have always done and then feel hopeless and disempowered when you get the same result?"

I brush the stubborn sand off my body and walk to the water's edge. Cooling my feet in the tide, I think about the many times I've been disappointed or dissatisfied with my life. I understand now that it's exactly the life I created.

So, I can ignore the truth of all I have learned, or I can listen to the wisdom of my heart and use my knowledge and powerful inner strength to create something new, something better.

I take one last look toward Catalina and say these words. "I choose something new . . . something better."

xoc

CHAPTER 28

Summer through Fall 2016

Ken's move to Ohio has not panned out—promised jobs and connections fell through. He and Avery inch their way back to California. When they run out of money, they call me, my family, or her family, asking for cash to be wired, hotel bills to be paid. They make it home and quickly fall back into addiction.

There are so many reasons to lose hope every day and reasons to find it again.

> Blog Post
> August 27, 2016
> Finding Hope in Rock Bottom . . .
>
> I walk into the classroom of a first-year teacher. A black line drawing of a turtle, its shell a patchwork of random designs and doodles, is projected on the large whiteboard. The teacher skips toward me and beams, "It's a directed art lesson."
>
> I smile. On every first-grader's desk is a large sheet of white construction paper, revealing

their interpretation of the teacher's instructions. There are small tight curlicues, perfect in their execution. There are good attempts at geometric shapes and interesting patterned squiggles. Some turtles are drawn tiny, hugging the bottom edge of the page. While others are very large, filling the paper, corner to corner.

I crouch between the desks and comment on one masterpiece, and suddenly I am peppered with requests, "Look at mine, did you see my turtle? Do you like mine? I'm an artist too."

Classrooms have always been my sanctuary. As a student, I excelled, and felt my true self in the company of teachers and classmates. As a teacher, I escaped the grind of raising teenagers. I found solace among my loving second graders, always a willing audience. And now, a principal exhausted by my son's return to addiction, more than ever, I yearn for the consistency and comfort of the classroom and the promise of those little faces.

Wandering between desks, I pause. A little boy looks up and asks, "How about mine, do you like mine?"

"It's fantastic," I say.

Full of pride, he explains his design choices, tracing them with his finger, his voice trails. I notice the name tag taped to his desk, only the last four letters exposed, but they are distinct. "You have the same name as my son."

He laughs and says, "I didn't know that."

As if we are old friends and this is a little fact

he should have known about me. "Where is he?" He asks.

My throat tightens as the lump grows. I successfully hold back tears and say, "He's a grown-up. He lives away from me and doesn't go to school anymore."

Satisfied with my answer, he turns his attention to his tablemates. I move his pencil box to reveal his full name, beautifully written in perfect teacher print; I say it out loud, "Kenneth."

Lost in my thoughts, I imagine my boy sitting right here, inattentive, and impulsive, completely missing the lesson's directions. Still, he would have created something beautifully different, something I would have loved and proudly added to the refrigerator gallery. My boy was, and is, smart but never loved the work of school. He loved art, friendship, and belonging.

Before my emotions get the best of me, I wave to the teacher and quietly slip away. The last twenty-four hours have taken a significant toll on my heart. I recount the last few days, still surreal. I received a call at work; my neighbor hysterical as she described police surrounding my son, guns drawn, he is arrested. He calls me, begging me to post bail. He is crying, and I am crying. I close my office door, "Please, Mom, I am your son, please don't leave me here, I won't make it, I'll lose my mind, Mom, please listen to me. I swear I am going to rehab tomorrow, I have a plan, why does bad stuff always happen to me, don't hang up Mom, please, please I'm begging you, listen to me, please

help me, I promise to never ask you for another thing. I mean it this time; I have to go to rehab. I have to. Please help me, Mom."

I cannot seem to say the word "no." But I don't say yes either. Instead, I tell him I cannot make any promises. He has lied too many times, and the help I have given has only hurt him, delayed his recovery. He wails and begs one last time. I tell him I love him and end the call. His cries play over in my head, so childlike, a boy who needs his mom.

He called me two more times, but I did not answer. I could not bear to hear him cry, and I would not say what he so desperately wanted to hear. I would not rescue him. It is up to him now.

I walk toward another classroom, looking for more peace. As I enter, children lift their heads, look my way, and smile. Some get up and hug me, and others call me over and proudly show me their work.

Despite everything, I am still hopeful. My boy will make art again, he will know the love of family and friends, he will remember how much he loved belonging, and he'll wonder why it took him so long to come home.

Xoc

Ps BIG love and gratitude to my friends and family. You are my strength. I love you all.

I think about calling Andy. To say what? "Hey, my kid is in jail. Wanna chat?"

Shouldn't it be enough that I have the love and support of good and important people in my life?

�֍֍֍֍֍֍

"Mom, I gotta spot. I can't believe it. I'm in sober living. I have a bed tonight, and I'll be here for sixty days. I had to test as soon as I got here, and I wasn't worried because I've been clean since my release from jail."

He tells me of curfews and rules, excited as if he is going to summer camp. I imagine once you've been in jail, experienced homelessness and hunger, sober living feels pretty good. "It's great news, Ken."

"Will you come see me tomorrow, Mom?"

"Yes, I will."

"I've gotta go. I love you, Mom. Goodnight."

✖✖✖✖✖✖

Ken's sober living arrangements are great, but they do not last. Changes in laws and funding that I don't understand cut his stay short. Couple that with Avery exiting rehab before her completion, and he is completely derailed. His priority is no longer his sobriety. His addiction to her is stronger than any drug ever was.

Blog Post
November 12, 2016
Letting Go of Pride . . .

Friday afternoon, I could work a couple more hours or keep a promise I made to myself and go see my son. Quickly scribbling a to-do list for Monday, my decision is made, and I pack my bag. It's crazy to get on the freeway at 4:30 p.m.

I inch along in rush hour traffic and wonder if I'll arrive only to be turned away. Do I have until 5:30 or 6:00 p.m.? I try to remember what I read on the website, but my memory fails. Compulsively, I check my navigation every few seconds. Traffic begins to flow, and I relax a bit.

I have never visited someone in jail, not ever. My son has been incarcerated before, but I always refused to see him, believing somehow that my absence made me a better person. He could throw his life in the toilet, but I would not play along as mother of the inmate. My moral high ground filled me with contempt and judgment.

I drive past the Juvenile Justice building, Orangewood Children's Home, and an animal shelter. Where the hell is Theo Lacy? I park and remember there are restrictions about items allowed inside. Shit, again, I cannot remember the list. I take my keys, ID, credit card, and phone. The garage attendant gives me directions. The jail is the farthest building from where I am. Check-in is 5:30 p.m. I check my phone for the time and break into a sprint.

Breathless, I arrive at a table manned by three young women. One asks for my son's booking number, which I don't have. Seeing my distress, she offers, "No problem. I'll look it up for you; what's his name?"

I'm surprised by the casualness of her questions, as if I'm picking up my dry cleaning. She flips through a thick directory, finds his name, along with his booking number, and writes them

in grease pencil on a plastic ticket I'm to show someone inside.

I head to the visitors' entry and drop my belongings in a tray before going through a metal detector. The deputy stops me, "No phones. There are lockers outside."

I rush to the lockers where I make my next rookie assumption. I actually believe these government issued lockers will be outfitted with a credit card swiper. Nope. I just need a quarter, twenty-five cents, and I don't have it. Even if I had time to run to my car, I know there is no change to be had. I run back to the table and ask one of the women to hold my phone while I visit. She shouts to the line of people checking in, "Come on, who has a quarter? Help her out, do a good deed."

A young woman with heavy black eyeliner, very red lipstick, and purposely ripped stockings holds up a quarter. I squeal, squeeze her forearm, and tell her she is my angel. A tiny smile forms on her ruby red lips.

I pass through the metal detector and wait my turn. There are over a hundred people waiting, mostly young women. They sit in uncomfortable plastic chairs, some with babies in strollers, others with toddlers and elementary-school-age children, laughing and talking. They appear to be whole families. I don't know whether to feel sad because visiting jail is a normal occurrence in their young lives or relieved that despite the circumstances, they seem happy. Elderly folks look tired and sad, maybe too many visits and too much heartache. I

see a few forty-somethings dressed in professional clothes, to visit boyfriends, I imagine, or maybe they are attorneys. I have a story for everyone. I wonder, do they have a story for me? Nicely dressed, middle-aged woman thinks she is better than us, but here she is.

Finally, at the window, I am greeted, "Don't be afraid, we're the good guys."

I quickly answer, "I'm not afraid."

Then he asks, "Have you ever been in jail?"

"What? Me? No."

He directs me to wait until I hear my son's name called and motions toward another waiting area. Eventually, I am directed to the visitors' center. I approach the small window. Only the deputy's hands are exposed. I hand over my grease-penciled ticket. "Go to number eleven," the deputy says.

Turning the corner, I see several stalls with metal stools. I'm surprised to see we will be separated by glass while we visit. A phone for each of us lies on a counter. I wonder if they ever get sanitized, and I cringe a little. An elderly man and woman sit next to me. Their inmate has not yet arrived. Her head rests in her hands. His arm is around her, holding her steady. Their heartache is palpable. I am startled out of my gaze when my son hits the glass. He is smiling.

Each of us, phone in hand, begins to talk. Strange to see him in jail clothes and clean-shaven. He looks good and tells me he is seventy days clean. I smile and tell him I am proud of him. He

asks about his sister and his nephew, and even asks how I am doing. He asks me to encourage others to visit and gives me a message for his girlfriend. I tell him I'll put some money in his account so he can get some shaving cream and some treats. He is so grateful; I want to cry. We've said all there is to say. I put my hand up against the glass and spread my fingers wide. He aligns his hand with mine. I am closer to my boy in this moment than I have been in more years than I can remember. We say I love you, smile, and lay down the phones. I watch him walk away.

I exit the building, passing the faces of those who are still waiting. We share a common experience. We love someone who made mistakes until they ran out of chances and now pay their debt. There is nothing left to do but love them without conditions. And hope for a second chance.

xoc

This stint in jail is different. No desperate, anxiety-ridden calls. He was clean upon his arrest; a parole violation was his mistake this time. Busy rescuing Avery, he missed required meetings with his probation officer. Lame excuses couldn't keep him out of jail. He writes letters and asks for pictures of Avery. Asks me to call her and tell her that he loves her. I don't have the heart to tell him. She doesn't care. She has already latched on to someone else.

The emotional rollercoaster of the last few months has me committed to my self-care regimen. Admittedly, I have the occasional meltdown; some days are too much. Walking the trail with Mary, I recount the low points and cry.

I haven't talked to Andy. When he crosses my mind, I stop myself from calling. I don't want to fake happiness, and I don't want to be vulnerable. Instead, I find an excuse to text him. It's his birthday. I text a photograph.

> Text
> November 12, 2016
> Me: Whenever I see beautiful sunsets,
> I like to imagine my mom painting
> it for me. Maybe your dad painted
> this evening's sunset for you. Happy
> Birthday, Hope it was spectacular.
>
> Andy: A stunning image . . . Thank you
> for your love and good wishes. I feel
> blessed to be alive and have you in my
> life. xoa

"Have you in my life"? I don't see myself in his life at all unless he is counting fond memories. Maybe fond memories are enough for him.

CHAPTER 29

Winter into spring 2017

Text
February 2, 2017
Andy: . . .

I stare at the ellipsis. I haven't heard a word from Andy since November. I sent him a Christmas card, me pictured with Luca, age five, and an announcement of a baby sister arriving in spring. I received no cheery holiday wishes in return. I keep up the pretense of cool and casual.

Text
Me: . . .

I love him. It's the stupid truth. I toss my phone on the bed and bundle up for a long walk on the beach on this blue sky winter day.

The chilly air makes my nose run and my eyes water. I've been thinking again about a move to a new city. Venice had been on my radar for a while—mostly because it put me

physically closer to Andy. I wanted to believe that proximity would somehow bring him closer emotionally. Seems silly now. Maybe Chicago. I'd be close to family in Milwaukee, but the winters, ugh. There is always Italy. If I'm going to go, why not go big? Why not prove to myself that I'm not chasing Andy?

> Text
> February 8, 2017
> Andy: What town are you moving to in
> Italy?

I don't remember telling him about Italy, but I must have.

> Me: Not sure, but probably north if
> I choose Italy. I'm going to Portland
> in April and considering that city as
> well. I know, lots of rain. Still have San
> Francisco in my heart too.
>
> Andy: I'm flirting with the idea of
> getting lost in Italy for a few months.
>
> Me: Hmmmmmm. You've always been
> good at flirting.
>
> Andy:
>
> Me:

He texts a selfie. Wearing a helmet and goggles, he grins broadly, beautiful snow-covered mountains behind him.

Andy: Epic skiing, glorious day . . .

Me: Look at you . . . happiness. I am
enjoying a sun shiny beach day.

Andy: Nice . . .

Again, away from work, relaxing alone, he thinks of me.

Text
February 14, 2017
Andy: Happy Valentine's Day xo . . .

Andy: I love you

Me: And I love you . . .

Andy and I are meant to be. We are going slow. We are
different than other lovers. I don't share my heart's desire
with anyone because I don't want to defend my feelings or
have them judged.

❋❋❋❋❋❋

"I'm proud of you, babe. Your writing is real and true, just like
you. Thanks for sending me the magazines."

Real and true? In my writing, yes. In relationships, not so
much. I still avoid being vulnerable where it matters most.
Without asking the question, I want to know if Andy can love
me and be proud of me as-is.

I tell him his praise means a lot to me, and then I
change the subject with tales of Luca, the excitement of a

granddaughter on the way, and the possibility of Italy.

Andy lovingly brags about his daughters' creative talents. He's happy because they are happy. I ask about work. He's ready for a change. His job has afforded him and his family a good and comfortable life, but his heart isn't in it anymore. He's not sure of what's next. When I sense we are running out of things to say, I artfully talk about nothing to keep him on the phone a bit longer. He indulges me. He says I sound good, really good.

❋❋❋❋❋❋

I count the months backwards. It's been ages since I saw Andy last. From the back of the dark bar in Matsu, I recognize his silhouette. He slides into the booth and kisses me. And like a broken record, I say, "It's been too long."

I think of some of my married friends who sometimes wish for breaks from their husbands. They say I should appreciate the freedom single life provides. Instead, I secretly wish that Andy and I saw each other so often that we could get sick of each other, like a regular couple. Although I can't imagine ever getting tired of him.

"Let's run away to Italy, get lost, eat good food, drink wine, and make love in the afternoon."

Stunned, I manage, "Okaaay."

He ignores my surprise and continues. He has given notice at work and is negotiating a plan for his exit. He would like to be in Italy in July. Holy shit. He sort of stole my thunder; I'm going to Italy! I interrupt him before he goes any further.

"I am taking a leave of absence for the next school year."

He squeezes my hand, and we start laughing.

✳✳✳✳✳✳

Our clasped hands swing between us as we walk the beach path toward Pacific City, Andy and I in sync. The struggles of the last couple of years haven't vanished, but I've put them into perspective. I appreciate the lessons learned and my willingness to grow. I tell Andy about a recent visit to see Ken in jail. He stops in his tracks, "Wait. What? You've gone to a jail? Actually visited your son in a jail?"

"Yes," I say. "I had to make sure he knew I loved him, even though he was in jail. It's the kind of support I am willing to give."

Andy looks at me thoughtfully, and I feel closer to him than I ever have. I know I have great strength, but I'm not sure he knew until now.

We sit facing the ocean on the patio at Bear Flag, sharing fish tacos and white wine. He asks how my planning for Italy is going, and I explain while he eats his taco. "I've started the process for dual citizenship. Because my dad was an Italian citizen when I was born, I am eligible to apply. It's not too difficult a process, but tedious. I've been curious about my Italian family. I want to be more connected, to learn more about my dad. Dual citizenship will allow me to come and go as I please, no limits. It may help with getting a job too."

His mouth full of taco, he raises his head and nods. He swallows, and then there is a familiar pause as he gathers his thoughts. I'm not going to like what comes next. He swallows again, "So, I've been offered a job. I didn't plan on it. A company reached out; they recruited me. An opportunity to make some real money, and I'm going to take it."

I am disappointed, but not surprised. I look at him and say without hesitation, "I'm moving to Italy."

His look is quizzical, "Well played."

I shake my head, "I'm not playing. It's not a game. It's something I want to do, and I'm sticking to my plan."

He backtracks, "I'm still going to Italy before starting the new job, for at least a few weeks. I want to spend time with you."

Old memories surface of Andy leaving for his world travels and me choosing Alec. Now I leave for my world travels, and he chooses a job opportunity. Are we just going in circles?

CHAPTER 30

Late Spring 2017

We ride bikes through the neighborhood, stopping where we see Open House signs and flags. Mike and Mary are looking to sell their small condo, a block from me, and buy something bigger in our same neighborhood. I'm tagging along.

We tour typical downtown homes, like mine—long and narrow, three stories, and a matter of feet between them. Mike and Mare discuss the pros and cons of size, layout, and style. Now and then I add my two cents, but I'm distracted by the glossy flyers and the prices. Focused on renting my house, I hadn't paid attention to the current sales in my neighborhood—a seller's market for sure.

When Alec and I split, he was entitled to alimony, half my retirement, and half of the house. I'll never forget the day he called to tell me he wanted cash for the house only, said it was my lucky day. It didn't make financial sense, but emotionally I needed my house. I was sure I'd fall in love again, the man of my dreams would live here with me, and the financial stuff would work itself out. The men in my life did fall in love with my beautiful home, but they didn't stay for me. Maybe that's

why I allowed Cal and Ken to stay. I needed someone there with me. After Tara's divorce, I thought she and Luca would live with me. But then she met Rick.

I've crunched the numbers, and rental income will barely cover the mortgage and living expenses in Italy. And there is no guarantee I'll get a job once I get there. When I return, I'll be locked into returning to work. I want more options.

All the houses look the same now. Mary and Mike call it quits for the day, and we ride downtown for drinks. Cruising down Orange Street toward Main, I pay close attention to the details of my beachside town. The giant eucalyptus trees' ancient roots have buckled the sidewalks that lead to St. Mary's by the Sea. The church Mom attended Wednesdays and where Dad joined her on Sundays. Between each numbered street, the Pacific Ocean appears to my right, and the sun's reflection, a shiny, silver thread, weaves through hues of blue.

I imagine leaving my home of nearly twenty-three years, the town where I have lived for over forty-eight years. I play the scenario in my head—selling everything I own and saying good-bye. I think of my Luca. My leaving will be hardest on him.

❋❋❋❋❋❋

I tell my family and closest friends first. Everyone's reaction the same: happy for me and my adventure and sad to see me go. When I am asked, Why? Why now? I say the same thing. "I love my job, and my family, and my friends. I love where I live. I have a good life, and I need something new."

But there is more. I've been watching from the sidelines, wishing for the love and life that others have. I'm always waiting. Waiting for love, waiting for time to spend with Luca,

waiting to be invited somewhere. It's time to take charge of my life and make something happen.

I'm ready for wide-open options, and I can only have those options if I sell my house. I say yes to freedom and put my house on the market.

✿✿✿✿✿✿

Text
May 8, 2017
Me: She's finally here, Aria Rose, another miracle

Andy: A wonderful and beautiful miracle . . . I'm so happy for you.

Me: Thank you, I'm so happy for my girl. We all took a guess at the baby's weight before she arrived. I picked 7 lbs., 7oz, 7-7 for my mom's birthday. And guess what? Yep, 7-7. A sweet message from my mom. All is good. Love you.

Andy: Bursting with happiness for you. Give my best to Tara. I love you. . .

Every day I second-guess my decision. My daughter, my new granddaughter, Luca—they need me. I'll miss the first year of Aria's life and Luca's kindergarten year. What if something happens to Ken while I'm gone? What if Andy meets someone else and falls in love? What if leaving my job is a mistake? What if selling my house is a mistake. What

if, What if, What if? Yes, these are all possibilities. I sit with the range of outcomes. I cannot live my life in fear of what might happen. *Stick with your plan Christine. You are ready for a change; you want a change.*

✻✻✻✻✻✻

Mary and I finish our walk on the trail—something I'll miss while I'm in Italy. Before we part ways at the alley, she casually asks, "Does Andy know you're selling the house?"

I shake my head.

"Christine, don't you think he would want to know? He might feel differently about you leaving?"

The truth is Andy is thrilled for me, encouraging me every step of the way. Selling the house is a detail that won't change the trajectory of our paths. He's committed to four years at the new job, and I am committed to Italy. A small part of me wishes he would ask me to stay.

Standing in front of my house, I look at the For Sale sign. I want to call Andy, but I'm afraid the sound of his voice will make me change my mind.

Text
Me: Hug please

Andy: Arms wrapped around you twice
. . . Holding you close . . . Bodies truly
connected . . . hearts as well, with the
strength of all my affection.

Me: Beautiful, I feel you, truly. Love you.

My mood improved, I don't tell Andy about my doubts.

❋❋❋❋❋❋

Randi and I sit at a small cafe in San Francisco, sipping Aperol Spritz, a traditional Italian summer cocktail—a taste of things to come. The hilly city indulges me with gorgeous blue skies once more as my long-time friend and I enjoy one last trip before I disappear for a year. A year without my girlfriends near will be tough.

I take my phone from my purse, cocktails in hand we pose for a selfie. I post the photograph, and a text from Andy comes through. A picture of him and his daughter; they are visiting family in Mexico. I reply with a photo of me standing at the top of the Lyon Street Steps, my arms stretched far above my head as I look down over the city—a victory pose of sorts. As if to say, Bring it on, life. I am ready for what is next.

He replies, "Beautiful. . ."

❋❋❋❋❋❋

A video plays on the large TV in Molly's living room: Staff members don blonde wigs and dash about campus. They are poking fun at me, the way I speed walk and play handball in high heels with the kids. Breathless laughter has me in tears. I'm glad I gave in to having a going away party, a chance to thank everyone for making my work so enjoyable.

Kay, our speech teacher, and my partner in all things special education, walks toward me with a gift. "From all of us," she says. I brace myself for the impending tugging at my heart strings. I remove the white ribbon and open the small blue Tiffany box.

A necklace. I hold it to my heart and then hold it high for all to see. I catch sight of Luca, standing next to his mamma. He scrutinizes the grown-up faces, trying to understand what all of this means. Our eyes meet, and I give him a reassuring smile. He looks at me as if to say, something big is happening, and I'm not sure what it is.

Old feelings surface as I remember the heartache I caused his mommy and his uncle when they were so little, like him. This is different, I know. But it hurts just the same.

✵✵✵✵✵✵

Text
Me: How are you?

Andy: Super busy, as usual, and great.

Me: Me too, 2 more days and I am no longer a principal. I've been super busy with my house. Decided to sell. So much to tell you.

Andy: Wow!

Me: It took me a long time to let go of the idea that I had to keep it. I've been here 23 years, it is time for something different. I can't learn and grow if I keep living the same life. Isn't it past your bedtime? I'm kissing you.

Andy: I'm so proud of you, babe. This is a really big shift.

Me: I'm proud of myself and a little
scared, some days a lot scared. I remind
myself to breathe and take one step at a
time. Today I'm grateful for choices.

Andy: Bursting with happiness for
you . . . xo
Let's find a time to meet up soon for a
dinner. Happy to come see you, xoa

There, I said it; he knows I'm selling the house. I reread his text. His invitation to meet up soon lacks urgency and leaves me feeling blah. When I focus on my Italian adventure, it is all I see. But in the quiet waking hours, when I allow my heart to influence my thoughts, I revisit the unfinished business of old dreams. No time to linger here. Eight weeks until I leave, the tasks that remain for me seem insurmountable. A wave of anxiety washes over me; I close my eyes and ask for strength.

❋❋❋❋❋❋

Sixth graders walk single file into the quad and fill the first few rows reserved for them. Music plays; Bruno Mars, "Count on Me." I sing along, my eyes well up with tears as I scan the audience, catching smiles and waves hello. Colorful helium balloons and beautiful flowers enhance the celebratory mood of the promotion ceremony. The sixth-grade teachers take their place on the stage with me. Barb, a wonderful teacher, and friend, sees I am about to crumble. She takes my hands, "You can do this."

This is my comfort zone—a career and community I love, a place I belong. And like the sixth graders who sit before me,

it's the belonging, love, and support we have received that prepares us for the leaving, prepares us for the next chapter of our lives.

✵✵✵✵✵✵

I learn through the family grapevine that Ken called it quits with Avery, once and for all. He has a room in a sober living house. I think about the last message I left him after he had broken into my home for the umpteenth time. Screaming like a lunatic, I unleashed years of anger and told him to stay away. I swore I would call the police. I asked my family to stop telling me when he reached out to them for money or help. I didn't want to know. I was tired of all of it. But this recent development was good news; my siblings wanted to give me hope. And they did. I know better than to get too excited. Instead, I am grateful for a moment in time, a step in the right direction. I remember my work in Al-Anon. I only need to get through today and then start again tomorrow.

CHAPTER 31

Summer 2017

Tanned in a white summer dress, my hair freshly cut and colored, I stand before the full-length mirror, content with my fifty-seven-year-old self. My mood is 1975, maybe '76—back when I had faith in my power to will dreams into existence. I have reasoned through the mistakes, examined every twist and life-altering turn. I understand now how I lost the magic of those days.

Andy will be here in minutes to take me out for a birthday celebration. I haven't seen him in weeks, but he's been a constant source of support. I wonder if or when our lives will intersect, when we will share a common dream, or common address.

When friends ask, "What about Andy? Will he visit you in Italy?" I give my standard answer: "He'll spend some time in Italy alone, cycling. Then I'll join him. He'll come back to LA to start a new job. I'll stay in Italy for at least a year to write my book, visit with my Italian family, travel the country solo, and complete my dual citizenship. I want to experience the writer's journey, and I don't even know what that means!"

I hear Dad's voice, "Broaden your horizons, Christina, broaden your horizons."

This is something he said to us kids—usually in frustration. He wanted us to be excited about learning and life. He would be impressed with me today.

Andy's hello echoes up the staircase. I look down from my bedroom to find him smiling up at me, "Aw, you look beautiful, babe."

If he asked me to stay right now, I might say yes.

�֍ �֍ ✖ ✖ ✖ ✖

We lie naked, our skin dewy, legs tangled in the sheets. The breeze gently blows the white linen curtains into the moonlit room. Our bodies cool. Breathing and beating hearts are the only signs of reality. This is not a dream. Sade's "Your Love is King" plays in my head. A cassette tape Andy gave me nearly thirty years ago. I listened to it again and again in the days that followed our breakup so long ago. I consider asking him if he remembers the gift but keep the memory to myself instead. *Stay in this moment, Christine.*

> Text
> Andy: Happy Birthday, my darling . . .
> spread your lovely angel wings and soar
> this next year . . . and always. Xo
>
> Me: Thank you for the beautiful wish
> and the lovely evening. I love you . . .
>
> Andy: I read your Holl and Lane entry
> last night before I went to sleep. I didn't

realize such a gift was included in my
weekly mail. It was honest, good, true,
and beautiful, just like you. And then
the card, so much love and meaning.
Filled with an abundance of love, clarity,
and emotion. I can't wait for our time in
Italy. I love you . . . xo

Me: Kissing you . . .

✻✻✻✻✻✻

I take a break from the questions and conversations about
my trip and stand alone among the crowd in the front yard.
Twenty years of Fourth of Julys here at the Gleason home.
Every year, a reunion of friends from elementary school to
high school, a chance to catch up, meet the new babies and
grandbabies, and marvel at the passage of time.

I catch Daniel in the corner of my eye; he's sitting on
the porch with his wife, a baby on the way. Life has certainly
gone on.

Across the yard, Tara is swaying gently under a shady tree.
Her baby girl sleeps soundly, limp in her arms. She visits with
friends while Luca sits front row on the curb. Nearly six years
old, he watches the passing floats and marching band with
interest. I tiptoe between the other kids and sit with him. My
arm around him now, I pull him close and kiss his forehead.
He pulls away, "Nonna, I can't see."

Laughing, I squeeze him tighter. He tells me all about the
parade as though it's new to me—through Luca's eyes, it is.
I am memorizing the sweet sound of his voice when I hear
Tara cry out in surprise. I look up to see her hugging Ken,

her precious bundle between them. She hasn't seen him in months. I had a feeling he'd show up today—a familiar haven, not home, but like home. He sees me.

I stand and walk toward them. Ken pulls me into the hug with his sister, then it's just the two of us. I don't cry. I'm out of tears for this story. Acceptance of what is, hope for what may be, and some lingering heartache are all I have. We step apart, and everyone takes their turn to hug him too. He is surely loved. I study him, head to toe: healthy, fit, and strong. He says he is clean, and he looks it, no traces of the abuse his body has taken over the last few years. He greets his nephew and coos over his new little niece.

He asks when I am leaving, and I tell him July 22. He promises a visit before I go, but I know today is the last day I will see him. I ask Mary to take a picture of me with my kids and hand her my phone. Three happy faces, the real story is always outside the frame. I smile at the image and accept it for what it is—a beautiful moment in time, captured.

Text
July 10, 2017
Andy: Arrived safely in Florence. See you soon . . .

Me: I love you . . .

Andy: . . .

Me: Smiling . . .

July 15, 2017
Andy: I wish you were here sharing dinner with me tonight . . .

Me: Me too, I love you . . .

Andy: Being here is living in a dream . . .

Me: Make it last

Andy: . . . How many more sleeps?

Me: Seven! Lucky 7!

Andy: Too many

Me: I know

Andy: I hope you'll still like me after spending days with me.

Me: Without a doubt

Andy: Phew!

July 22, 2017
Me: Today is the day . . . I'm running full speed toward the cliff and jumping off. I'm scared, but I'm not stopping. I don't even want to stop. It's time.

Andy: You're doing the right thing. Continue to have faith . . .

Me: That's all there is . . . love you

Andy: I love you . . . Safe travels . . .

Me: I'll be in Italy in 23 hours . . .

Andy: 22 hours . . .

Two new suitcases lie wide open on the bedroom floor, my backpack propped against the wall. Minus some keepsakes and financial documents left in storage, it's all I have, all that's left of twenty-three years on Twentieth Street. I hear Nili's knock and gather the linens I promised her. Once inside, she is struck by the emptiness. Something that suddenly hits me hard too. Holding both of my hands, she sighs. I try not to cry, but I do, and she reminds me that she'll be visiting in the fall. A quick hug, and she's gone.

I take a last walk through the house; every room, cabinet, closet, and cupboard is empty. A familiar tiny knock, I open the door to find Luca looking grumpy. Tara says it's been a rough morning. Arms crossed, he growls, "I'm just a bad kid."

We sit on the stairs together. His chin rests in the palm of his hand. Brow furrowed, he frowns. I put my arm around his tanned shoulders and tell him he can start again. My mind wanders to the false notion that only I understand him, only I can help. I reframe my thoughts. Luca and I have a special bond, that won't change. *Let go, Christine.*

Outside the coffee shop, under the umbrella, Luca's mood is improved. I let him sip my coffee. With frothy milk on his upper lip, he smiles, "We're sharing, right, Nonna? It's my coffee too because it doesn't have caffeine. Mom, Nonna always lets me have her coffee because it's decaffeinated. We always share."

Back at the house, I go over a to-do list with Tara: a few things she'll wrap up in my absence. I repeat myself more times than needed, and she assures me she'll handle the loose ends.

And then, it is time. I hold baby Aria and look into her eyes, they are clear blue like her big brother, her daddy, and her great-grandma Judy's. Luca wraps his arms around my hips, and Tara snaps the last photograph of my grandchildren and me in this house.

I kiss the baby as I hand her back to Rick, then I smother Luca with kisses. He squirms and laughs. I tell him how much I love him and promise him postcards from every place I visit, presents too. His head cocked, he tries to read my face, my tears. He may not understand today, but over time, he'll learn the lessons of absence, time, and missing someone. I breathe him in one last time. I save the last hug for my girl. We hold on tight and say the only words left: I love you and good-bye. A year without her mom nearby, she'll learn and grow too. She'll be okay.

From the balcony, I watch them drive away. The weight of my decision hangs in the air. I hate endings; I hate good-byes. I hate missing people. I focus on happy memories of a houseful of family and friends. And while my parents passed years before my remodel, I see them standing in the place that was once my tiny kitchen, enjoying a glass of wine with their grown kids and grandkids. I see Mary, Susy, and I standing at the kitchen counter singing The Beatles "When I'm 64" to Dad, his head down, but smiling. I see Mary and me in sweatpants and slippers on the turquoise sofa, feasting on Del Taco or junk candy, watching Forensic Files or Seinfeld late into the night. Past the kitchen and down the long hallway, I am chasing Luca in a game of cops and robbers. His laughter uncontrollable, he runs as fast as his legs will carry him to reach the safe spot, an armoire in the guest room. His squeals and giggles fill the air and my heart once more. I rest my hand on my heart and say three times, "I am peaceful, I am present, I accept what is."

✷✷✷✷✷✷

Tom Bradley International Terminal is busy, with long queues in every direction. The line moves slowly, and I scoot my luggage along. When I reach the counter and hand over my passport, the young woman looks at her monitor. Bewildered, she asks, "Did you know the second leg of your flight was canceled?"

In all the chaos of leaving, I never checked my flights. It takes some effort, but she gets me on another flight and tells me to run to security.

I am one of the last to board the plane. Maybe the last-minute hustle was best. It left no time to panic or second-guess. I find my seat and half-listen to the flight attendant's instructions. I take a photo of my boarding pass, reflecting the changes, and text it to Andy. Then I turn off my phone and say a travel prayer.

We pick up speed, and the engines roar. I look out the window at the tilted Southern California landscape. The landing gear clunks as it folds beneath me, and my stomach drops in a moment of weightlessness and quiet. Tears spill down my cheeks, my neck, and chest. Wiping them with the back of my hand and sleeve, I cannot keep up with their constant flow. I suppose this is where I muster all that bravery and courage everyone has been telling me that I possess.

I've done harder things: I was a teenager who took on motherhood and college in the same year. I survived two divorces and the accompanying judgment and gossip. I broke the hearts of my children and spent the next thirty years punishing myself. I sat bedside with death and watched it take my mom, but not before it unexpectedly took my dad. I have witnessed the unrelenting hold of addiction. Seeking

answers, I dug up the old skeletons, the secrets, and the pain. I wrote and shared my stories and owned my mistakes. Moving to Italy isn't easy, but it's a beautiful choice and an amazing opportunity.

I thank God for every obstacle, every challenge, and every lesson that got me on this plane today. I meet Andy in Modena in less than fifteen hours—a soft place to land.

CHAPTER 32

Still Summer 2017

Four months ago, Andy suggested I watch a particular episode of *Chef's Table* that featured world-renowned Chef Massimo Bottura. I watched as Bottura spoke of his family, his grandmother's cooking, living in New York, falling in love, returning to Italy, and eventually opening what would become a Michelin Star restaurant in Modena: Osteria di Francescana. Andy said I would love his story and promised that the two of us would have dinner at his restaurant one day.

We've been in Modena for three days, and for three days, Andy has called the restaurant to inquire about the possibility of dinner. He's been told repeatedly that he should have made a reservation at least six months ago. Neither deterred nor discouraged, he politely says, "Yes, I understand, but please take my name, just in case. Our hotel is literally around the corner."

Sure enough, a call to our hotel room late in the afternoon thanks to a cancellation. It seems when we believe anything is possible, the Universe delivers.

One exquisitely plated dish after another is set before us. Andy looks at me and raises his glass. "To us; thirty years and thirty more."

"Has it been thirty years?" I ask, quickly doing the math in my head, "Twenty-eight, I think."

His eyes twinkle, "I don't care. I'm calling it our thirty-year anniversary."

I laugh at how he changes the facts to enhance our love story. Married to other people for most of those years, we acknowledge wondering about one another in the years we were apart.

He asks, "What day is it?"

I whine, "Oh, don't ask that. Then I have to think about how many days are left with you, and I don't want to do that."

"You're right." He taps his glass to mine.

"*Cin, Cin!*" I say.

He points to his cheek, and I kiss it. Then he leans back in his chair and gives me a serious look, "Are we going to be together?"

I give an emphatic, "YES, YES! Yes, we are."

I want him to respond, "Perfect," or "Yes, that's exactly what I wanted to hear!"

Instead, he gives a thoughtful smile. Maybe what he wanted to say was, "Do you think we'll survive a year apart, pick up where we left off, and make a life together?"

That's the real question, isn't it? But neither one of us asks. It's too big. Leaning into him, I kiss his lips. Two more nights.

We stumble back to the hotel, holding hands, giggling. He drunk dials a friend who is in Bellagio with his family. He had hoped to meet up, but it doesn't work for this trip. Then he calls another friend in California, whom I have never met, and says, "I am in Italy with Christine."

As though this is something his friend would expect to hear and might reply, Oh, great, tell her I said hi.

He told me once, "Everyone who knows me, the people I am closest to, they know who you are. They know that I love you."

These are the stories he tells to express his love for me, to show me and others I am important in his life. Maybe we don't need a promise; maybe our commitment is understood.

We fall into bed, into each other. There is no talk of the days, weeks, or months ahead. We are here now, together.

❋❋❋❋❋❋

I take in the Tuscan countryside, rolling green hills, farmhouses, and vineyards—so different from our time in Modena, Parma, and Milano. I am happy. Despite my declaration of independence and moving full steam ahead with my adventure, my heart wants Andy. When I visualize my future, Andy is always there. Even during the year of silence between us, he would appear in my dreams and meditations. It infuriated me. Pissed, I would think, What the hell are you doing here? Stop visiting my dreams.

When I mentioned this to a meditation partner, she said, "Why get angry? Welcome him and your feelings. Work through them. Pushing them away only sends them into your future, unresolved."

So, here I am, in my future: Andy driving, me navigating. I put my hand on the back of his neck and push my fingers upward through his hair. My eyes wander down his familiar profile and pause at his lips. I tug his hair gently, release, and give his neck a gentle massage. He takes my hand and tenderly kisses my fingers.

�֍�֍✯✯✯✯

We push our luggage over the uneven cobblestone streets toward our hotel. Scooters and taxis whiz by. Hot and humid, my sunglasses slip down my nose. Andy glances back at me and pushes them up, and neither of us misses a step. The hotel lobby is air conditioned, thank God. Andy checks us in, and a uniformed bellman takes our luggage. We are shown to an elegant suite: dark wood, lovely linens, and a bathroom with exactly what we are hoping for—a huge shower and tub.

✯✯✯✯✯✯

Freshly showered and ready to explore Florence, Andy tells me he loves my dress. With raised eyebrows, he indicates he likes more than the dress, and I laugh. While I am fresh and lovely in the comfort of our hotel room, I'll wilt as soon as we get outside. I better get used to it. I'll be here for at least a month, and weather predictions promise hotter and more humid days ahead.

Andy is on a mission to get a couple of gifts but insists he show me something first. He takes my hand and leads the way through shaded alleys. We approach a piazza, and he tells me to stop and close my eyes. I feel the sun again, and we stop. He positions my body ever so slightly and says, "Okay, open your eyes."

I am awestruck: the Duomo di Firenze, Santa Maria del Fiore, in all her glory before me. Her beautiful marble, the shades of pink, green, and white are breathtaking. Proud of his surprise, he says, "Amazing, right?"

"Oh my God, yes, amazing. Thank you."

"This is your town, babe. This is where you'll live, where you'll start your adventure."

We walk the narrow streets, chat with shopkeepers, and make time for a gelato. I savor its deliciousness and every minute with Andy. We sit on an ancient stone bench, cool in the shade.

An intimate dinner at Quattro Leoni, we share a bottle of Chianti and savory summer salad. Tonight is quiet; there are fewer words between us, and every sentence is punctuated with silent recognition that this is a night of lasts. The blissful days of eat, laugh, make love, sleep, and repeat are nearly over.

After dinner, I sit on the bed and watch Andy pack. There are nagging thoughts. But I can't articulate them, so I make mindless small talk. He interrupts my babbling and asks, "You're having breakfast with me, right?"

"I didn't know there was time. Of course I will."

He grins, climbs on the bed, and crawls toward me. I lean back on a pile of feather pillows, and he lies on top of me. I wrap one leg around him and pull him even closer. We confess to being tired, but not too tired.

Our rhythm found, we rise and fall. Catching my breath, I am overcome with emotion; the dam bursts, and I cannot stop. I cry and cry and cry. Between gulping sobs, I tell him, "I'm not sad. I think it's just the emotion of everything. There's been so much, I can't . . ."

I take one long, slow breath after another until I am calm. And then I sniffle, "Will you come see me?"

"Yes. Yes, I will."

"I'm okay now. I'm fine, really. Go to sleep, babe, I'm fine."

Cuddled up behind me, he kisses my shoulder and is sleeping in no time.

In the dark, I slip out of bed and dig through my backpack

in search of a pen and my journal. Light seeps out from the large walk-in closet. I open the door and close myself inside. Sitting on my carry-on bag, I use my large suitcase as a makeshift desk.

A,

Borrowed words...

Real love is selfless and free from fear. It pours itself out upon the object of its affection, without demanding any return. Its joy is in the joy of giving.

Florence Shovel Shinn

So, here we are, me living in Italy for a year, and you starting a new job in California. And I love you as I have always loved you. I am able to love you and our time together without fear, without needing or wanting conditions, because my life is full and amazing all on its own. I have no idea what the future will bring. I only know that I love you, and right now, that's enough.

Your angel,

xoc

I leave the note on his duffle bag and slip between the sheets again. A sweet memory comes to me: It is 1989. I'm lying naked on my side, Andy snuggles up behind me and whispers, "Like spoons in a drawer."

I fall asleep.

❊❊❊❊❊❊

I wake to Andy's gentle touch. "I got your beautiful note. Thank you."

Foggy with sleep, I pull him close to me. He pulls me up, indicating I've got to get busy.

Breakfast on the rooftop, I find the Arno in the distance. Somewhere out there is my home for the next month.

We hold hands in the elevator, through the lobby, and as we wait in front of the hotel for his taxi. I don't let go. I'm already dreaming about the next time I see him.

He interrupts my thoughts to say, "Did I tell you I love you today?"

"Yes, several times, but tell me again."

And he does. I sigh a long, contented sigh, grateful to have shared the beauty of Italy with Andy. The cab arrives. We hold each other for a long, long time. He gives me the extra squeeze, and I breathe him in and kiss his neck. With my face in his hands, he kisses me, "I love you."

I wait for the final good-bye. But he surprises me and says, "To be continued."

I take those words as a promise.

Eyes fixed on me, he walks backward toward the cab. He lifts his index finger and gives a tiny single finger wave. I kiss my fingertips and blow him a kiss. The taxi loops the circular drive and merges with city traffic. Andy's arm is out the window; his waving hand appears above the cab one last time.

Back in the room, I fall onto the bed and push my face into Andy's pillow, his scent still present. I kick off my sandals and wriggle out of my clothes, stripping naked, and I slip into bed. I am alone in Italy. Once I leave this hotel, every sight and sound, every action, and every experience is mine alone. I can

only move forward, no more repeating stories and patterns of the past. There is no one here to play along.

✻✻✻✻✻✻

I take a small private room and bath in an apartment owned by a professor and artist in the quaint San Nicolo neighborhood across the Arno. Her art hangs on every wall. Her living room serves as her studio: finished paintings are stacked against every available wall, and works-in-progress rest on paint-spattered easels. Light pours in through open windows to illuminate her work.

I spend my days exploring the city, walking along the river, pushing through the crowds at Ponte Vecchio, and always enjoying a delicious *cioccolato* and *lampone* (raspberry) gelato in the shade of the Duomo. People watching and taking in the beauty of Italy are my favorite pastimes. Those I love sleep while I wander the cobblestoned streets of Florence. Each day begins with a comforting habit from home, a good long walk.

Blog Post
August 1, 2017, Florence, Italy
A New Path . . .

I have chosen a new path these days, or perhaps the path has chosen me. The coastal breeze from the Pacific Ocean no longer cools me, Catalina and the pier are no longer in my view, and crashing waves and seagulls squawking cannot be heard from where I walk today. My sister's voice in thoughtful conversation, the sound of her laughter, the smiling faces that graced my path

each day are stored away in my memory for now. That well-worn beach trail, its smells, sounds, and the comfort it gave me on my most difficult days are still so dear to me.

Walking my newly discovered trail, I am deliberate in my observation of all that is new. Rectangular, dark slate stones of different sizes puzzled together fill the walkway. Corners worn to rounded edges, uneven and cracked in many places. I am less surefooted here. The rush of cars and scooters along the Viale, the occasional cyclist, jogger, or tourist, and the sweet smell of pine trees occupy my senses. At nearly any point along the way, I can see all of Florence. Occasionally I stop and gaze across the Arno and make mental notes of the points of interest I will visit later. I cross through the Piazzale Michelangelo and race up and down its many steps—only once—and then catch my breath and continue my pace on the Viale.

Not yet adjusted to the time change, I oversleep daily and find myself walking as the temperature climbs toward 100 degrees. Somehow, I don't mind. Maybe I am too distracted by the surroundings beauty to care about the heat. Or perhaps my mind is busy with countless swirling thoughts— the aftermath of my dramatic life change.

I sweat as my body temperature rises. Mother Nature bestows relief, providing shade and a gentle breeze that rushes through the pine branches. I inhale and hold the scent for a moment, then release a long exhale. I maintain a fast pace and

meditate and pray along the way, just like home. And then, as I always do, I allow my mind to wander, to replay the thoughts, discussions, and decisions that gave me courage and brought me here, to Italy.

The last few years have been rough. My heart ached for so many reasons. But, with a focus on gratitude, grace, love, acceptance, and forgiveness, I found purpose and a way out of darkness. Walking along my new path, it's hard to imagine living any other way.

My thoughts drift to a few days ago: to our last morning together, down there, across the river, in a beautiful hotel. He is the one great love of my life. He taught me the simplicity of love a long, long time ago and, more recently, showed me again because I had forgotten. If you met him, he would tell you that he has loved me for nearly 30 years.

I am happy that we didn't spend our days rehashing the past. Loving, laughing, and experiencing life to the fullest is how we spent our time. We didn't count our days together and did our best not to talk about the days ahead. We simply loved our adventure and each other. And then we said good-bye.

Every day I am challenged by stubborn habits. But I resist old patterns and continue my journey toward living in the light.

My path here in Florence is temporary. The same is true of every path I will discover this year in my travels through Italy and in the years

to come. Each path will have its own lessons and stories to tell.

My heart will always be faithful and true to my old beach trail at home. She was always there, always listened. I trusted her with my greatest secrets, the first to hear my stories before they were ever written.

If she could see me now.

xoc

CHAPTER 33

Summer through Winter 2017

There is no air-conditioning in my apartment building, or anywhere in Florence for that matter. In the evenings, I get relief from the heat with a cool shower. I lie on my twin bed in my underwear, an oscillating fan whirrs at my feet, and I read. After dropping the paperback on my face a few times, I give into my heavy lids and close my eyes. I think about Andy and wonder if he is thinking of me. It's late afternoon at home. Should I send him a text? I can't text every time I feel lonely. Or can I? I distract myself with thoughts of Forte di Marmi. Tomorrow, I have an early train for a week at the beach, toes in the sand, and the smell of the sea. *Think about that, Christine.* My phone pings.

> Text
> August 24, 2017
> Andy: I am with you . . .

A month since I saw him last. He is six thousand miles away. A few simple words put him square in my heart and hold his place in my future.

❋❋❋❋❋❋

I sit in Uncle Roberto's living room and wait for the late summer storm to pass. His personal library and cherished art collection cover the walls, floor to ceiling. A large picture window and a glass door to a balcony make storm watching easy. I've been in Monza for a few weeks, living with my dad's younger brother and his wife, Marisa. He's been my translator as I navigate Italian bureaucracy in my effort to establish residency and Italian citizenship. Before living here, I didn't know my uncle. He came to Milwaukee when I was four years old. Until now, black, and white images of him and Dad glued in our family photo album were more familiar to me than the man lounging on the sofa next to me.

The skies brighten to a lighter shade of gray, the rain has stopped. I shout, *"Ci vediamo,"* see you later, and run out the door.

The path along the canal is peaceful. I need to clear my head; I've been preoccupied with my residency since my last visit to city hall. I could not understand a single word of the rapid-fire Italian spoken. Roberto translated, and I handed over documents I had collected before I left the States. I had hoped my residency would be approved that day, allowing me to stay in Italy without limitations, but the woman said we must come back another time, meet another person— someone who possessed more authority than she did.

A cyclist whizzes past me, and a runner gives me a quizzical look, both puzzled by my speed walking. Leisure walkers bristle as I rush past. I'm not sure powerwalking is a thing in Italy.

Despite the dreary weather, the landscape is particularly pretty. The grass has gone from green to golden; fall is days

away. I take a photograph of a large grassy field I pass every day. Tall junipers line its edges, their tips touching the gray sky. I send it to Andy.

Text
September 4, 2017
Me: A walk after the rain. Hope you're enjoying the weekend . . . love you.

Andy: I wish I was holding your hand and walking alongside you . . . Love you.

❇❇❇❇❇❇

I pour boiling water over the teabag, and the smell of cardamom fills the small kitchen. Roberto and Marissa lift their heads from the morning newspaper. They can see the tension on my face as I slowly shuffle around the kitchen. I was under the false belief that migraines and back pain were something I left behind in California. But stress and worry are here too. Marisa offers to make an appointment for me at some kind of physical therapy studio on the first floor of the apartment building. I'm willing to try anything to relieve my pain.

Together Marisa and I knock on the door, and a young man in stocking feet answers. There is a short exchange between him and my aunt in Italian, and then he turns to me, his infectious smile grows wide, and in English, he says, "I will see you tomorrow then."

His name is Gabriele. He has a full beard, wears thick, black-framed glasses, and still somehow manages a boyish look. I'm guessing he is in his early thirties. After a few

questions, he begins. The protocol for our session is not clear to me. Based on the brief description Gabriele has given me, he'll do some kind of adjustment. Okay, but do I undress? Does he provide a sheet of some kind? Does he leave while I prepare? How do they do this in Italy? Finally, I ask, "Do I undress now?"

"Sure, yes."

I'm pretty sure something is lost in translation, but I strip down to my underwear anyway. I search his face for some clue or direction. Based on his slightly bewildered expression, I'm pretty sure I got it wrong. I wait for him to gasp or politely turn away. He pretends it is perfectly normal for a fifty-seven-year-old woman to stand nearly naked in preparation for treatment. He directs me to lie on the floor. I want to laugh and say, "Seriously, you're going to act like this isn't weird?"

But I control myself and play along. I imagine he and his colleagues will be laughing about this over pizza and I make a mental note to arrive in comfortable workout clothing for all future appointments.

I see him weekly. He teaches me specific breathing and muscle isolation techniques to relieve tension in my neck and shoulders. And I teach him the meaning of "gnarly" because that's the word I use to describe the way he tortures me.

Our sessions always begin with friendly small talk. I tell him that my last meeting at city hall went badly, and my citizenship hit a major snag. Of course, I have to explain the meaning of "major snag." Speaking English in Italy has made me very aware of my overuse of colloquialisms and slang.

Gabriele shrugs his shoulders and asks, "What will you do?"

"I don't know."

He glances at his watch and claps his hands, "Let's get started."

I sigh. Sessions are hard work, and I'm feeling blah. He surprises me, "Kreesteen, you get to relax today. I'm doing all the work."

Lying on my back on the matted floor, I breathe deeply as he crawls around me, adjusting my limbs and my stubborn spine. We don't talk. I am supposed to concentrate on breathing. He taps my chin, a signal for me to stop clenching my jaw. He taps it again. And then again. With each tap, he says, "Relax, relax, relax."

And finally, "Relax your fucking jaw, Kreesteen."

I burst into laughter, "I can't relax if you make me laugh."

We settle into silence once more, and my mind wanders. Perusing Facebook last night, I caught a rare post on Ken's wall—a photograph of a courthouse receipt for a marriage license. A second photo showed a young woman with the bluest eyes and Ken beaming the biggest smile. The two of them grinning into the camera, selfie-style. I am happy for him, for them, and I am sad for me. He didn't think it was important to call me, to tell me he got married. I suppose this is the relationship I cultivated. I didn't even know he had a girlfriend.

I learn from my sisters that the family is getting together to celebrate. I'll send money—something a faraway relative would do.

Annoyed with my inner whining, I shift my focus back to Gabriele's healing touch. He is skilled in finding all the knotty gristle, and I relax. It feels so good, and I am reminded of affection. While there is no shortage of Italian two-cheek kissing, it's not the same as being embraced, held tightly, leaned into, or the simple gesture of holding hands. Two tears escape. If Gabriele notices, he doesn't say a thing.

✻✻✻✻✻✻

Pushing my cappuccino and cornetto aside, I make room on the small cafe table to sort through a stack of recently purchased postcards. Novelty cards, shaped like scooters or covered in glitter, go to Luca. I send one a week as promised. Tara says he is struggling in school. Certain he isn't capable of kindergarten tasks; he worries and has sleepless nights. Every morning he begs to stay home. As a principal, I referred to kids like Luca as frequent flyers. They make daily visits to the health office and complain of mystery pain to escape the stress of the classroom. I want to fix this, talk to his teacher, impart my wisdom. In reality, he is getting the support he needs. I'm struggling with not being an integral part of the rescue team. Physical distance can't keep me from wanting to control outcomes.

Andy gets nearly as many postcards as Luca. I want him to know that I miss him, remind him that I'm here, that I'm still the one. And while his messages indicate that he misses me, I'm afraid I might fall victim to out of sight, out of mind. Another outcome I think I can control.

Scooping the remaining thick foam from the bottom of my cup into my mouth, I am reminded of Ev's visit last month and our morning cappuccinos in the Galleria Vittorio Emanuele II. It was fun to show her my neighborhood, the Duomo, the Castello Sforzesco, and Spazio Lingua, the school where I study Italian. A week later, Nili arrived. We toured picturesque Lake Como and its villages, and then drove through the lush green hills of Tuscany.

After Nili's visit, it was time to get serious. I moved from my uncle's home to Milan. Now I rent a room in the Navigli neighborhood, in the home of an American ex-pat, Terri, a random connection I made through Nili. My new

powerwalking path is along the Canal Naviglio Grande. The rowing clubs, graffiti-covered brick walls, and surrounding buildings are becoming familiar, like home.

Exiting the cafe, I step into the chilly November afternoon and search for the nearest *Tabacchi* shop to buy postage stamps. Like an American convenient store, they are on nearly every corner. Entering the store, I say in heavily accented Italian, *"Buongiorno, vendi francobolli per Gli Stati Uniti?"*

"Si, quanti?"

"Tredici per favore?"

I purchase the thirteen stamps for the United States, stick them on my postcards, and drop them in the red metal mailbox mounted on the building outside. On the walk home, I pass the young woman who sweeps the sidewalk. I give her a few euros when I pass. She holds my hands, *"Molto gentile, tesoro."*

She says I am kind, a treasure. I smile. I live in Italy.

Blog Post
November 11, 2017, Milan Italy
So Far . . . Pretty Good

Not sure of the time, but I know I am calling it close. Racing down the metro station steps, the familiar rumble and long slow hiss of the arriving train have me running now. With seconds to spare, I politely push my way into the full car. *"Scusa, Scusa."*

I secure a spot, and the doors close behind me. I grab the single handle hanging above my head before the train lurches forward, saving me the embarrassment of falling onto fellow passengers.

Something that occurs frequently on the crowded metros. I appear to be a veteran commuter. With my free hand, I dig around in my bag for my phone to check the time. I glance up at the red line route, two more stops.

I emerge from the underground, squinting into the sun, a nice change after a few days of rain. The majestic Duomo di Milano poses beautifully as the tourists take his picture. He doesn't have a bad side. Realizing my hair appointment will take me through lunch, I've got to quickly scarf down some food. I run the words through my head, *"Buon giorno. Vorrei un panino per favore."*

I duck into the first bar I see, say the words, and point to a small sandwich exploding with zucchini, prosciutto, arugula, and brie. I hurry past the shoppers in the Galleria, peel back the foil, and *mangio il panino.* It's delicious. Eating on the run is a very American thing to do.

Wiping my mouth with a wad of napkins, I run my tongue across my teeth and gums searching for greens stuck here and there. I miss giving Michele a big toothy grin and asking, "All good?"

Without a friend or a mirror, I hope for the best. Traffic lights are not in my favor. I scan for oncoming cars, trams, scooters, bicycles, and busses and bolt across the street. Even though I have plenty of time, somebody blasts their horn. I remember how the chaotic traffic used to unnerve me. Now I take it in stride.

I enter the building. The elevator arrives on cue and delivers me right on time. *"Ciao, Ciao. Io*

ho un appuntamento alle dodici e mezza" Twelve-thirty.

The lovely receptionist shows me to my chair in the salon. She cheerily asks, *"Come stai, Signora?"*

"Tutto bene," I say.

The woman who colors my hair speaks no English, and my Italian is still pretty skinny. I understand she has asked what I want to drink, and I reply, *"Acqua minerale, naturale, per favore."*

She smiles and then asks if I only want my roots colored. I wish I could say I understood her, but really it was obvious as she tapped the pointed end of her comb on my glowing silver part. *"Si, si,"* I reply, looking like a genius.

As she skillfully and methodically applies the color, I read a book I brought with me. I wish I could carry on a conversation, ask about her family, her life. I miss my salon chats with Maria. I miss small talk and getting to know strangers. I miss the connected feeling that comes with all of that. I miss so much of home. I do my best not to get down on myself for not having made more progress with my Italian or creating any kind of social life. And then I remind myself of all I have accomplished so far. I am doing pretty well.

She combs through my freshly washed hair, preparing my head for the capable hands of Marco, who will give me a trim. He slides his stool up close to me, lifts a handful of my wet locks, and asks, *"Cosa facciamo?"* What are we going to do?

I reply in English because I have no idea how to say it in Italiano. "Just a little trim."

Marco frowns. He is dying to cut off all my hair. He gives me that look that says, Geez, you're a woman in her fifties. Don't you want something a little more sophisticated? Age-appropriate? Instead, he says in English, "A change?"

I repeat, "No, just a trim, a little shape."

Then he says something that would have left my old self feeling puny and small. "Ah, you are afraid of change."

I want to laugh out loud! Instead, I smile and think, You have no idea.

xoc

PS: Long hair intact :-)

✻✻✻✻✻✻

My teacher Marta writes the word *"Figlia"* on the whiteboard and asks for adjectives in Italian to describe my daughter. I respond, *"Bella, simpatica, intelligente—"*

Without warning, my voice cracks, and I start to cry. Marta rushes to me; hand on my shoulder, she tries to comfort me. I'm sure she thinks something awful has happened to my daughter. Homesickness snuck up on me. I catch my breath, *"Tutto bene, tutto bene.* Really, I'm okay. I just miss . . ."

I can't finish my sentence. Marta understands, and we start the lesson again. This is my last week of classes. My English-speaking mouth grapples with foreign sounds and pronunciations. I'm an old dog, and new tricks are hard. Marta says that any improvement in speaking Italian can only come from using the language every day.

Walking to the Metro, I call Tara and catch her as she is

driving Luca to school. Luca shouts from the back seat. "I miss you, Nonna!"

"I miss you too, my boo. A package is coming to your house. Be on the lookout."

"What is it?"

"A surprise. Call me when you get it. Do your best in school. I love you, pally."

"I love you too, Nonna."

See Christine. He's okay.

CHAPTER 34

Winter 2018

Text
Me: Ciao Bello, Happy New Year! Buon
Anno! I love you . . .

Andy: Ciao Bella, my love. Happy New
Year!!! Xo . . .

Me: Cheers to an amazing 2018

Andy: Last year was a year of big shifts
for both of our lives. So much learning
and growth. I'm so proud of you and
know you've remained committed to
reach your goals. Sending you love and
prayers that the year ahead brings you
all the wishes and blessings you so richly
deserve . . .

One of those wishes is that we are together forever. But I
don't say so.

Journal Entry

January 1, 2018

Rainy day in Milan, headed to Venice via train. Happy New Year to me!

Wet arrival, pouring rain as I wait for the Vaporetto on the Grand Canal to take me to my Airbnb. Dumped my stuff, took advantage of a break in the rain to find food, and then it poured again. Soaked, I ducked into a warm cafe and peeled off my wet clothes. Enjoyed so-so gnocchi, but the wine was divine, warmed my bones.

Dinner alone. A foursome spotted me and asked me to join them. David and Patricia, British ex-pats living in Rome thirty years with a second home in Venice. They are traveling with friends from Amsterdam, Tritia and Stefan. Fast Friends.

❀❀❀❀❀❀

I relax into the train's low rumble. Hands resting on my keyboard, I search my brain for the right words, better words. Nearing the midpoint of my memoir, I am wearing out adjectives and adverbs to describe the sights and sounds and emotional twists and turns of my story.

This past week I've been more tourist than writer, enjoying the unique beauty of Venice. On long, wandering walks, I noticed everything: Layers of peeling paint on ancient stucco walls revealed terra-cotta, deep greens, creamy yellows, and sometimes crumbling brick. Rows of docked gondolas, how their shiny stainless-steel bows reflected the afternoon sun.

Laundry hanging from a clothesline strung between two open windows conjured up memories of Mom. She hung her linens in the backyard to dry. Pulling them from the line, she'd bring them to her face and breathe in their freshness. "Ah, nothing like the smell of clean sheets dried by the sun," she'd say.

More of a homebody, she didn't love travel; she found and appreciated beauty in everyday life. She always said my sense of adventure came from Dad.

I remember a picture of my parents taken in St. Marc's Square. Pigeons flapping around them, a photographer captured their surprise, and their youth. I imagine they spent hours in the cathedral marveling at its golden glory, as I did. I wonder if they saw the stunning Peggy Guggenheim Collection or if they visited the Galleria dell Academia. Mom would have been captivated by the many paintings of Madonna and Child.

I look out the window; farms and small villages whiz by. Train travel—romantic, often picturesque, and always thought-provoking. I send Andy a text.

> Me: I start and end each day with thoughts of you. I think you should come see me in spring, or tomorrow if you want :-)

> Andy: I play the film in my mind over and over of all the time we shared in your new country . . . I play it constantly and enjoy reliving every moment . . .

> Me: You are masterful at not answering questions.

Andy: Yes . . . Springtime would be
magical . . .

Smiling, I set my phone down, return my gaze to the window, and daydream about springtime.

Blog Post
January 23, 2018, Milan, Italy
The Journey Continues . . .

Scrittrice . . . the Italian word for a female writer—and extremely difficult to pronounce. When I walk along the canal, I say it out loud, repeating the tongue twister slowly, trying to get the sounds exactly right. *"Sono scrit-trice, Sono scrit-trice."*

I am a writer. I am a writer.

Elisabetta, the woman who practices Italian with me, cringes at the word I produce and shouts, "Christina, you must say this word correctly. This is who you are!" Frustrated, I scream, *"Cazzo!* I'm doing the best I can!"

Swear words come easily, and *cazzo* is a favorite. Sometimes I want to give up and use *scrittore,* the word for male writer—much easier. But I am a woman writer, and I want to say it proudly in Italian.

When I stepped off the plane six months ago, I imagined by this time I'd be chatting up an Italian storm. Alas, I am not. I can order food, buy my groceries, get directions, ask to try on clothes and shoes in my size, and throw around salutations like nobody's business. But any lengthy conversation

is a struggle. I have the vocabulary and speaking skills of a toddler, not much fun to chat with at a dinner party. Even in the most casual settings, when I attempt to speak, the natives recognize immediately that I am learning Italian, and they switch to English. When I continue in Italian, sometimes they smile and encourage me. More often, they continue in English, completely ignoring my attempts. They are not rude or unkind, just trying to hurry along the process, to get me whatever it is I need.

All my family here speaks English; one-on-one, it's what we speak. For dinner table conversation and large gatherings, everyone speaks Italian. I understand some of what is said, but the speed at which they speak and the infinite number of verb conjugations make my head spin. So, I stop listening when it becomes too hard to keep up. When there is a lull in the conversation, someone will invariably ask, "Christine, do you know what we are talking about?"

I shyly explain what I understood. This is cause for lighthearted jokes about my progress and lectures to practice more. A couple of things get in the way of my progress. One is solitude: I spend the majority of my time alone, mostly writing. When I don't have my face glued to a screen or my nose in my journal, I am learning about my adopted country. Traveling, sightseeing, eating, and using tourist Italian fill my days—not exactly ideal for developing conversational skills. As silly as it sounds, it never occurred to me that writing

would keep me sequestered from the human energy that I crave, and the interactions required to learn to speak another language. It cannot be done in isolation.

The bigger factor that keeps Italian words stuck in my throat is fear, plain and simple. As much as I try to kill the perfectionist in me, she lives! She'd rather be silent than make a mistake. Every day I face her, and every day I manage some small victory. I try a new phrase and persist in Italian even when the listener looks as though they are hearing fingernails on a chalkboard.

As I arrive at the midpoint of my Italian adventure, it's natural to check the vital signs of my hopes and dreams. To that end, I open my journal to look for clues. There, inside the cover, I find a note I had written in August.

 1. WRITE
 2. Learn Italian
 3. Get citizenship

The list is circled in blue pen, and the words HAVE FUN are written next to it, with a tiny, scribbled heart. I smile at the image and give myself a break. This experience will not be graded; it's extra credit. Enjoy the ride.

I continue to blog and write for Holl & Lane while working on my book. I am on target to finish my first draft in spring. Thanks to my spiritual running buddy, Candi, I've learned that writing does not have to lead to solitary confinement. She

reads my work, provides advice, and cheers me on via email and Instagram. I am never alone.

As for my Italian, if I stop listening to my inner critic—and some outer critics—I can say it is coming along just fine. I never intended to be a linguist. Still, I've stepped up my conversational practice, forcing myself to talk even if I sound like a two-year-old.

My dual citizenship is not going as planned. But I persist. It may not happen how I want or when I want, but it will happen. Fingers crossed for a breakthrough.

And with all of this, I do have fun.

"Sono scrittrice!"

I know you can't hear me, but take my word for it: I pronounced it perfectly.

xoc

✻✻✻✻✻✻

In the bookstore, I peruse beautiful stationery, Valentines, and postcards. I consider writing a long overdue apology, to Catherine. A floral pastel card is a good choice.

It's not the first time this has occurred to me. It's probably crossed my mind a hundred times. I've justified my silence with the belief that I would only be opening an old wound. Had that been an excuse to not apologize? My gut tells me to do it.

As I work through the words, I wonder what makes a good person do bad things. Back then, I would have said I was driven by love. I don't believe that anymore. Bad things don't come from love. What I thought was love was something else—love's imposter.

Text
Andy: Happy Valentine's Day . . .

Me: Happy Valentine's Day. Ti amo caro
mio

❄❄❄❄❄❄

Bundled up in a knee-length, down coat, I leave a solitary trail of boot prints in the fresh snow. It's thirty degrees along the canal this morning. Cold weather was one of the reasons I didn't choose San Francisco or Chicago for my writing adventure. I take a selfie for posterity's sake; Christine covered in snowflakes—crazy.

Cold, rain, sleet, or snow, nothing keeps me from sticking to my self-imposed writing deadlines and goals. Well, except for art exhibits and museums. Today there are no distractions, and I trudge to Base Milano, an old factory converted into a community workspace. My preferred table is available—a high-top with stools. I can stand and type when sitting gets uncomfortable. I peel off my layers, set up my laptop, and retrieve journals and my favorite pen from my backpack.

I order my usual cappuccino. The barista has grown accustomed to my tourist Italian. She is patient as I carefully choose my words. I can understand her more rapid speech and answer her simple questions. Progress.

Late in the day, and buried in writing and word counts, I'm startled by a man's voice, *"Voi un caffe?"*

It takes a second to register that he's offering to buy me a coffee. I recognize him, a regular worker bee here at Base Milano. Blonde and blue-eyed, tall, and broad, even before I

heard his accented Italian, I knew he wasn't a native. I thank him and tell him I've already had my allotted caffeine. His name is Carsten, and he is Danish, a financial advisor. He loves Milan and bounces between Denmark and Italy. He guesses that I am an American. I suppose he knows I'm from the States in the same way I know he is not Italian. He says he sees me writing every day and announces, "You are a fashion writer."

I laugh, "No. I'm writing a memoir."

With Fashion Week around the corner, he was sure I was busy interviewing designers and predicting fashion trends. I'm amused by the story he has written in his head. He seems disappointed by the truth. With little left to say, I pack up and wish him a nice weekend.

On the walk home, I pass several gorgeous humans. More evidence of Fashion Week. I go unnoticed as I stare at their youthful beauty. Tall and lean, barely out of their teens, they are on a path far different from mine at their age. It's not until this time in my life that I can appreciate my courageous seventeen-year-old self.

Terri is out of town, and I have the place to myself. A steaming bowl of minestrone cools, and I open my journal and scribble an entry.

> *Productive writing day. Almost finished with Mom and Dad's passing. To date, the hardest thing I've had to write. Looking forward to writing about dating alcoholics. Geeeezzzzz.*

I check my email, a message on LinkedIn. It's Carsten. With only my first name and a few random details, he found me. Headed to Denmark tomorrow, he was compelled to tell me he felt a connection between us. He didn't want me to think he had

disappeared. I laugh. He is at least twenty years younger than me. I don't mention our age difference in my reply. Instead, I tell him my heart belongs to someone in the States.

I wonder, do women ever approach Andy. What does he say?

�ખ✿✿✿✿

A book on meditation and cherished notes from friends are the tiny bits of inspiration I chose to bring with me on this journey. I figured there would be times I'd want to read them, feel their encouragement. Tonight is one of those times. It's been a long, lonely winter—not a visitor in months. I'm doubting my decision. Is finding myself and writing my story more important than working as a public servant, more important than my family, or more important than being with Andy?

I take my treasures, climb into bed, and read them one by one. There are words about grace and gratitude, prayer, and peace. And then tucked between folded pages, handwritten in a beautiful card from Lynda, are these words.

> *Thank you, for everything,*
>
> *A warrior's heart that is still willing to risk being vulnerable*
>
> *Fierce and gentle honesty*
>
> *Boundless (or almost boundless) energy*
>
> *A generous smile*
>
> *The ability to keep your council*

I tear up. It's okay to put myself first, to chase dreams. I am exactly where I need to be. I needed these words. With

any path, there is doubt. The trick is to keep doubt in the back seat, never let it navigate.

Text
Andy: ...

Me: . . .

His modified ellipsis, his I love you, small and pinched together, is like a whisper, intimate. I do not doubt him or his intentions. I trust his love.

CHAPTER 35

Spring 2018

Text
Me: Photographs of beautiful
Renaissance paintings taken at an art
exhibit in Milan, with a caption:
A little of this and a little of that . . .

Andy: I like this, I like that, I love you . . .

�֍�֍✖✖✖✖

I wake to an early morning tap on my shoulder. It takes me a second to remember why I slept on the couch. Dave, a friend, visiting from California, wakes me to say good-bye. I gave him my comfy bed last night knowing he had a big travel day ahead.

My first visitor in months, within thirty minutes of his arrival in Milan, I whisked him off to the Duomo and then the Vittorio Emanuele Galleria. Before I lost him to jetlag, we had an espresso at the sophisticated and decadent Marchesi Cafe,

located above Prada. He got the boost he needed and pushed through like a champ as we walked the canals in the Navigli.

The following morning, we flew to Sicily. I was a nervous wreck at the airport, afraid I'd be asked to show my passport, revealing my undocumented status. A month ago, I spoke to an immigration attorney. I explained the problem with my documents and hoped that actively working on my citizenship gave me a valid reason to remain in the country. He advised me to go home, and I made a conscious decision to ignore his advice. My cousin assured me that I would go through security without a hitch. He was right.

Dave and I visited Siracusa and Taormina and hiked Mount Etna. Ass-kicking hikes took us to breathtaking views. Chianti and piles of pasta were the rewards for our efforts.

The beach towns along the coast felt like home. I had missed the ocean and its comforting presence in my life. The crystal blue Ionian Sea is a worthy and appreciated substitute for the Pacific Ocean.

We returned to Milan and made a last-minute decision to rent a car and tour the villages of Lake Como. Without a reservation, we were lucky to find a hotel room in Varenna with twin beds—a luxury. Until now, our Airbnbs had offered one bed and one uncomfortable sofa sleeper, so we took turns. The social media posts of the two of us created quite a buzz. Friends sent private messages asking if he was a love interest. Nili called, pleading, "Please tell me you've kissed that face!"

Annoyed, I replied, "Of course not. I love Andy."

It bothered me that she minimized our relationship. I hated the seeds of doubt it planted in my head. But she had witnessed the Napa disaster. She had reason not to trust Andy. I didn't want to tell her about the messages he sent me,

the way he assured me of his love. I didn't want to explain or justify my feelings. I didn't have to.

With Dave on his way back to the States, I have a million things to do. It's my last day in my Milan apartment, and I have sheets to wash, a room to clean, and packing to do. I fill my original two suitcases and two large shopping bags. It was inevitable that I would accumulate stuff over the last eight months, mostly winter clothes. My remaining months in Italy will be spent almost entirely on the road with one suitcase. Roberto and Marissa will let me store my excess in my old room, and I'll crash there between travels.

I had hoped to explore much more of Europe. With my undocumented status, I must fly under the radar and travel in Italy only. It's not a bad place to be stuck.

Loaded like a pack mule, I take one last look at my bedroom and say good-bye. Terri will return tonight to an empty house; we've already said good-bye. Hugging her, I got teary, and she laughed, "Don't cry."

I told her endings were hard for me. I leave my keys on the kitchen counter, close the door behind me, and lug my belongings across Corso Cristoforo Columbo and down the stairs into the Porto Genova Metro Station, my stop, for the last time.

Text
April 16, 2018
Me: I left my place in Milano. My housemate needed a full-time renter, and with spring in full swing I'll be travelin a lot more. The timing is right. When will you come?

Andy: I'm so happy for you! Can you see
how big I'm smiling. As for my travel
plans, it looks like I won't be able to plan
something until later this year. These
early months in my new business are
keeping me extra busy.

. . .

Me: I can imagine your smile. I look
forward to feeling its warmth and seeing
you face to face, heart to heart, when I
come home in August. I hope we come
back for a visit together . . .

I am terribly disappointed and afraid he's losing interest,
but I ignore the doubt in my gut and take him at his word. He
is busy with his new job. That's all.

✸✸✸✸✸✸

My sweet Airbnb, Casa de Musica, is situated in the tiny
village of Olcio on Lake Como. A thirty-minute walk south is
Mandello del Lario, home to the Italian motorcycle company
Moto Guzzi and many of Dad's cousins. A narrow, winding
road from Mandello leads to higher elevation and the village
of Somana—the birthplace of my paternal grandmother,
Nonna Ester, and her thirteen Rompani siblings. I plan to
immerse myself in writing.

Sitting on the patio with my Mac open, I do my best
impersonation of a writer hard at work. But it's not happening.
Distracted by unseasonably warm spring temperatures,
gorgeous blue skies, and the desire to explore mountain trails,
I give in to playing hooky.

I examine a map of local trails in the shared breakfast room and look for the trail that leads to the cemetery where my grandparents are buried. I've only traveled there by car, and from the opposite direction. My host Stefano outlines the trail with his finger and says it's only a forty-five-minute trek.

Where the path is steep, it's also slippery, muddy, and covered with damp, fallen leaves. I'm wearing proper shoes for a change but still manage to slip and fall twice. Standing quickly and brushing off the dirt, I laugh out loud as I imagine my sisters here with me, laughing at my expense.

I pass a couple donkeys and take their photograph. About the time my legs start to burn with fatigue, the trail opens to a farmed plateau. I pause to breathe in the fresh mountain air and take in the panoramic view of the lake and surrounding mountains. Working farmers and grazing cows raise their heads to acknowledge my presence as I pass. I accidentally trespass, stumbling onto private property. I scurry past, offering, *"Permisso, mi scusi."*

I came to Somana a couple months ago with Uncle Roberto and Marisa. Cousin Graziela gathered all the mountain cousins at her home. Roberto had not seen one cousin in nearly fifty years. He joked that the family gathered for only two reasons, weddings, and funerals; my arrival in Italy gave them a third reason.

When we arrived, Graziela's husband, Francesco, stood in a small open shed manning an industrial-sized electric mixer. A homemade contraption producing a low buzzing grind as its metal arms pushed through a mass of polenta. Enough to feed at least twenty Rompani cousins. Our breath visible between us, my teeth chattered as I tried to make conversation. I detected bits of local dialect mixed with standard Italian. I managed *"Si"* and *"Ho capito."* The only thing I understood

for sure was that there were two kilos of butter in that mix.

We gathered for supper in a large dining room, separate from the main house. It took two cousins to hoist the stockpot onto the dining table. I was given a fork and invited to join those standing over the steaming pot. Leaning over the gooey mixture, we dug in, melted cheese draped from our forks as we took our first bites. *Delizioso.*

Warmed by the red wine, I listened to the stories but struggled to understand. I stopped trying and examined the Rompani faces instead, finding traces of Dad in the creases near their eyes and in the way they used their hands. I felt his presence, and I knew he was with us.

Looking for ways to break the language barrier and engage, I shared a short video on my phone. Nick had given it to me, footage from a trip he and Dad made to Mandello in 1990. Our grandparents had passed by then. In it, Rompani cousins sat at a large table and sang *"Cimitero Rosa,"* Cemetery Rose. Dad leans against a wall, thoughtful, arms crossed, his face reflecting the melancholy melody. The camera cuts to Zia Franca greeting Dad in dialect, her voice loud and strong, her joy palpable. The next shot is Zio Rico pitching hay near the barn. Hearing Dad's voice, he looks up. Reaching over his donkey, he grasps Dad's hand and pulls him in for *due baci*, two kisses. Then Nick captures Dad from behind, walking the narrow streets of Somana. I wonder what he is thinking. Did he miss his family, his home, his country? Questions I never asked him.

The path grows wider, and it's paved. I recognize the power lines above; the mausoleums in the distance come into view. I made it to the cemetery. I am fearless here in Italy. I trust my instincts and find my way.

I gently push the gate open. Gravel shifts beneath my feet as I walk toward my grandparents' gravesite. Photographs

of their younger selves are mounted on the tombstone, and their names below: Ester Rompani and Domenico Amoroso. Someone has left potted yellow flowers. I did not know them well. I first met my grandfather when he came to California. I was nine years old. Every day he met me at my bus stop, and we walked home together. I perched on the arm of his chair while he read the newspaper aloud. My job was to correct his English. He had to prod me, "Christina, if I am wrong, you must tell me."

When our family visited Italy in 1976, I saw my grandfather for the second time and met my grandmother for the first time. She cried and cried when we arrived and when we said good-bye. I never saw them again. I put my hand on their tombstone and thank them for my dad and passing on the DNA that makes me who I am.

✻✻✻✻✻✻

Windows down, the mountain air blows through the car. I gather my hair and wrap it around my hand to prevent a tangled mess. Moira, Graziela's daughter, taps her horn and waves to passing cars and walking neighbors, *"Ciao, Buongiorno!"*

Their greetings trail off as we speed past. I ask Moira if she knows everyone. She laughs. In fact, she does, common in these small mountain communities where folks have lived for generations. I think about home. I miss the familiarity, hearing someone call my name, or giving me a hug in passing. When I return to California, there will be no physical house waiting for me. I will go back to my beach town as a visitor. I won't stay.

Moira stands with me on the platform, and we wait for my train to Rome. She reminds me to pay attention, listen for my

stop, and always be aware of my purse and belongings. I have managed on my own for nine months, but I smile and thank her, grateful that I have family here that care about me. We kiss, *due baci,* and I promise one more visit to Mandello in July when Susy and George visit.

I find my seat, and before long, I am immersed in the next chapter of my memoir, the part where Andy and I find each other after so many years. I sigh. I was counting on his company in spring. My mind jumps to the worst-case scenario: He never intended to come see me again. He's delaying the inevitable end. I try on the idea for a second and let it pass. I don't want to give attention to outcomes I don't want. Instead, I read through his texts of the last several months and find the reassurance I am looking for.

<p style="text-align:center">✳✳✳✳✳✳</p>

The cab driver drops me at the edge of Piazza Campo di Fiori. I spot the restaurant where I am to pick up keys for my Airbnb and approach with my luggage. I catch a waiter's eye, and I mime opening a lock with a key. He shouts, *"Chiavi?"*

"Si." I need the keys to the apartment.

A long, narrow hallway, piled high with bagged garbage, leads to a staircase. The smell of rotting produce tempts my gag reflex. Holding my breath, I climb three flights of stairs to the tiny, claustrophobic apartment. Kudos to the person who took the photographs for this listing. They managed to make the room look twice its actual size. I open my laptop and attempt to log on to the internet. No connection. I text the hostess about the wi-fi and the trash. As I unpack, I hear the responding ping. Turns out the internet is spotty, "Sorry :-)." And trash collectors are on strike.

My stomach growls. I'm more hungry than annoyed, and I'm late for lunch even by Italian standards. Most places will be closed until the dinner hour. I venture out. A touristy trattoria will have to do. I order a simple Margherita pizza and a glass of red wine.

The waiter asks, "Where are you from?"

"California," I say.

"Ah, bella."

He visits my table more than necessary and asks me to kiss him no less than a dozen times. He is kidding, but not really. My only escape is to promise I'll be back for dinner. I do so with absolutely no intention of ever returning.

My belly full, I walk beneath the canopy of sycamore trees along the Tiber River. Their yellow pollen covers the sidewalk and my sandaled feet. I unintentionally kick up the dust, and sneeze. Taking in my new surroundings, I map out my powerwalk for the next few days. Instead of heading back to my apartment to write, I walk to the Altar della Patria and the Tomb of the Unknown Soldier. My siblings and I stood in this very spot with Nonno Domenico as Dad gave one of his famous history lessons. We learned about the significance of the tomb, and the patriarch of Italy, Vittorio Emanuele. I was here last in 1990 for a business trip mixed with pleasure. Some faraway places are worth seeing again. Not only for their beauty, but for remembering people we love, and miss.

❋❋❋❋❋❋

Spring's blue skies and warm temperatures were reliable in Rome, and I was looking forward to summer as the days grew longer. Here in Piglio, high in the mountains east of Rome,

it's rainy and cold. With my winter coat packed away in Milan, I resort to wearing layer upon layer, and still, I'm freezing.

Dad's sister, Aunt Cristina, is hosting me. I look forward to my bed each night, beneath a heavy quilt and blankets—the only place I am warm. Once the lights go out, I cannot see my hand in front of my face. There are no streetlights to illuminate the night sky.

Aunt Cristina left the city years ago and retired here. I haven't seen her in twenty-eight years. Her English was better then; practicing with her high school students and teaching her own children kept her fluent. In the seclusion of the mountains, there is no use for it. Even with her rusty English and my more limited Italian, we manage to share stories and deep emotion. She loved my dad very much, a faraway hero living in America. She says Dad was a Boy Scout here and even met the Pope nearby when he was fifteen years old. A story he never told me.

Anticipating my visit, Cristina filled two large albums with family photographs, many I had not seen. We sit at an outdoor table, turning pages of black and white images. A young Nonno Domenico in his military uniform holds Dad's toddler hand. More photographs of the family in Eritrea, Africa, where Dad, Uncle Roberto, and Aunt Cristina were all born and lived until 1950. I tell her that Dad and I had planned to travel there together in fall of 2008, first to the World Cup in South Africa and then to Asmara, the city where they lived. I turn the pages, Dad as a boy, a young man, and his life in Rome before coming to the states as an exchange student.

Pages filled with color pictures of my siblings, me, Mom, and Dad—every photograph my parents had ever mailed to our family in Italy. Cristina removes a photo of me and my sisters from the protective sheet and shows me Dad's inscription on

the back, *"I miei gioielli,"* my jewels. And then another picture of himself, *"Ai miei cari genitori con tanto affetto. Orlando,"* to my dear parents with much affection.

I recall Dad speaking Italian—loudly—during rare overseas phone calls. He would gather us in his study to say hello and translate our grandparents' responses. It never occurred to me that he did something as sentimental as sending photographs penned with sweet messages.

Cristina and I talk about the passing of Uncle Giampaolo in 1988, their youngest brother, thirty-three years old. My dad flew to Paris to see him two weeks before cancer took his life. Nonna Ester died six months later, a broken heart. I had never seen Dad so sad.

Nonno Domenico lived two more years, and Aunt Cristina took care of him. She chokes back tears as she tells me about his last days and the regret he expressed for sending his oldest son to "the wolves" in America.

I think back to a conversation I had with Dad a decade after my first divorce. I had joined him on one of his midnight drives to Vegas. He apologized for insisting I marry Cal. Surprised, I reminded him that I loved Cal, I wanted to marry him. I didn't feel forced by him or hold him responsible for the failure of my marriage.

It seemed Nonno Domenico had held on to guilt, maybe even false beliefs, confessing to Aunt Cristina on his deathbed. I hope that I had relieved Dad of any lingering guilt long before he died. I assure Cristina that I had witnessed Dad's love for his adopted country. He lived an incredible life. But I'm not sure I've convinced her.

And then I wonder, were we enough?

We sit quietly with our thoughts. I take photographs of the pictures to share with my brother and sisters.

There are a hundred reasons to celebrate my journey, and then there are days like today when the only thing I want is to talk to my dad one more time.

❈❈❈❈❈❈

Bundled up at the dining table, I write more than I have written in weeks. My aunt sits at her computer desk, tapping away on her keyboard. She is writing a book of her own. We take turns stoking the wood-burning fire.

> Text
> May 5, 2018
> Andy: . . .
>
> Me: Last night's dream, a knock on
> my hotel room door. I open it. You are
> standing there wrapped in a blanket.
> You tell me that you are staying there
> too, but you wanted to get in bed with
> me. We snuggled up, and I swear I could
> feel your warmth. I buried my nose in
> your neck and just breathed . . . so real.
>
> Andy: What a wonderful dream . . . I
> believe dreams can come true . . .

This is my best-case scenario.

CHAPTER 36

Late Spring and Summer 2018

Blog Post
May 31, 2018, Milan, Italy
School Days . . .

An early morning message has me misty-eyed.
A former boss, colleague, and friend wrote
"Bittersweet" after having just seen my name
on the Resignation Report at the school board
meeting.

"We miss you, Christine."

I felt the good-byes of last summer, wrapped
in love and well wishes, all over again.

When I received the email last month from
Human Resources asking about my plans for the
fall, I had already made my decision. I would not
be returning. It was time to formally resign my
position, no more leave with the possibility of
return, the official end of my tenure in the district.
There was a finality that didn't exist until the

moment I saw my words in black and white. I took a breath and hit send.

I thought about my decision as I fell asleep that night and all the next day. Throughout my travels, I have met many young families from around the world. When asked my profession, I would proudly say, "I'm an elementary school principal in the states, on leave, chasing a dream for a bit."

The children's eyes grew wide at the mere mention of my job title. Their parents shooting them a look as if to say they had better behave in my presence. To calm their nerves, I'd smile and ask a few questions, "Where are you from? What grade are you in? What has been your favorite part of your trip?"

Then I couldn't' get them to stop talking.

I reply to my friend's message, "I miss all of you. I'm learning that sometimes we must leave the things we love to find out who we really are."

Walking this morning, the park and the paths are empty. It is peaceful, perfect for reflection and meditation. At the end of the trail, I turn and face the trees to stretch. I hear them before I see them, school children, laughing and talking. A field trip to the park, I suppose. Soon they are in full view, a long trailing line walking toward me, led by their teacher and a few parent chaperones. I smile as they pass me, one by one. It starts with a little girl who looks up at me and smiles, *"Ciao."*

"Ciao," I reply.

And then one sweet smile after another follows, *"Ciao, Ciao, Ciao, Ciao."*

I am transported back to the school playground, greeted by my students, and feeling their love.

Life goes on, but those twenty years, those smiles, those faces, they are forever in my heart.

xoc

I read my words again, "Sometimes we must leave the things we love to find out who we really are." It's not easy, but it's worth it. Two more months in Italy. There is more to explore—around me, and within me.

❋❋❋❋❋❋

I make quick work of unpacking. With summer near, I travel with less. A few sundresses, a pair of sandals, and good tennis shoes are all I need. I open the shuttered windows, and the sound of laughter rises from the wine bar patio below. I am ready to explore the bustling streets of Monterosso in Cinque Terre.

A week ago, I walked the circumference of the walled city of Lucca. Clover blanketed the surrounding terra, its sweet smell fresh in my memory. Yesterday, I climbed the worn marble steps to the top of Pisa's famous leaning tower.

I examine the map given to me by my hostess, Laura; she highlighted points of interest. I definitely want to hike from Monterosso to Vernazza, an estimated two hours on a mountain trail. I'll do it tomorrow. She also gave me the name of a hair salon. I can't imagine there is more than one in this small seaside town, but she tells me this one is the best.

Slipping on a sundress and sandals, I set out to find food. As usual, I have arrived hungry. Unfamiliar with Monterosso, I follow my nose to the smells of fish and mussels in a

bubbling spicy red sauce. I enter the crowded patio and ask, *"Tavolo per uno?"*

"Da Solo?"

"Si."

I nod. Yes, a table for one. Yes, I am alone. That usually gets a less desirable spot, but I don't mind. A glass of wine and a giant plate of pasta covered in *frutti di mare,* all things from the sea, is all I need. I dig in and then wipe my plate clean with a piece of bread, *la scarpetta,* the little shoe. Something Dad taught us as kids, but I never knew the Italian word for doing so until I lived here.

I find the hair salon tucked among the tourist shops. The young hairdresser checks the silver roots creeping down my scalp and squeezes me in on Friday.

Along the waterfront, perfect rows of colorful umbrellas, orange, blue, and white, line the beaches. The umbrella scene can be quite expensive. I find the free beach. Farther from the town center and quiet this time of year, I prefer it. I'll be back later this week to lie among the other sun worshipers. Quite by accident, I stumble upon the trailhead to Vernazza. Staring down at my sandaled feet and looking ahead at the condition of the path, I give into spontaneity and forge ahead.

"Signora, Signora!"

I glance back toward the shouting to see a wooden shack and a young woman leaning out of its window. I had forgotten there was a toll for the hike. I walked right past the collection booth. *"Scusi. Quanto costa?"*

"Sette euro."

I pay the seven euros and continue on my way. The path is level for a short distance and then begins to climb. I pass hikers returning from Vernazza, all smiles as the end of their hike is near. I note their proper hiking shoes. More than a

few of them look quizzically at my well-worn sandals. I smile broadly and offer, *"Salve!"* hello.

I'm the only solo hiker. Most are in pairs or small groups. A young mother holds her toddler's hand. Her husband walks behind them, and a baby rides in the carrier on his back. Elderly couples sit outside their homes and greet me as I pass.

The views are spectacular. Looking toward the Mediterranean Sea, I calculate the time difference and FaceTime Mary. This beauty must be shared. I show her my exposed toes, their nearness to the path's edge, high above the rocky shoreline, and I pan the seascape. We say good-bye, and for the first time in nearly a year, "See you soon."

Before I begin my descent into Vernazzo, I stop to admire the village's charm from above. Tall, colorful buildings surround a small marina. Moored fishing boats bob in the gentle current. I record a video of the picturesque town and the rugged Ligurian Coast for Andy, then turn the camera on my smiling self. "Wish you were here. Love you."

In town, I buy a gelato, *cioccolato* and *lampone*—my go-to. I meander and take in the local color. I read that each of the five towns of Cinque Terre has a unique personality. It's certainly true of the first two I've visited. I plan to see all of them. Settling on a wooden bench, I finish my gelato and appraise my filthy feet. Fatigue sets in. I'm not sure I can make the hike back before dark, so I decide on the train, checking my phone for the schedule. I chuckle. The hike that took two hours is less than a five-minute ride by train. Squeezing my way into the crowded car of beachgoers and others who skipped the hike back, I grasp the center pole. I am happy, keenly aware of the dream I am living, the dream I made come true.

✳✳✳✳✳✳

Yesterday Randi and I sat poolside sipping fancy lemon cocktails under the azure skies of Sardinia. We picked up right where we left off a year ago, happy to be together again. Today under those same skies, we walk a mile, hot and sweaty, carrying two giant bags of dirty clothes. She had been traveling with her husband for the past two weeks, and I had been on the road. We are desperate for clean clothes.

Taking advantage of the nearly empty laundromat, we do all the loads at once. The dryers are a bit tricky, and a British guy lends a hand. Then he invites us for coffee while we wait for our clothes to dry. His accented request is so polite that turning him down feels rude. Keith is his name. He and I convince Randi to have her first cappuccino. The caffeine jitters hit her hard, and I regret my insistence. While she tries to calm her nerves with some tea, Keith tells us he sailed alone into Sardinia from Majorca yesterday, something he's done more than a few times. We tell him about our long friendship, our love of travel. He asks if we'd be interested in meeting for dinner or a G and T later. A *G and T*? Seriously, who says that? We give him a tentative maybe.

Randi and I make dinner reservations for La Saletta, a restaurant that we passed on our walk back to the hotel. I text Keith and tell him we have plans. He offers the possibility of drinks after dinner. Maybe.

We stuff ourselves with roasted pork, chicken, potatoes, and zucchini, and chase it with a bottle of red. Another text from the persistent Keith, and we agree to meet—just one drink. He finds us on the lantern-lit streets of Alghero, takes us to a local hole-in-the-wall, L'altra Vineria, and asks, "Fancy a G and T?"

Randi and I stifle a laugh and say no to the gin but yes to more wine. We stay longer than we intend, and it becomes clear that Keith fancies more than a G and T. And while he's a nice enough guy, I do not fancy him. I lie and tell him I gave up men while living in Italy. It's easier than the truth. The few times I've mentioned my heart belonging to someone at home, my words were met with a look that said, "You're kidding, right?"

Rather than appear naive and schoolgirlish, I lie and wonder why I care what a stranger thinks.

It's late, we've had a lot to drink, and before Keith can talk us into one more, we say goodnight. He adds, "Please call me when you decide you like men again."

I laugh and clarify my lie, "I never said I didn't *like* men. I said I gave them up for a while, that's all."

Over the next couple of days, he texts a few more times. He wants to meet again. Instead of saying I'm not interested, I tell an easier truth: Randi and I are headed to Capri and the Amalfi Coast. We never see Keith again, but we impersonate him constantly, "Fancy a G and T?"

We do this every day, even when there isn't a bar in sight. And every time, we laugh.

❋❋❋❋❋❋

Randi and I plane, train, and taxi our way to Sorrento. La Hotel Tonnarella, our peaceful sanctuary, sits on a rocky point with dreamy views of the Gulf of Naples. Three days remain of our time together. We lie on our beds and search the internet for one last destination, one more adventure. Randi concentrates on the task at hand, and I disrupt her focus, laughing as I recap stories of the last few days.

We missed a local bus and ran nearly two miles to catch a ferry for Capri. Side-splitting panting turned into high-fives and laughter when we reached the boat with minutes to spare.

"Can you believe we made it?" I ask. "Thank God Italians aren't punctual."

"And what about that tiny cartoon bus chugging its way up to Alta Capri? That was just a warm-up for the gnarly coach ride from Amalfi to Positano. Those sheer drops to the sea and the hairpin turns. Yikes!"

Randi gives in to reminiscing, recalling fancy dinners and the delicious charcuterie we prepared with purchases from a local market. Chased off the patio by a sudden rainstorm, we finished eating in our room.

I have missed my friend, someone who completes my sentences and my thoughts. I have missed speaking rapid English and the comfort of everything that is home. Randi stares at her iPad and sighs, "What if we stay here in Sorrento? We've had such a good time. We love it here. Why are we trying so hard to find another destination?"

She's right.

When Randi leaves, I'll travel on my own until Susy and George arrive in July. Then, it'll be time to go home. I click on an airline site and buy my ticket.

Blog Post
June 23, 2018, Sorrento, Italy
Sea Glass wisdom . . .

Wearing flip-flops, I walk slowly, stooped, along the pebbled shore. I am careful to maintain my balance on the water's rocky edge as I search for sea glass. Most are emerald green, some milky

white, or clear. Wedged between the dark-colored stones in crystal clear blue water, they are easy to spot. I scan the shoreline and shallow waters for flecks of green or white. Once spotted, I quickly snatch them up before the small incoming waves ripple the surface and obscure my view or bury my potential treasure. I turn each captured piece between my fingers, feeling for imperfections. Taking a closer look at the shiny wet nuggets resting in the center of my palm, I keep the smooth ones and toss those with rough and jagged edges back out to sea.

As I watch the rejected piece splash into the deeper water, I imagine the years it spent tumbling among the rocks. First sharp and broken, it becomes smoother, polished with each tap and bump against the rocks.

I continue my search, and my mind wanders to memories of broken days with sharp edges. Relationships that had me bumping up against the same obstacles, repeated patterns, time and time again. It took me a long time to learn that my circumstances were no accident. Every person, each incident presented was for the sole purpose of teaching me something. In the old days, I ignored the lessons, ran away, or quit before they were complete. Life, relentless in its teaching, simply provided more opportunities for me to try again. When I finally decided to listen and learn, my rough edges smoothed, and I gained wisdom.

Squinting into the water, I see a large piece, the biggest so far. I scoop it up and immediately

rub my thumb against it. It is almost perfect except for one nicked corner—too deep to ever smooth, I think. The color so vibrant, I decide to keep it for my collection anyway.

As I admire its green glistening luster, I pick at the small gouge. Pressing it between my thumb and index finger, I imagine I could probably rub it away over time. I chuckle to myself, always trying to fix people and things, mold them to my liking. I stop and accept it as it is. It is perfect in its imperfection. Just as I am perfect in mine.

It was in acknowledging my imperfections that I learned who I really am. In accepting myself as-is, I found an abundance of love and compassion for others.

So, I risk, I stumble and fall, I learn and grow. And I look and listen for the lessons. I change the things I can and accept that which I cannot. I am meant to find joy, beauty, and love beyond imperfections, rough exteriors, and differences. I am meant to love my fellow humans and myself as we are.

And I thought I was just looking for sea glass . . . :-)

xoc

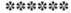

Text
June 27, 2018
Andy: Happy Birthday my love . . .

Me: Thank you Babe. No one here
knows it's my birthday. And I kind of
like it. I'm secretly celebrating myself
and a year of accomplishments. Can we
celebrate together when I come home? I
love you . . .

Andy: Enjoy your quiet celebration
today. We will honor it on your return
. . .

July 2, 2018
Me: I finished. I finished my first draft.
I did it and I'm pretty proud of my
work. A long way to go with edits, but I
accomplished what I set out to do . . .

Andy: I'm SO PROUD of you . . .

Thousands of words and hundreds of pages later, I have
written my memoir. I fussed over the ending and settled on
the day Andy and I said good-bye outside the Grand Hotel
Baglioni nearly a year ago. "To be continued," he said.

I've thought of his words often in the last year. They gave
me the courage and confidence to write my happy ending.

CHAPTER 37

August 2018 through February 2019

Close to midnight, I pull into Tara's driveway. Up way past his bedtime, Luca stands beneath the porch light, waiting for me in his pajamas. Barefoot, on tippy toes, he squints through the headlights, searching for my face behind the windshield. Jumping up and down, he shouts, "My Nonna's here!"

He wraps himself around me, hugging me tightly. His head presses against my ribs; he has grown. I stand back, hold his face in my hands, and kiss him, "I have missed you, my boo. I have missed you so much, more than anyone. I am so happy to see you. So happy to spend my first night home with you."

"Can I sleep with you, Nonna? Can I sleep in your bed?"

"Of course, you can."

Exhausted, we fall into bed. Luca curls up next to me, "I hope you stay home for a long, long time."

Clutching his green, fuzzy blanket, he sucks his thumb. A quick toss and turn, and he is fast asleep. Something Tara told me months ago comes to mind. Luca had said to her, "My life is way much more harder when I don't get to see my Nonna."

I hope his little life is better now that I'm home.

❋❋❋❋❋❋

Andy drags my barstool closer to his with a mischievous smile, "No, no, that won't do. You are too far away from me."

He nuzzles my ear and kisses me. He is exactly as I left him, sweet and charming.

He was in San Francisco visiting his daughter when I arrived on Saturday. We made a plan to meet for lunch midweek. Leading up to this day, his communication felt distant. I chalked it up to being busy and giving me time to settle in. I needed it. I had made it past the jet lag, but a migraine had me down for days. I woke up each morning disoriented, taking a second to remember I was home. After staying at Tara's for a few days, I made my way to Huntington Beach to crash at Mary's. Back in my old neighborhood, I was like myself again.

In Andy's company all doubt washes away, and our year apart vanishes. We share a cold fish platter, sip crispy Sauvignon Blanc, and talk, and talk. Beaming, he tells me about his girls. They are doing well, both college graduates now and making lives of their own. His mom's health is good; she's celebrating her eightieth birthday next month. The new job has been quite demanding, and he has loved the challenge. I tell him about my sweet reunion with Luca and that my absence was hardest on him. Andy leans into me; we kiss again. The wait is over.

The wine is going to my head. I talk faster and gush about my plans to move to LA. I go on about possible neighborhoods. Venice is on my radar again. I am excited about living in the same city, the same time zone. My head in the clouds, surrounded by rainbows and butterflies, his words don't register right away. And then they hit me so hard

I stop breathing. "In the interest of full disclosure, you should know that I am dating someone. Someone I want to continue dating. And I love you."

Blinking in disbelief, stunned, I manage a barely audible, "Oh."

I look at the remaining food, our second round of nearly full wine glasses, and then directly at Andy. I blurt out, "I am amazing!"

As if those words will snap him back into wanting only me.

He meekly replies, "I know."

And then he is silent.

I excuse myself to the bathroom because I don't know where to go or what to do. I'm buying time. Giving him a chance to change his mind. I try to collect myself as my head spins in a fog of humiliation. I thought he was going to surprise me, extend our date into evening, take me back to LA with him. This date is over. *We* are over.

I want to go home, but I don't have a home.

On the tense drive back to Mary's, I gather my courage.

"Do you love her?"

"Yes," he whispers.

"Has she met your girls?"

"Yes."

"How long have you been seeing her?"

"Since November."

He *lied* to me. He pretended.

"And you never thought to tell me before today? For more than two hours, you let me believe we were finally going to be together." I spit the words at him.

"I thought it would be better to tell you in person."

"And your girlfriend, she would be okay with you kissing my lips and telling me that you love me?"

He clears his throat, "Probably not."

I am furious. "You let me do this to another woman?"

I think about my book and its hopeful ending. My voice cracks, "My book."

My words trail into nothingness. I close my eyes and watch my dreams get sucked back into the Universe, leaving a big hole in my heart. I will myself to be strong, to not cry, to not let him see my pain. He pulls up to Mary's condo, and I stare into my hands. I want to scream, punch him, unleash my anger, and hurt. Instead, I maintain my dignity. I will not lose my shit over this. I take a deep breath and say the one true thing I know, "I love you, Andy. I always have."

He says nothing.

I leave the car and stand on the curb, looking at him through the windshield. His lips purse and quiver; I think he might cry or form words. But he does neither. He never says, "Stop," never says, "Don't go," and never says, "I'm sorry." And for the first time, ever, we part ways without him saying that he loves me.

I text Mary, asking her to open the security gate. Andy and I lock eyes. I kiss my fingertips and turn my hand toward him, a final gesture, and I walk away.

The new beginning I envisioned is just another ending.

❁❁❁❁❁❁

Blog Post
September 4, 2018, Huntington Beach
To Whom it May Concern: Don't wait . . .

Don't wait to tell someone you don't love them anymore, or that you never did, or that you have

351

fallen in love with someone else. Don't linger in a relationship because you have nothing better to do, or because it feeds your ego, or because you are afraid of hurting someone. Don't rationalize your cowardice with excuses about the right time or the right place. There is no good time to break someone's heart. But when you know in your heart you are finished, honor the relationship's end with dignity by telling the truth as soon as possible.

Don't fucking pretend . . .

Don't pretend that you are still in love. Don't use terms of endearment and kiss them tenderly. It's cruel. While you pretend, they continue to trust you, to believe in you and a future. Waiting and pretending robs them of precious time; time to hurt and heal and find someone who believes they are amazing exactly as they are. Don't hold their heart hostage and steal their opportunities for real love.

Truth?

I've been on both sides of this equation. Believe me when I say the regret can be unbearable. It took years to rebuild my character, my integrity.

Ending relationships is never easy. There is pain, sadness, and often anger. Hard truths hurt in the best circumstances. And heartache is only made worse by deceit as you drag out the inevitable conclusion.

As you read these words, you know right now if this is you. Don't perpetuate false hope. Let

them go; give them a chance at true love, sooner than later.

Sincerely,

A Friend

PS: If you are on the receiving end of this heartache, I promise you, you deserve more.

Andy will never see this. He never read my blog. I don't care. I didn't write it for him. I wrote it for me. I deserve more.

✿✿✿✿✿✿

I bite into my toast. A piece of avocado slips down my chin, and I catch it in a napkin. Outside, people hustle by. A homeless man picks through a trashcan. He looks up at me, pulls his ragged blanket tighter, and shuffles past. I've been in LA a couple weeks, cat sitting for a friend's daughter. Her apartment sits adjacent to Union Station. Most mornings, like today, I walk to Blue Bottle Coffee, next to the Bradbury Building, and write. I love the buzz of downtown, but friends discourage me from moving here. They point out the traffic, the isolation, and the expense. They're right on all accounts. But I'm obstinate, hell-bent on living in LA to show Andy, and everyone else, he had nothing to do with me wanting to be here. In the meantime, I had hoped my being here would get me closer to a decision about where I might live in LA. But I'm still unsure.

Blowing on my hot coffee, I reread my memoir's optimistic ending. The words that suggested a happy future with Andy piss me off. I can't leave them be. Writer friends suggest I include my year in Italy. And then what? End my story with Andy dumping me. I don't have the emotional stamina to

revisit the lies that kept me believing we'd be together. Shit. I don't know how to finish my book. I don't have a plan, but I do have a ticket to Italy. No decisions about my move or my book's ending until I come home in November.

❊❊❊❊❊❊

I lie on the floor mat as Gabriele stretches and massages the tension away. He reminds me to relax my fucking jaw, and I laugh. Is it weird to ask if he inherited his funny charm from his dad and then follow up with, "Is your dad single?"

I keep the question to myself, but I'm glad my sense of humor has returned. We finish our session, and Gabriele asks, "What have you been doing since you arrived a month ago?"

"So much. I went to Venice, Varenna, and Florence with friends. I tortured them with the uphill walk to San Miniato. Have you ever been?"

He shakes his head, no. I practically shout, "You must go! It's one of my favorite places in Florence. The cathedral is a thousand years old. So beautiful, and peaceful."

He holds me in his gaze for a second, then smiles. We have an unspoken fondness for one another. It's easy for me to name feelings when I have no expectations, when the boundaries of the relationship are clear. It's when I want intimacy, when I attach myself to a dream or an ideal, that I lose all sense of reality. Was it reasonable for me to trust Andy's love when he had shown me more than once that he could live his life without me? Probably not. I had let the hopeless romantic in me rule my heart; I was vulnerable with the wrong person.

I smile back at Gabriele, "It was great to see you. *Ci, Vediamo!* I'll be back in May."

He raises his thick eyebrows, *"Arrivederci, ciao, ciao."*

✾✾✾✾✾✾

Home from Italy a month, and I am no closer to finding a permanent place to live or an ending to my story. Bob Dylan's "To Make You Feel My Love" plays. Its words find my heartache, and tears run down my cheeks. I feel the stare of the tattooed young woman at a nearby table, but I don't look up. I keep on typing. Finishing this book might be my undoing. Maybe I'm already undone. I check the time. I've got to pick up Luca soon.

Staring into space, I analyze my sadness and depression and blame it on the upcoming holidays. I haven't been sleeping well at all. In the middle of the night, I make a mental list of worst-case scenarios: terminal illness, losing all my money to pay for medical care, dying alone. My mind spirals. My doctor says I am a broken record, repeating all my same ailments of three years ago, same symptoms, same anxiety. I sob, and he asks, "Do you fear me, this visit?"

I give a feeble laugh, "I fear crying in front of you."

I am afraid of being vulnerable, afraid to say I'm sad, when it's all so obvious. He offers the possibility of meds. I shake my head, "I'd rather focus on meditation, yoga, and acupuncture."

Now it's his turn to shake his head. "And how is that working for you? You need more. You can't go through this alone. How about a therapist?"

I nod, "Okay, I can do that."

I promised to make an appointment, but I haven't yet.

✾✾✾✾✾✾

Outside Luca's school, I wait in my car. Light rain falls, and the dismissal bell rings. I've forgotten an umbrella. I wait until his class reaches the pickup gate and then dash to meet him.

"I'm so happy to see you, my boo. We better hurry so we don't get too wet."

He reaches for my hand, and we run to the car. Laughing, he says, "Nonna isn't this fun? Don't you love holding hands and running in the rain?"

"Yes, yes, I do. Especially with you."

In Luca's world, my troubles vanish.

❀❀❀❀❀❀

Write. Edit. Repeat. If I had known what it took to write a book, I would have never done it. The elation I felt when I "finished" my manuscript in Italy has been replaced with the misery of seeing no end in sight. I'm being dramatic, but lately, I hate my story. I'm sick of it.

The goal today, finish editing a single chapter. I had hoped that a new location would provide some inspiration, but instead, I'm distracted by memories. I haven't been to the Main Street Library since my kids were little. Before then, it was Dad who brought my siblings and me here when we were in grade school. Like many things from childhood, what once seemed grand is now small and tired looking. When the modern Central Park branch opened in the seventies, we never returned here. I notice a wall of shelves, empty; maybe the library will close for good. A young man, homeless, I think, sleeps on a large beanbag chair in the children's section. At a nearby table, a white-haired, older woman reads the newspaper. The solid oak library chair beneath her is old and worn, but sturdy, like her.

A break in the clouds and sun pours through the floor-to-ceiling picture window, providing beautiful natural light

but no warmth. Chilly from the dampness of the rainy day, I spread my down jacket over my legs and pull my wool beanie over my ears.

Turning my attention back to my manuscript, I flip through its pages. Words in red ink shout at me: "What is my story about? What are its universal themes?"

Good fucking question. I'm still not sure. I pull a journal from my backpack and skim old entries looking for clues, words or phrases that resonate—nothing. The library table shakes, startling me. An old woman puts her motorized wheelchair in reverse and then tries another route. She glares at me as though I had put the table in her path. I smile and say hello. She growls and grumbles under her breath, and I chuckle. My phone pings, a text. *We would like to rent the apartment to you.*

Blog Post
February 14, 2019
Detours . . .

Bedding and sheets lie neatly folded in cardboard boxes in the corner of Jack and Ev's guest room. Gigantic plastic bags stuffed with new pillows are piled high on the corner chair. Two suitcases packed with clothes, and a single chair I purchased on sale a few weeks ago, block the sliding door. Today I move into my new place. I swore when I returned to the states that I would rent a small furnished bedroom in someone's LA home, remaining unencumbered, and sticking to my two-suitcase rule. And now I find myself renting a one-bedroom apartment in my hometown—a

charming craftsman built in 1914, not at all what I planned or expected.

A few weeks ago, as the skies unleashed on a Monday afternoon, I sat staring at my laptop, sick and tired of scanning rental ads. Everything looked the same, dorm-like, and ugly. Frustrated, I left the cozy comfort of the coffee shop and set out in the pouring rain. Flooded streets kept my driving to a slow crawl as I searched for posted rental signs. No luck. Turning onto Main Street, I hit the brakes and did a double take, a "For Rent" sign. For thirty years, I have admired the stately gray shingled building with white trim and have NEVER seen anyone move in or move out. Cycling past all those years, I would remark, "When I'm an old lady, I'm going to live there."

An odd comment, given I owned a home. Why would I need a rental? But then, I never imagined I would live in Italy either. I dashed out into the downpour and took a snapshot of the sign with the rental details. The following day I walked through the property. No dishwasher, no garbage disposal, a single wall heater, and I wanted it. I completed an application, and on the following Sunday, I signed a one-year lease.

Six months ago, I said I would absolutely not move back to my hometown. I had big, big plans. When those didn't work out, I made smaller plans. And when those didn't work out, I got stuck in old thinking. I doubted myself and my ability to live my best life. It was time to declutter my mind. I slowed way down, paused,

and simply listened. Unhurried, my heart opened to opportunities I had not considered, and POOF . . . something magic came my way.

I guess John Lennon was right when he said, Life is what happens while you are busy making other plans.

Turns out the Universe knew best . . . always does.

xoc

CHAPTER 38

Spring 2019

The morning sun brightens my dining room. I sit at the table and situate my laptop to avoid glare on the screen. Preparing for a Skype session with my therapist, Rebeca, I open my journal, press it flat at the binding, and date the blank page. I click to connect, and she appears, "Good morning, Christine. How are you today?"

We've been Skyping once a week or so since January. With Rebeca's support, I'm less anxious, but loneliness and longing linger. I wonder aloud, "With all the work I'm doing, shouldn't I be happier?"

Most people would consider me a happy person. Thoughtful musings about life make their way onto my blog. My Instagram feed tells the story of my experiences with beautiful pictures. But carefully chosen words and photographs don't tell the whole story. I'm depressed.

Rebeca asks me to consider a term: radical thinking. It doesn't make sense right away. To clarify, she repeats language I have used in our sessions to evaluate myself and my choices. The words are extreme and harsh. I am intolerant

of my mistakes and errors in judgment. I have an endless list of "shouldas" that would have resulted in a better, happier life. Not only for me but for people I've hurt. When she asks why I am crying, I say, "I don't know how to be gentle with myself."

She asks me to consider a new way of thinking. For me, it's the most radical thinking of all: I must accept that I am human, flawed, with a history that includes some missteps and many worthy accomplishments. I am not perfect. There is no perfect love, no perfect relationship, no perfect life.

I stubbornly offer a final argument to justify my lack of self-compassion. I talk about Andy. I tell Rebeca I am furious with myself for the many times I believed he loved me. I am embarrassed by the love I gave away. I deserve the heartache. I clear my throat and say, "I should have known better."

And there it was, another should.

I lift my gaze from my fidgeting fingers and look at the screen to find Rebeca's kind eyes focused on me. She takes a thoughtful, and maybe exasperated, breath and says, "Christine, you are a human. It was never expected of you to be an expert in your past relationships, nor is it expected in your future. I want you to understand this: You don't have to do another thing in your life, accomplish one more goal, help one more person, or fix yourself in any way to be worthy of love. You are worthy of love right now, just as you are."

I thought I had conquered all the self-worth stuff. I'd read the books, written the blog posts, and proclaimed myself worthy. But I never believed it.

�֍✖✖✖✖✖

Billionaires Row on Broadway, one magnificent mansion after another, and my path as I power walk toward the Lyon

Street Steps. I fantasize about a chance meeting with a single, sixty-ish billionaire taking out his trash, followed by a love at first sight moment. But I'm pretty sure billionaires don't take out their own trash. Even more improbable is a love connection. Before heading down the 288 steps, I detour into Presidio Park. Through the iron gate and thickly wooded area, I reach a clearing and take in the beauty of the San Francisco Bay. Stretching my arms out wide and then over my head, I breathe deeply, bend right and then left in half-moon pose. Two years ago, I stood here exhilarated by my future, nothing but blue skies, figuratively and literally.

Another deep breath, my face toward the sky, I acknowledge that the passage of time, and therapy, has improved my state of mind. I'm looking forward to dinner tonight in the Marina with a high school friend. Tomorrow, I head to Mill Valley for Nili's son's wedding. Next month I'm off to Italy, France, Spain, and Portugal. I'm meeting Nick and his family and then connecting with Randi. Life is very good. I walk beneath the canopy of trees and head back to Lyon Street.

I race down the steps. My right hand hovers above the handrail, just in case. At the bottom, I do a quick one-eighty and ascend as fast as I can, never looking up. It's easier to keep on going if I'm not preoccupied with the finish line. My thighs burn, my pace slows, but I don't stop until I reach the top.

Back in my hotel room, I lounge on the bed and read the most recent edits to my manuscript, glad to have snapped out of my writing funk. Finishing my book had taken a back seat to so many things, including volunteering in Luca's classroom and lunch dates with girlfriends. When I complained to writer friends about my writer's block, procrastination in disguise, they recommended an editor.

Jean was exactly what I needed, a professional who gave me a gentle push, and deadlines.

Secretly, I refer to her as my writing therapist. I confide in her about my writing insecurities. I told her I managed to write a book about nothing and that I wanted to set the whole damn thing on fire. She assured me a theme would emerge. I wanted her to tell me what my story was about, wrap it up, and hand it to me, publisher ready. But that was my work to do. Reluctantly, I revisited old journals, blog posts, and texts. I scrolled through the beautiful photographs that had chronicled my journey. Thousands of words and hundreds of images later, I rediscovered the story I worked so hard to bury.

I had done something big; I had traveled far outside my comfort zone and explored unknown territory. I learned to speak Italian like a proficient two-year-old. I used it to greet people, find the nearest bathroom, and order delicious gelato. And I dug up ancient hurt and welcomed powerful healing and took the greatest risk of all. I trusted someone with my heart. Wanting to be loved didn't make me weak. It made me human. In writing this chapter of my life, my desire to be authentic is stronger than my fear of looking foolish. There is no shame in a story that exposes my vulnerability. I have accomplished what I set out to do. I wrote my memoir.

I put my editing aside and dress for dinner. Standing before the full-length mirror, I check my appearance. I miss dressing for someone. I miss being loved in a romantic way. And for the first time in my life, it doesn't leave me feeling sad, or bad. Of course, I'd like to meet someone. I tried online dating again, but the dating pool, and the guys swimming in it, hasn't changed. I'm finished with it, at least for now.

I think about past relationships. I'm the ex that maintains friendships after breakups, remembers birthdays, and answers

calls for help. Unless they need something, none of my exes ever reach out to me. I'm done with one-sided relationships. Self-care includes making choices that set me free.

Blog Post
May 14, 2019
Making it Last . . .

Love is in the air . . .

Well, not for me, but I'm certainly surrounded by it. A few weeks ago, I sat under the shade of redwoods and listened to a young couple speak their wedding vows and share their love story so beautifully. The following week, drinking wine at a backyard barbecue, two couples compared the crazy similarities of their love stories. First meeting in high school, then moving out of state, marrying other people, eventually divorcing, and then finding their way back to one another. After more than twenty years! A few days later, at book club, my girlfriends and I stumbled onto the topic of divorce and the redemption of finding love again.

Among my friends, there are those who found "the one" the first time around and have been married twenty, thirty, even forty years. Others have gone through tough divorces, filled with hurt and anger, but say they'd do it all again to be with their one true love the second time around. I've seen proof that the third time really can be a charm. A massive relief because I'm counting on it.

I enjoy watching and listening to the love stories unfold, even if I have heard them before.

Talking over one another to confirm accuracy, chiming in for missed details, and playful teasing reflect the comfort of a good partnership. I can only be happy for them. Though, I admit to occasionally comparing myself to their success. It's sometimes lonely to be the only single person among married friends. But I can't complain. My life is good in so many ways. Besides, it's never too late to try again.

I have found and lost love in just about every possible way. When relationships were doomed, I hung on to the hope that it would work out because I had seen long shots work out for my friends. When they found lasting love in the most unlikely ways, I was sure it could happen for me too.

Of course, no relationship is perfect. I've watched from the sidelines and seen friends hit some rough patches, but they have come through stronger as individuals and as couples.

When I compliment them on their lasting relationships or ask what makes it work, they talk about their commitment to one another. But mostly, they smile and chalk it up to luck, grateful to have found lasting love.

I've heard the stories, know the players, even watched them beat the odds.

I see this . . .

When two people love each other, when they want to be together for the rest of their lives . . .

They find a way, and they make it happen.

xoc

CHAPTER 39

Life goes on
June 2019, Sintra, Portugal

Randi and I stroll the grounds of Quinta de Regaleira, exploring separately and then drifting together again. Now and then, we pause and stand in silence, gazing at the ornate gothic architecture of the castle. One of us speaks a thought, and the other says, "You're reading my mind."

The result of forty-five years of friendship and many trips together, I suppose. I tell her, "One day, we'll travel as a foursome. You and Bill, and me and my guy."

There is no guy. Randi humors me and smiles in agreement. She wanders toward a stone bridge, and I get lost in a daydream. I imagine a future that includes a man and neatly weave him into my memoir. Maybe that's the way my story ends. I smile because coupledom is no longer a requirement for happiness.

I've lost Randi again. Scanning my surroundings, I spot her on a gray stone balcony high above me—the benevolent queen taking in her kingdom. I snap a picture and then climb the stairs to join her and share the view.

We follow signs to the Initiation Wells. I consult Google, my resource library, and learn that the wells were never intended for water collection; they were used for secret initiation ceremonies. Randi and I shudder as we wonder aloud about the types of rituals that may have taken place here.

We enter the larger of the two wells, and sunlight illuminates its mossy walls. Its winding stone staircase includes nine platforms believed to represent Dante's nine circles of hell, nine rings of purgatory, and the nine celestial bodies of heaven. I am amused that my travels would bring me to a place that symbolizes life's journey.

Carefully, I lean forward through an arched opening and take a few photographs. I've lost her again. I shout into the well, "Randi, where are you?"

"Look down!"

Weak-kneed, I peer over the opening's edge, a little further this time, to see Randi's extended arm waving at least two levels below. She yells, "I'll meet you at the bottom. It's the only way out, no turning back!"

At the bottom? Eighty-eight feet according to Google, it's dark down there. Old fears surface, but I don't let them rule me. I descend into the unknown. My footsteps echo. Eventually, I arrive at a maze of paths and caves. Unsure of which direction to go, I chase shadows, make wrong turns, and hit dead ends. Getting nowhere, I stop, and let the shadows go. In the stillness, I hear faint voices. They become louder as I walk in their direction. A few tourists who seem to know the way. They pay little attention to me as I quietly tag along.

My phone pings, Randi letting me know she is already outside. I text her that I'm close. A few more twists and turns and my accidental guides and I reach a queue. We wait our turn to cross a small pond. I watch those ahead of me navigate

the uneven stones to reach the other side. Some are quick and light-footed, others slow and cautious. An obstacle course I would rather avoid, but I don't see another way out. I chuckle to myself. The easy way and shortcuts have never taught me a thing. My turn, I look down at my sandaled feet. Once again, I'm not prepared. That's life.

I take a breath, firmly place my foot on the first stone, and step into the light.

ACKNOWLEDGEMENTS

Candi Sary, you encouraged my memoir writing dream from the start. Your critique of my early chapters and its ridiculously wordy first draft gave me direction. Your wisdom kept me from setting my manuscript on fire. I am forever grateful for the time and energy you invested in my story.

To my friends in the fun, creative, and always thought-provoking Chicka Chicka Boom Writers' Salon, you made me believe I was a storyteller. Cindi Berg, Mike Miller, Annie Quinn and again Candi Sary, our Wednesday writing meetings were sometimes hard and always honest. I'm sorry you had to witness my ugly cry more than once. My memoir is better because of your thoughtful input. Thank you all.

Randi Haithcock, from my lowest low to my highest high, you have been the bestie by my side for decades, there for every chapter. Your critical eye and loving heart guided me from my first draft to the final version. Phyllis Kerlin, we are kindred. I always say you lived my stories before I did. After reading my first draft you reminded me that I am more than my mistakes. Barbara Colbert and Jenny Dory, your critique motivated me to give meaning to the messy parts of my life. Thank you.

Sarah Hartley and Mia Sutton, you published my stories in *Holl and Lane* and later in *The Kindred Voice.* Thank you for believing my stories were worth sharing. You helped me believe it too.

Jeannie Ardell, my first professional editor, you suggested I rewrite my ending to include my travel in Italy. I resisted, but you were right. Since your passing in 2022, I have mentioned

your name with gratitude more times than I can count. Thank you for the nudge. You would love the new ending.

Pam Shepard, you recommended I change the first chapter of my book. "Open it with a bang," you said. And you challenged me to cut 40,000 words! Best advice ever! Thank you.

Chelsea Rider, editor extraordinaire, you meticulously cleaned up my manuscript and made it publisher ready. You were the first professional to say you loved my story. I'll never forget the pride I felt in that moment.

Huge gratitude to my publisher, Teri Rider at Top Reads Publishing. While I questioned the appeal of my story, you saw its value in relatable, authentic, and vulnerable storytelling. I have leaned on you for professional and emotional support, and you've been there every step of the way. Thank you for everything.

Jori Hannah of Torchflame Books, your marketing expertise has been invaluable. You were so patient with my lack of knowledge in all things techy. If you ever get the bug for a second career, I think you'd make an excellent teacher. Thank you.

Patti, Susy, Mary, and Nick, the best sibs a girl could ever want. Digging into our collective memory, and recounting memories kept my memoir real, thank you.

Mom and Dad, you are the origin of my story, my beginning. Though you are gone, your love and lessons are lasting. Some part of you is in everything I write. You are my strength, my vulnerability, and my courage. I think you would be proud of my work and proud of me. I feel sure you'll give me sign.

ABOUT THE AUTHOR

Christine Amoroso resides in Southern California where she grew up and raised a family. As a school principal, she craved a creative outlet, and started a blog.

A contributor to *Holl and Lane Magazine*, she has written articles about body image, mental health, aging, and grief.

In 2017, Christine sold her possessions, and moved to Italy to write. A year later she returned home with the first draft of her manuscript.

In 2019 she was invited to share her inspirational story with aspiring student writers at the University of California in Irvine.

When she's not writing, she power-walks along the coast, plays soccer, and indulges her grandchildren. She travels abroad every chance she gets.

To learn more, visit: christineamoroso.com
and read her blog at: barenakedinpublic.com

Printed in the USA
CPSIA information can be obtained
at www.ICGtesting.com
LVHW040836160724
785556LV00023B/143